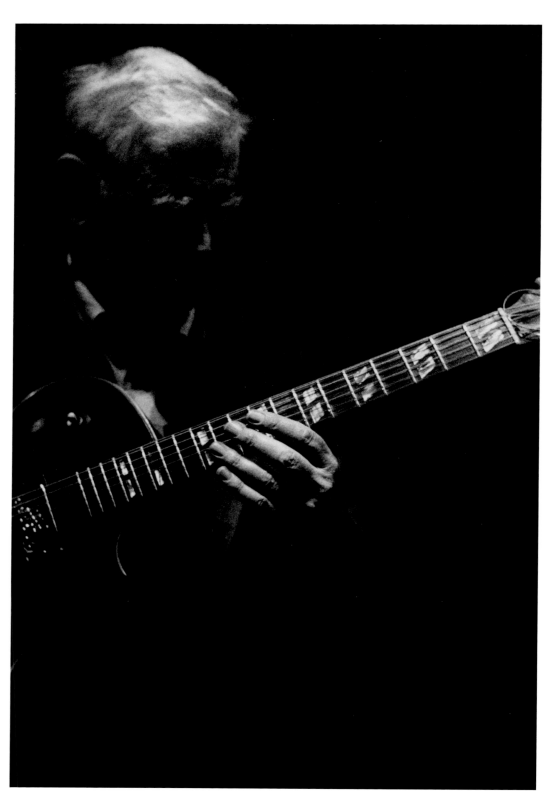

Dedicated to Derek Bailey, 1930–2005

State of the Axe

Guitar Masters in Photographs and Words

Ralph Gibson

Foreword by
Anne Wilkes Tucker

Preface by
Les Paul

The Museum of Fine Arts, Houston
Distributed by Yale University Press, New Haven and London

This book accompanies an exhibition organized by the Museum of Fine Arts, Houston,
and presented there from September 20, 2008, to January 19, 2009.

The publication of this book is made possible through the generosity of Chris and Don Sanders.

All photographs are the property of Ralph Gibson and are reproduced with his permission.

Graphic design: Ralph Gibson

Distributed by Yale University Press, New Haven and London
www.yalebooks.com

Cover illustration: Brandon Ross (detail)

Library of Congress Cataloging-in-Publication Data
Gibson, Ralph, 1939–
 State of the axe : guitar masters in photographs and words / Ralph Gibson ;
 foreword by Anne Wilkes Tucker ; preface by Les Paul.
 p. cm.
 "This book accompanies an exhibition organized by the Museum of Fine Arts, Houston,
 and presented there from September 20, 2008, to January 19, 2009"—T.p. verso.
 ISBN 978-0-300-14211-2
1. Guitarists—Exhibitions. 2. Guitarists—Portraits—Exhibitions. I. Title.
ML141.H69G53 2008
787.87092'2–dc22

 2008023141

Printed in Italy by Arti Grafiche Amilcare Pizzi

timbre tenor tone
meter measure mode
metal wood bone

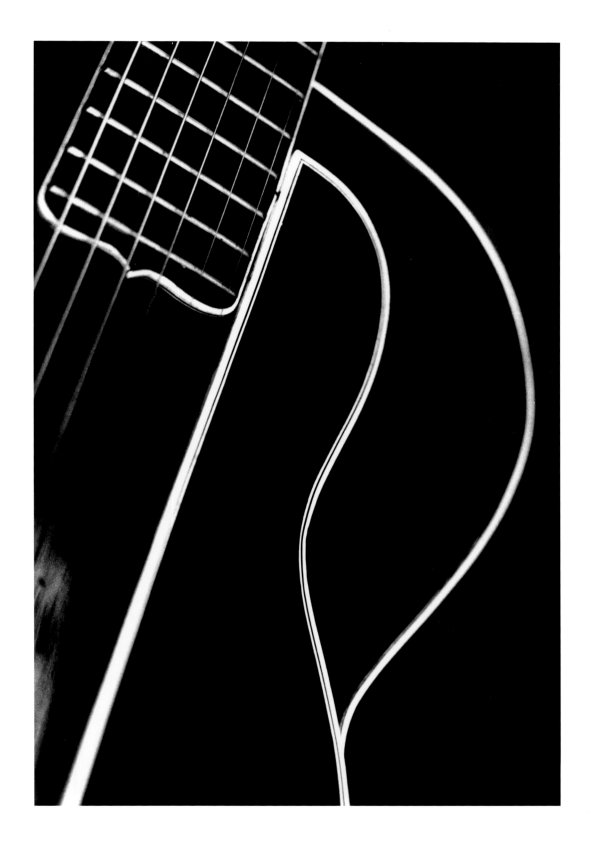

Contents

Foreword

People who are familiar with Ralph Gibson's photographs will be surprised by this new series of portraits. Since he first published the slim, elegant, and influential book *Somnambulist* in 1970, his work has been recognized for its highly personal vision. When he photographs, he moves in so close to the subject that he creates provocative ambiguity, rather than heightened clarity. The pictures are unabashedly romantic, and as such, offer a sharp counterpoint to the crisp, detailed, and sometimes critical visions in photographs by his contemporaries, such as those of Robert Adams, Lee Friedlander, and Garry Winogrand. As suggested by the title, *Somnambulist*, and the titles of his subsequent books, *Deja-Vu*, *Days at Sea*, and *L'Anonyme*, Gibson's images resemble the disconnected realities often associated with dreams, fantasies, and desire. They are not documents in any traditional sense. Nothing in them could be used to date the picture or determine where it was taken. In only a few instances could a person be recognized.

In *State of the Axe*, it is imperative that we know the sitters by name. They are featured here as master guitarists. Gibson has traveled widely to collect their portraits. He shares with them his love for guitars and for music, which, as Gibson has noted, shares with photography the use of abstraction. Maybe Gibson's grasp of visual abstraction has enhanced his sensitivity to jazz in particular. In his portraits of musicians, his signature style of moving in close to the subject prevails. The guitarists were photographed in many different settings, including nightclubs, studios, and apartments, but their environments and any other musicians that may have been present are excluded. These photographs are primarily of the face, hands, and instrument. Occasionally, a picture includes a sheet of music, stage lights, or background objects too blurry to identify, but what holds our attention is how each musician fingers the strings and holds the instrument relative to the body. They may be conscious of being photographed or completely absorbed in playing, but few are simply posing, and they rarely look at the camera. The pictures' dramatic lighting is characteristic to both Gibson's photographic style and to onstage performances.

Most uncharacteristic in this book is the amount of text. Gibson's prior publications have minimal or no text, which was appropriate to his photographic vision. Here, he lets the musicians speak about their lives and influences, and sometimes even about their guitars—what kind they purchased, when, and why. Their words echo similar statements made by photographers about their choice of cameras. Both groups have found creative expression through an instrument, which over time has become as familiar to them as an appendage. Both cameras and guitars are portable, and often photographers and musicians keep their respective instruments at hand. Gibson understands that relationship between artist and instrument and employs it with varying visual rhythms throughout this book. It's the physical manifestation at the heart of each musician's artistic expression.

Anne Wilkes Tucker
The Gus and Lyndall Wortham Curator of Photography
The Museum of Fine Arts, Houston

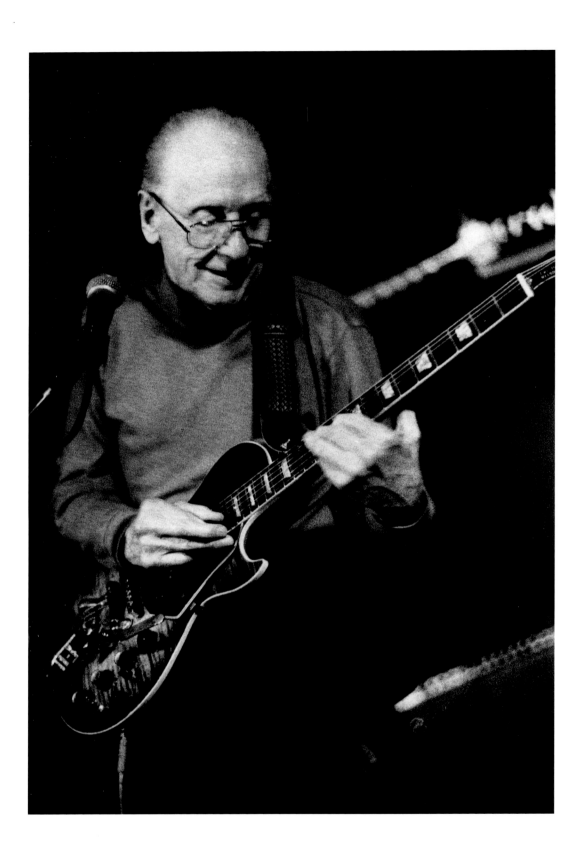

Preface

Many years ago I knew that the guitar was going to be the number-one instrument in the world. But in the early days it was an apologetic orphan that didn't fit into the orchestra. It has evolved to the point that now it is the dominant instrument in the world. I knew this would be the case way back when the piano was the most popular and important instrument. But with the piano you had your back to the audience. It didn't fit into the backseat of a car or work on the beach.

Now, seventy years later, those of us who sowed the seeds can harvest the crop. The guitar has finally arrived and has proven itself to be the most versatile of instruments. There are things that are necessary now that were not necessary in the orchestra in the early days. The guitar then was a cushion. Now it is "His Master's Voice." The players in this book all have something to say. It is a great privilege if you are a guitar player. And what is a guitar? It is your best friend. It is better than a dog; it's a psychiatrist, and it's a mistress (which is why you need more than two). With a guitar you can make a person laugh and cry. It has the ability to do that.

Les Paul

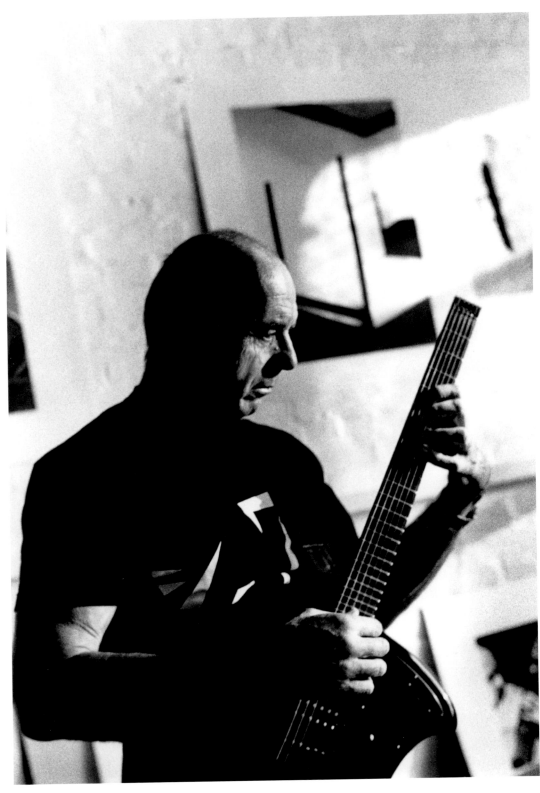

Ralph Gibson, photograph by Chuck Zwicky, 2006

Introduction

During the past fifty years the guitar has evolved to an exponential degree. The pioneers of yore must surely be pleased and amazed by the current role of the instrument. Today the guitar is a social component, and many people have a personal relationship with the instrument. By the age of fourteen or fifteen years a remarkable percentage of young people know how to play a few chords.

The point of this book is to show how this instrument is a medium through which the intelligence speaks—not merely rhythm or accompaniment, rather a pure echo of a true artist. In photography, there are those practitioners whose work is immediately recognizable as being theirs. I am referring to a visual signature that arrives after many years of honesty and effort within the medium. There are guitar players whose sound is unique and reflects their truest expression.

The aesthetics of music are so different from those of visual artists. Music is ephemeral and absolute in its abstraction. It is interesting to note that while music is the most abstract of all forms of communication, it is the most widely understood language in the world. Everybody speaks music. I wrote in my journal recently that to be a photographer one must have an eye for the abstract quality in things. To be a musician one must have an almost metaphysical understanding of the ear. It has been said that only humans can understand melody; the songbirds communicate on a purely vibrational level. Humans can transform sound into emotion.

Throughout my career as a photographer, I have been privileged to meet many of the masters of twentieth-century photography and discuss their creative process. Only recently did the idea occur to me to attempt to engage some of the great guitarists of our time, to make their portraits and ask them for some words about their relationship to music and the guitar. In making this book, I soon realized that I could not render homage to all the great players, but I have found my eye and ear drawn to a kind of artist who has advanced the medium beyond criticism or comparison, and I thank them all for their candor and their music.

My warmest thanks are given to Don Sanders, who has been generous and forthcoming with his personal encouragement and support throughout the evolution of this project. I am grateful to Chris and Don Sanders for their generosity in making this publication possible. Anne Tucker is owed a special word of gratitude for her insight and perception of the work. Her enthusiasm for the photographs brought the exhibition

to life. She, Director Peter C. Marzio, and the entire staff at the Museum of Fine Arts, Houston, have made working on this exhibition and publication a unique and wonderful experience.

Many club owners and managers were magnanimous in indulging this project. I am personally thanking Charles Carlini of the Carlini Group and Queva Jane Lutz at the 55 Bar, Lorraine Gordon at the Village Vanguard, the folks at Tonic, Jazz Gallery, Birdland, NuBlu, Iridium, BB King's, the Stone, the Downtown Music Gallery, the Knitting Factory, the Jalopy, Roulette, Tina Pelikan at ECM Records, Mitch Hauppers of the Berklee College of Music, and David Spelman of the New York Guitar Festival. I couldn't have done it without you. My assistants Renato D'Agostin and Helena Kubicka De Bragança helped to advance this work in numerous instances. Caleb Cain Marcus provided his expertise and extended efforts in the final stages of production.

Yale University Press has enabled this book to see the light of printer's ink. It has been an honor working with such esteemed bookmakers.

Stay tuned,
Ralph Gibson

Guitar Masters in Photographs and Words

Andy Summers

In 1971 I lived in the Chelsea Hotel for a few weeks, and although I only had an electric guitar—a Fender Telecaster—I practiced the classical guitar studies of Villa-Lobos on it. I often did this through the night while in the room next door two people fucked like the end of the world was nigh. Their animal moans went well with Villa-Lobos, particularly Etude 11, and although separated by a wall, our tempos often seemed in sympathy. I didn't know who the girl was, but I always liked to think of her as Suzanne from the Leonard Cohen song. I heard that he too had lived at the Chelsea. Sometimes I played until the sun broke on the hissing radiator in the corner, and then, exhausted, I would fall into bed with raw fingers and a sense of loneliness, wishing I was with "Suzanne" next door.

In the evenings I would go to the Village to eat or listen to a band. Sometimes I went to the movies. I went to see *The Seventh Seal* by Bergman, and it set me on fire. As silver images strobed across my face, I imagined conjuring up all kinds of music on the guitar for this film—an early impulse toward film-score composing perhaps. I left New York and went to California, where I traded my Tele in for a white Stratocaster that apparently had belonged to Buddy Guy. But I didn't like it, and I swapped it a few weeks later for a Gibson SG.

I liked the SG and kept it for a while. I liked to get up around midday and lie in the dirt above the pool with the sun on my face. Lying on my back, I would practice solos with my eyes closed, never looking at the frets. Most of these solos would be over open drones in E, D, or A minor, sometimes in the Phrygian mode, which still sounded exotic but later got boring. For variation I would lay on the diving board and invite sleepy-eyed girls from the house to step between my legs and dive into the pool. As they sprang from the board, I would twang the not-very-good tremolo arm of the SG in time with the vibration of the board.

One thing I realized around this time was that my thirst was for music just as much as for the guitar. I came to this idea by talking to other guitarists, who all seemed to be much more into things like strings, amps, and pickups than me, but I wasn't bothered because I was sure about my playing.

A few years went by, and eventually, despite not thinking of myself as a guitar freak, I ended up with 150 guitars and going up. I don't know if that made me any happier, but I got a dumb kick out of it. Somewhere along the line, I arrived at the idea that I was a guitarist and that, whatever I had been through, there was always a guitar there.

I began working up a minor bit of guitar lust, maybe in a shallow mimicry of guys who would rattle off names and years of models that I hadn't heard of but felt that it was now my duty to acquire. One night I crowded into a filthy telephone box at the

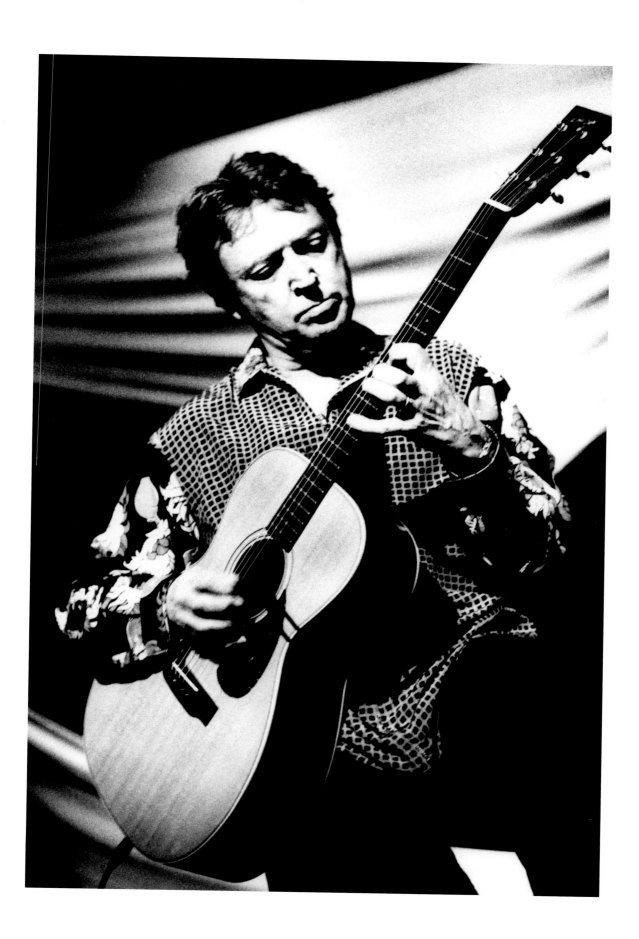

corner of Mercer and Spring streets to make a call to a tenement in the Lower East Village, where someone was selling a hard-to-find instrument. I was with a lissome young actress, currently starring in the biggest box-office film in the country. I hoped to impress her on this first date.

We took a cab over to Alphabet City and entered the tenement up a dark set of stairs as the rain whipped down in icy sheets. I handed a wad of dollars to a small man with a greasy cap who grunted and counted them slowly and then went to fetch the guitar that was in a bedroom at the back with his blind cat. It felt more like a drug deal, and I felt sure that any chance of romance was dead. We left with the guitar and grabbed a cab heading uptown. She told me on the way that she played blues harp and that we should jam. I stared through the window at the bitter rain and saw a ray of light.

As I finally became successful with the guitar, I opened up the territory of my own sound by running the signal through all kinds of devices to color it, choke it, strangle it, make it roar or cry like a woman. For years I had played mostly through Fender Twins, trying to get a liquid sustain by the judicious setting of whatever knobs Fender supplied along the front of the amp. Tone, phrasing, and choice of notes were what I was interested in. These remained, but now I played with a maze of pedals under my feet, trying to create a prismatic arc of sound behind the singer. This was fun for a while, but eventually it palled and I returned to a simpler setup, preferring to make music out of space, time, and touch.

Being a guitarist can be like inhabiting a Kafka novel, with strings, frets, chords, and notes alluding to a presence that, if not returned to and kept in order, pulls you into the shadows. But sometimes the geometry of the guitar is a haven, a lucent oasis, and you return to drink again.

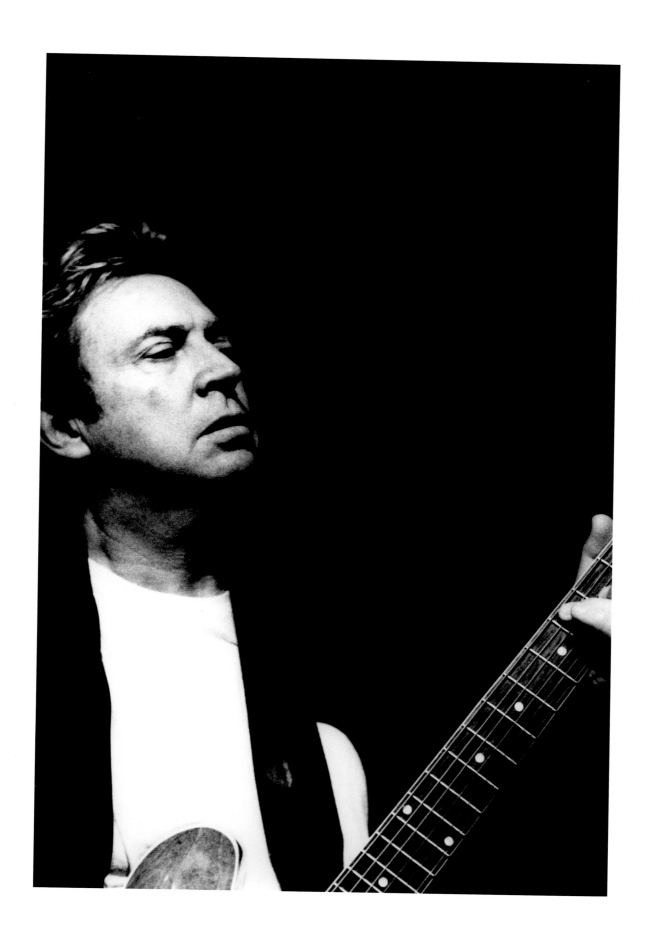

Bill Frisell

I was born in 1951, not long after the first Fender guitars. When I was about four years old my family got a television. Every day I watched the *Mickey Mouse Club*. I loved the part at the end where Jimmy (the leader of the Mouseketeers) would play his guitar and everybody would sing. I took a piece of cardboard, cut it into the shape of a guitar, and put rubber bands on it for strings. This was my first instrument. Outer space, dinosaurs, the future . . . A few years later my parents got me a twenty-dollar archtop guitar for Christmas. . . . Surf music, the Ventures, the Astronauts . . .

The first record I bought was a 45 of the Beach Boys with "Little Deuce Coupe" on one side and "Surfer Girl" on the other. John F. Kennedy got shot . . . atom bombs . . . In 1964 I saw the Beatles on the *Ed Sullivan Show*, got my tonsils out, and went to my first concert . . . Herman's Hermits. In 1965 I got a paper route and saved up enough money to buy a Fender Mustang guitar and Deluxe amp and started a band right away called the Weeds. I liked Manfred Mann, the Animals, the Yardbirds, the Byrds. I went to see Bob Dylan. On TV I watched *Hullabaloo* and *Shindig*. I went to see Bob Dylan, Jimi Hendrix, Buffalo Springfield, James Brown, Paul Butterfield, Cream, Canned Heat, Chuck Berry.

I loved the Temptations, Otis Redding, Aretha Franklin, Wilson Pickett, Sam and Dave. In 1967 I heard Wes Montgomery's music for the first time. I learned how to play "Bumpin' on Sunset." In 1968 Wes died, Martin Luther King and Bobby Kennedy got shot. I went to hear Thelonious Monk, Larry Coryell, Charles Lloyd, Ravi Shankar, and Jimi Hendrix again. I graduated high school in 1969.

I love music, not just guitar music, but some of the guitarists that have inspired me are Segovia, Robert Johnson, John McLaughlin, Derek Bailey, Dale Bruning, Bob Quine, Julian Bream, Boubacar Traoré, Merle Travis, Doc Watson, Jim Hall, Willie Nelson, Michael Gregory Jackson, Arto Lindsay, Ali Farka Touré, Djelimady Tounkara, Kenny Burrell, Roscoe Holcomb, Lightnin' Hopkins, Joe Maphis, Blind Willie Johnson, John Fahey, and thousands more. I don't think I ever wanted to do much besides play the guitar and try to make some music. I wish everyone played the guitar.

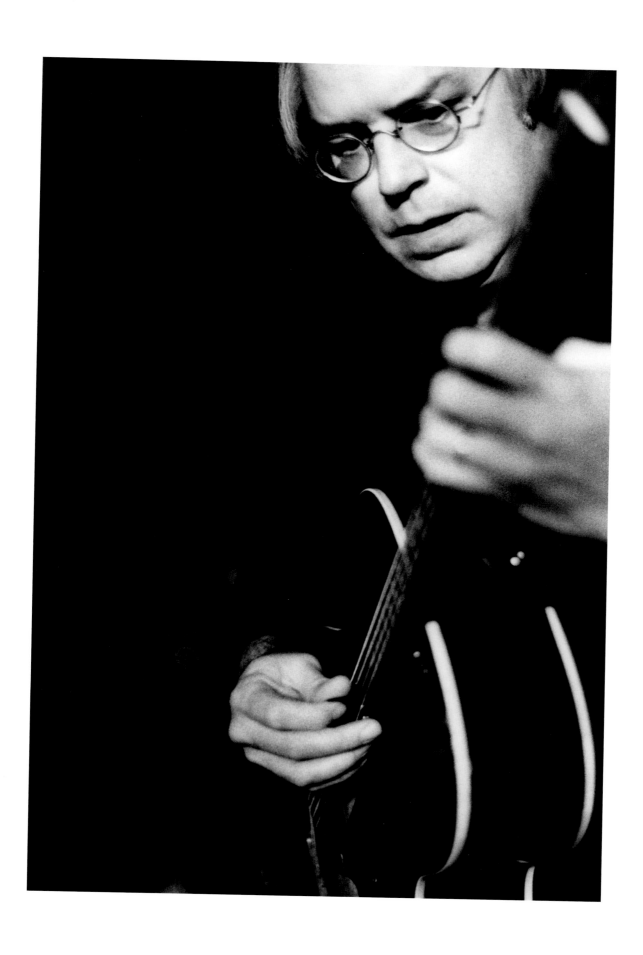

Brandon Ross

The guitar takes no prisoners. It's easy to play a little, relatively quickly after spending some time with it. The sucker punch is the realization that to get the most out of it requires a profound degree of commitment, enthusiasm, patience, and repetition . . . not unlike much else worth doing in life.

I remember composing songs on the guitar almost immediately: "art" songs, chords and melodies for the poems of Robert Frost. I was ten or eleven. Secret fantasies of being a creator of beautiful music for the tender and true of heart consumed my thoughts about music. Two strings, three chords, one melody—I spent a good amount of time doing that in my darkened bedroom, lit only by the pilot light on my guitar amp. I escaped into that space often.

I once told a really good guitarist friend of mine that I thought the guitar was stupid. He just kind of looked at me and asked what I meant. I didn't have a good answer. It was more of a suspicion that reflected my ongoing endeavor to find a pure pathway to my voice on the instrument. Systemically speaking, the guitar is illogical. It is illogical because most players are always manipulating it in some fashion to get it to do other things than what it was apparently designed to do. It is beautiful because it will never be finished. An amazing thing about the guitar is how flexible it is in almost anyone's hands. It will sound like whoever's playing it, once they choose to sound like their self, which, in fact, is no small matter . . .

Other instruments possess a similar quality, but the guitar has that "first-date acquiescence" that makes it seem as though anything is possible. True.

The guitar for me is, and always has been, a mirror of the order of my consciousness. In the most literal sense, it is unfailingly honest with me. It tells the impersonal truth without hesitation, without guile.

Integrating new information into ordinary, conversational musical language is what occupies me of late. Solving musical problems expands my vocabulary. Thinking in a spiral helps a lot.

I choose to be of origin, to be "original," an honest musical self. Any guitarist will tell you how great a challenge that can be. Any artist will ask you, *What other possible choice is there?*

Conundrums abound on the guitar until it all becomes clear. When is that? Some say it's when we're done with these costumes called bodies. Guitar would most likely be redundant at that point. I play guitar because trombone was . . . well, you figure it out.

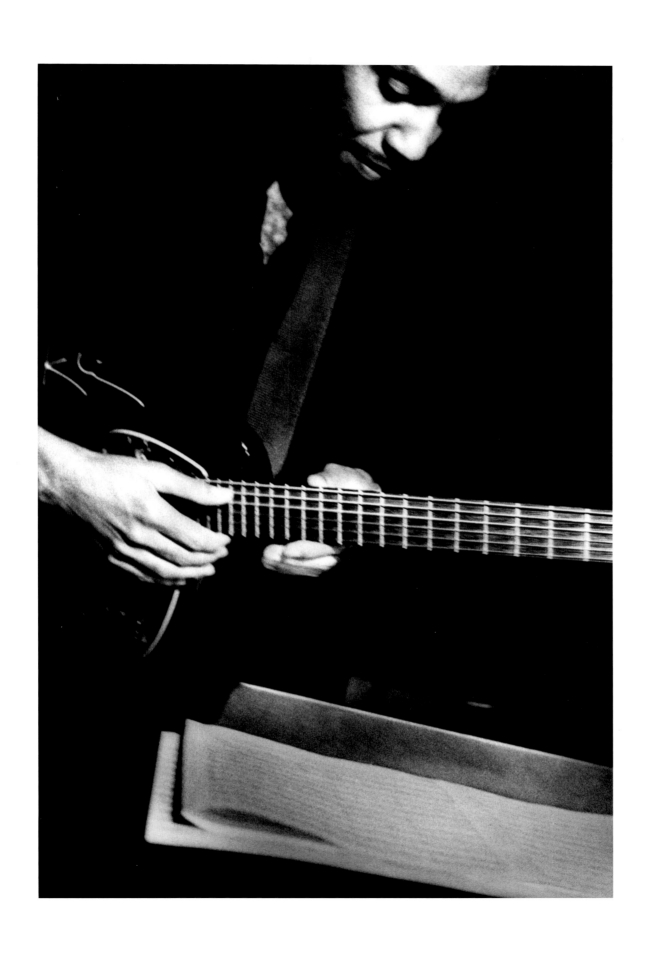

Jim Campilongo

I think at this point I communicate what I feel more successfully through my guitar than through my own words. It's probably why I'm drawn to music. It's more obvious and ambiguous than, let's say, writing lyrics, books, or even painting or acting. I can say whatever I need to say—without getting thrown in jail or in an insane asylum!

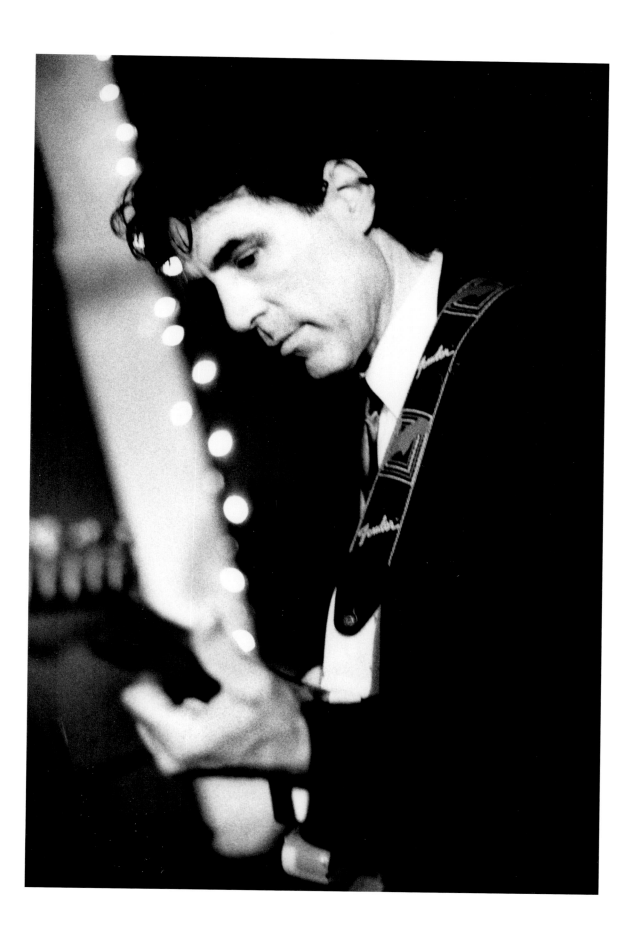

Marc Ribot

My relation with the guitar is one of struggle—I'm constantly forcing it to be something else—a saxophone, a scream, a cart rolling down a hill. Sometimes it obeys. Sometimes I give up and play surf music (what all electric guitars want to play). Surf music's OK, for a while. Then something always comes up that needs translation, and there we go again. . . . Guitars don't mind struggle. Guitars *are* struggle. Classical guitars aren't built in that wavy shape only to imitate the bodies of women (although it's a lovely shape), but precisely because wavy isn't the natural shape of straight-grained wood. Bending the wood, then binding it together in this unnatural shape, gives guitars the tension that creates their resonance.

A guitar is a kind of wooden spring. Serious classical guitarists prefer guitars under twenty years old. After that, they lose the tension that makes them beautiful. I often think of guitars abandoned in closets, silent constructions against the memory of the wood, a resistance, like Atlas's, noticed only when it fails. Rock and postrock solid-body electric guitars, at least those not shaped like Vs or teardrops, only mimic this shape, and don't strain against themselves in the same very literal way—which may be why the sense of tension became transferred into the aesthetic content of the material being performed, or into the bodies of the performers, who now, inexplicably, feel the need to stand up. In any case, I've lived with guitars a long time. I've bent them. And they've bent me.

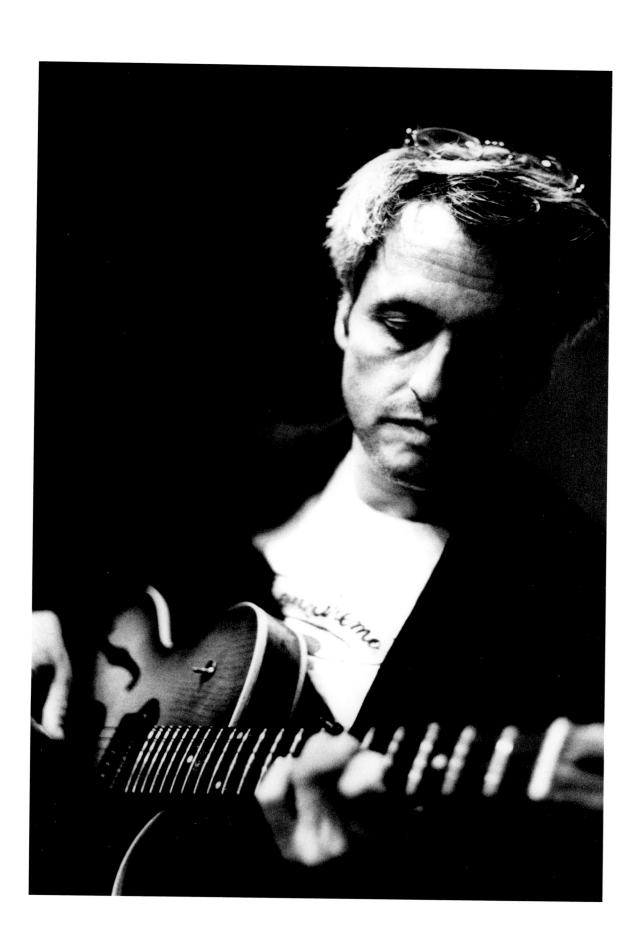

Pat Martino

A toy, a healing machine, an incredibly close friend, a common bond, a book of changes, an encyclopedia of similarities . . . all these things and more . . .

It began as a toy, as well as a challenge, and stays the same, along with the childishness. It's provided sustenance. It remains there for me, especially when isolated as my closest friend. It's given access to virtue and endurance through dedication. It has helped to clarify many definitions. It's been an introduction to others gifted in countless ways, and what's been shared in common continues to grow. It's demanded an open mind while residing in the heart. More than anything, it continues to refine intentions throughout the experience. The guitar is an amazing container for the blessings that have been given.

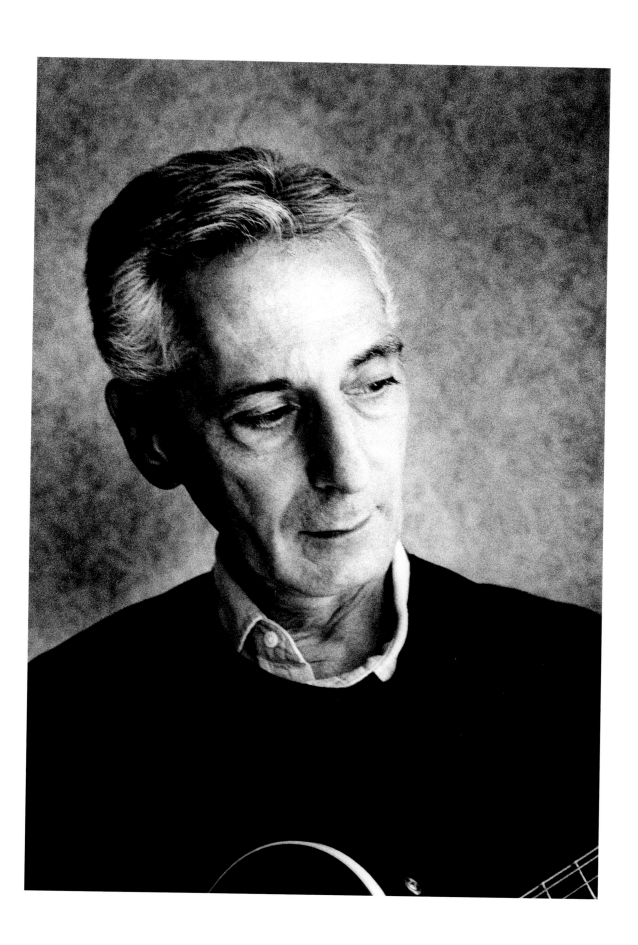

Jeff Richman

The guitar is my pride, my passion, and my partner. Over the years I have been able to express my personal stream of consciousness and emotions: happiness, sadness, anger, fear, hope, comedy, manic insanity, even unexpected frenzies.

It was my mother who first exposed me to this glorious instrument. She was a guitar teacher who loved to play and sing folk songs from around the world. When I was eleven, I went to summer camp, where my love affair with the guitar began. It was the turbulent and tumultuous '60s, and the world of music was changing rapidly. The radio airwaves exploded with the irresistible surf sound of the Ventures, the Motown sound, R&B, pop and, of course, the British Invasion of the Beatles and Rolling Stones.

All music turned me on, and the more I listened, the more I was inspired to learn and grow as an artist. Another great influence, guitarist Jeff Beck still remains my absolute favorite to this day. His eccentric, unexpected rocking insanity ignited a fire in my soul that still burns brightly within me to this very day. Then, in my twenties, I fell in love with jazz and began the intense study of the complexities, harmonies, and wonders of Miles Davis, John Coltrane, Thelonious Monk, and countless other jazz greats.

Today, I am working to create my own sound, which blends all of my influences, with no boundaries between them. I don't only strive to play the notes, but to hang in the spaces between them. During my live gigs, I no longer fear those accidents on stage. Instead, I see them as ways to expand my skills as I allow these happenings to take me to another level of my craft.

Even to this day, I retain my childlike enthusiasm and sense of wonder whenever I play, listen to, or even look at a guitar. All aspects of this wonderful instrument are forever fascinating to me. I am very grateful to be blessed with this passion, and it continues to give so much meaning to my life, and I hope it can give that same pleasure to others.

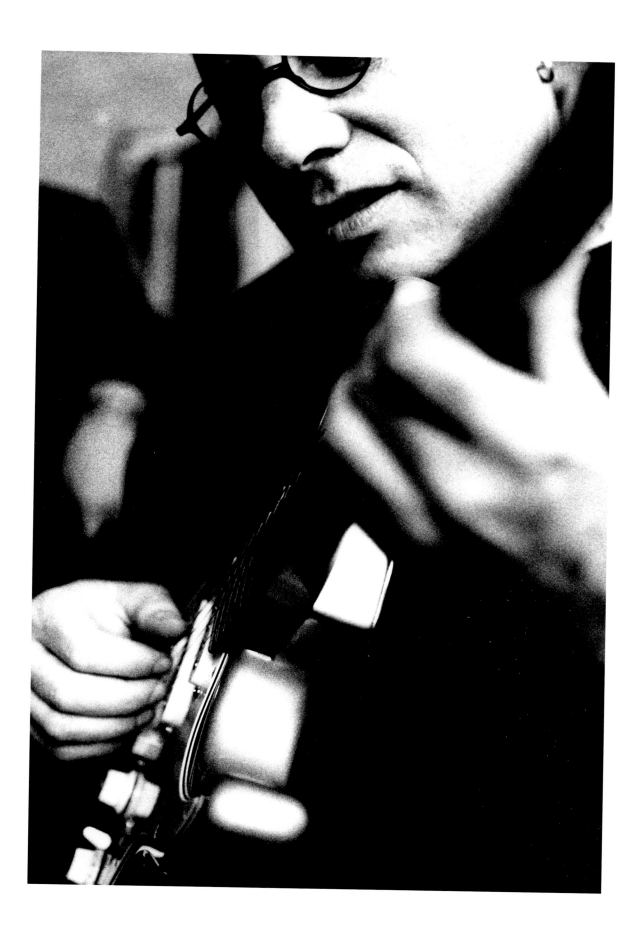

Steve Cardenas

It seems like I was playing the guitar before I ever held one in my hands. Among my earliest memories of music is hearing my brother's Beatles and Jimi Hendrix records. The guitar, being so much the center of these bands, seemed huge and mysterious to me. When I finally got my first guitar, a second-hand Silvertone classical, I remember how fascinating the strings looked to me across the frets and fingerboard, and how I wanted to know what all those notes were. And when I got an electric, with all its pickups, knobs, and switches, I would just sit and look at it like it was some beautiful piece of art . . . which it is, really. Soon I began playing in bands and getting exposed to all kinds of music and guitarists. I've learned a lot about myself through music and playing the guitar . . . and fortunately, that never seems to end.

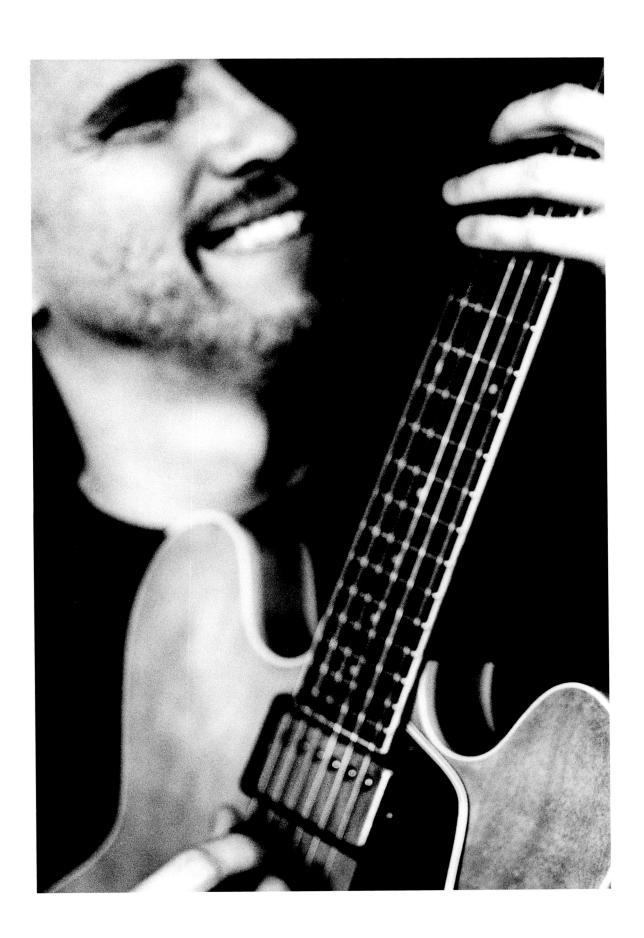

G. E. Smith

There was a guitar in the basement of the house I grew up in, an El-cheapo acoustic from the thirties, Collegiate brand on the headstock. It was dusty (very) with only four strings left, but I was only four, so it was a perfect match. My mother got it down for me, and I pretty much never let go.

I really can't remember not playing, not having that thing in my life to the extent that now, as an adult, the only time I feel at ease in the world, at one with my own body, is when I'm playing my guitar. The rest of the time is just waiting.

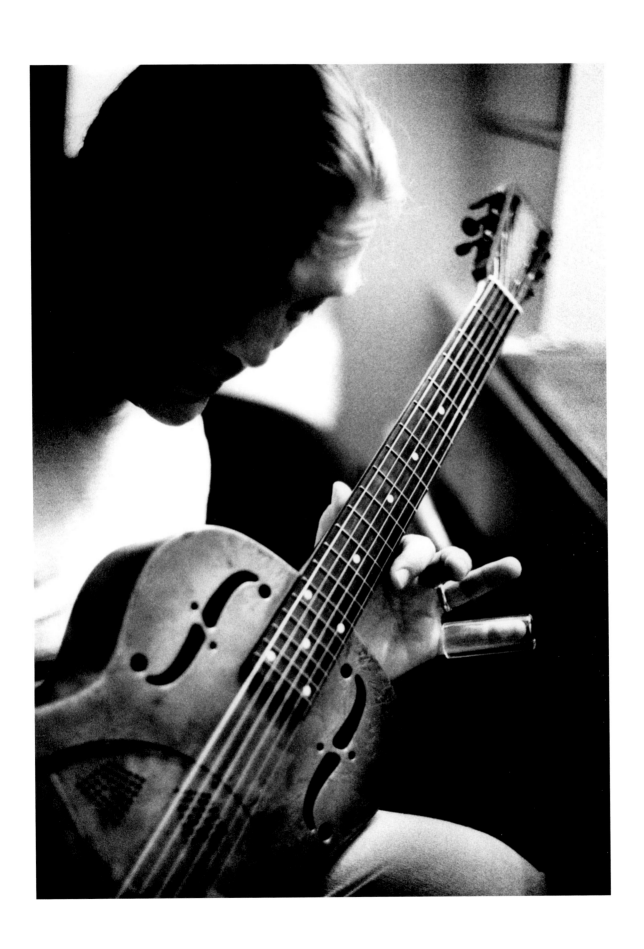

Jim Hall

How has the guitar influenced my life? "Let me count the ways."

As a working musician in my early teens, the world began to open up. All nationalities, Charlie Christian, Django Reinhardt, Béla Bartók, Duke Ellington, joined together through music.

Since then I've been privileged to visit much of the world—playing music and experiencing different cultures. I could not have asked for more!

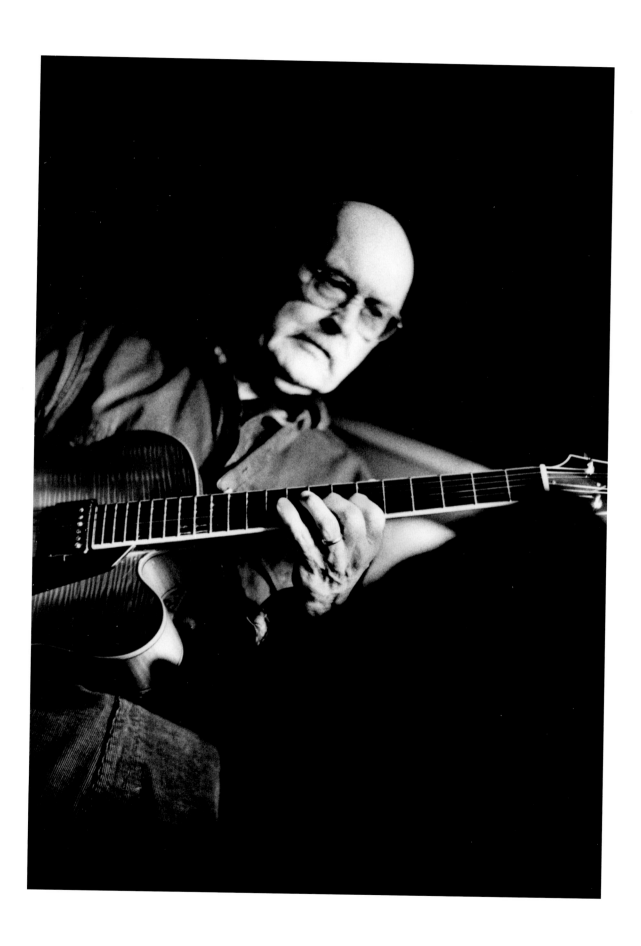

Liberty Ellman

I force jittery rhythm-language through my shielded cables. I cause disturbances. I push energy through a vacuum, rattle paper, and command the air around me. Metal whiskers bend, stretch, scratch, and whine while wrestling my fingertips for a natural state of calm and rest, yet their sole purpose is to be shifted, annoyed, and broken. My guitar speaks in tongues.

It coughs, sputters, barks, screams, soothes, and sings. It's the versatile champion of my cause. My axe can mend. No other tool can deliver my message across the universe in such a manner. My music is born from nature's polyrhythm and a respect for the infinite.

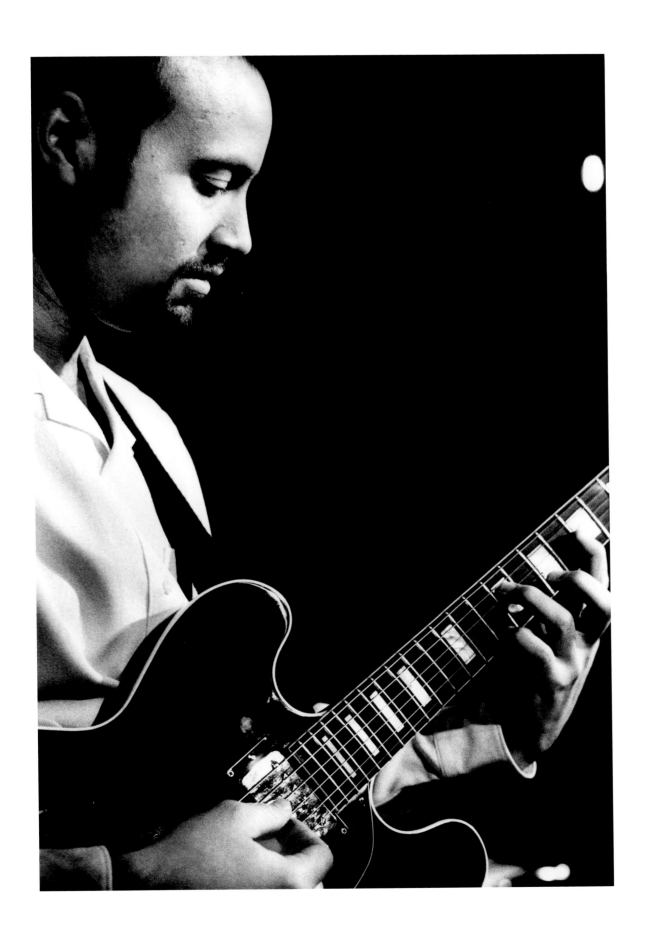

Joe Morris

Except for about six lessons, I'm self-taught. I started playing songs by the Beatles and Rolling Stones. I wanted to solo, which led me to the blues and then to Hendrix, which led to electric Miles and jazz and music in a bigger way. I practiced for many hours every day for years and years.

One night when I was about seventeen, during another long practice session, while trying to play exactly like John McLaughlin (who was the guy we all admired the most in those days), I realized that I admired him because, besides being tremendous, he had his own way of playing. He spoke with his own voice. If I wanted to be like him, I should try to speak with my own voice. From that moment on, I would just play what I wanted to play and not worry about doing it in a way that others thought was right. I started listening more seriously to what I heard in my head. I listened to everything else, too: jazz, twentieth-century classical music, Delta blues, and ethnic music. Free jazz really grabbed me, and I found a slot in it that I thought I could work in. I've been out and gone ever since.

I've always loved the plain, naked sound of an electric guitar plugged directly into the amp. It has an unpretentious grit and hum like a human voice. Before there were effects, guitarists could only plug in and deal with that space between the string and the magnet on the pickup. So many guitarists from the '40s, '50s, and '60s confronted this limitation and made it personal. The idea of a personal sound has meant the most to me since I started improvising in the early '70s. So, except for occasionally using a wahwah pedal, I have only plugged in. I tried to change the way I played to change the sound.

There are still people who think of the electric guitar as a second-rate instrument. That's something I like about it. It's an excellent tool to annoy snobs. Anyone can pick it up and play some music. If you break the rules to be yourself, then you just add to the tradition, and there's more for everyone to play. That said, I think the electric guitar is the serious string instrument of our time. There are so many different ways to play it and so many great players. It's really a separate and enormous musical world.

The guitar is the learning tool that has taught me nearly everything I know. Without it, I would be a very different person. The effort to play it and to discover my creativity puts me in a place where I can contemplate my existence every day. It's been a deep and rewarding experience, and I'm just getting started.

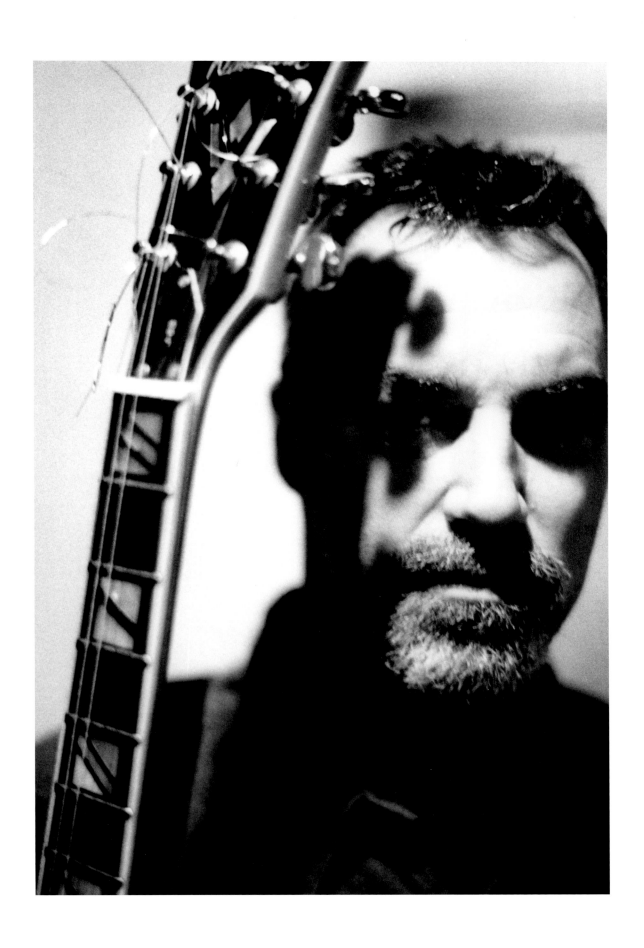

Andre LaFosse

The solid-body electric guitar is an inherent dichotomy: fundamentally electronic *and* acoustic in nature. Without the pickups and output jack, an electric guitar isn't much more than a very quiet practice instrument. But all of the electronics involved—the pickups, the onboard controls, the amp, and any effects in the signal path—are there in order to amplify and enhance a basic impulse that is purely acoustical in origin. So, as an instrumentalist who grew up (both musically and personally) in a post-DJ world, I see the electric guitar as a way to connect some of my far-flung musical dots into a coherent and meaningful picture.

"Turntablist guitar" means taking the old debate "Are DJs musicians?" and flipping it on its head and asking: "Can a musician be a DJ?" It's about looking at the guitar as a vinyl record, the Echoplex as the turntable, and my MIDI foot pedal as the mixer. It's about turning studio-based production concepts into a real-time, live performance discipline, filtering nonlinear, postdigital ideas about sound and structure through my actual guitar playing. And it's about trying to make a room full of people dance at an avant-garde party.

The soundtrack to modern life encompasses squawking modems, intermittent cell-phone breakups, chirping personal computers, singsong ring tones, caterwauling car alarms, and the stutter of skipping CD players. Fragmentation underscores our lives in countless ways, with glitches, errors, and irregularities woven into our environment on numerous levels. From that point of view, fracturing my own playing and throwing it back at myself seems less like an obscure musical undertaking and more like a survival tactic for the twenty-first century.

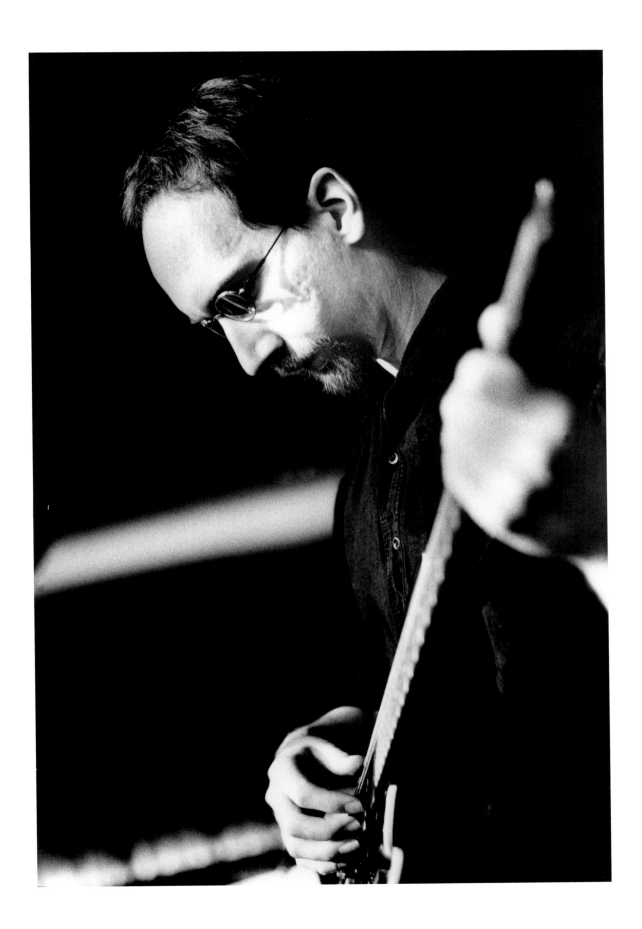

John Abercrombie

I guess it's always been the electric guitar. . . . When I first heard it, there was an immediate attraction. Just the sound of it, drifting across from a neighbor's porch, drew me like a magnet! I think I knew then that I was hooked. The sound was the main thing, but I couldn't deny the visuals involved. The electric guitar is also great to look at. They're like cars in a way, from elegant Mercedes to hotrods, and everything in between.

There's also some kind of mystery about the instrument. Those pickups and all the dials, with wires hidden inside that transmit your notes through cables, and eventually to an amplifier, with a speaker that's usually several feet from where you actually are! That's still far-out to me, while at the same time being perfectly normal!

In the beginning of my musical life, the focus was all guitar: instruments, players, types of music. . . . Later that focus was (fortunately) switched to music—jazz, to be more precise. The influences of other players on instruments different than my beloved guitar began to make themselves known.

I wanted to make my guitar sound like Bill Evans, or Sonny Rollins, or Art Farmer. This was a good thing. I realized that, through my touch, I could get closer to those things. I always felt that the way Art Farmer played the flugelhorn was an ideal sound, and I kept that in my head. Both Wes Montgomery and Jim Hall got to me, not only for their great lines and ideas, but for the beautiful sounds that they drew from their amplified guitars. The sound is the first thing you hear when you listen to someone play. Then you become more aware of the content of what they're playing.

My concept of sound changed somewhat in the early '70s with the arrival of jazz/rock, rock/jazz, or whatever you want to call it. Sound-altering devices (distortion, wahwahs, reverbs) were part of what I used to get closer to something that I couldn't describe. Now I guess it's just somewhere in the fingers, the brain, and the heart, where the sound starts from. But it still has to go to those pickups, dials, wires, and cables and still emerge from that amplifier several feet away. Some things never change!

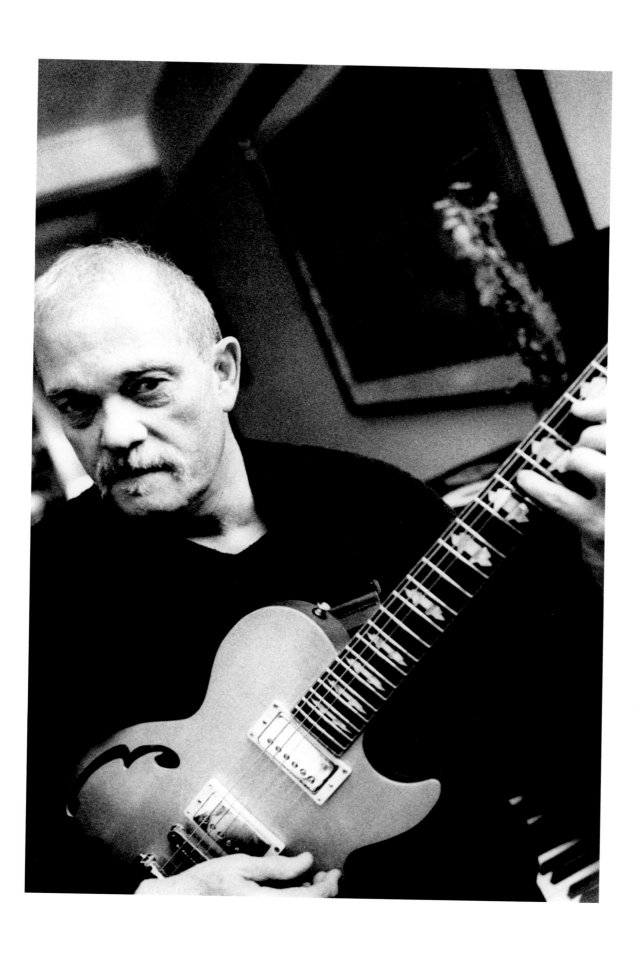

David Torn

The guitar still engenders much wondering in me. . . . I often wonder how the electric guitar might survive its currently self-referential, self-stereotyping, and nearly comatose public state to become, once again, a continuously culturally invigorating instrument. Any premature idiomatic narrowing and attendant classicizing of the once emboldeningly "dangerous" electric guitar (see Eddie Durham, Charlie Christian, Jimi Hendrix, Jeff Beck, James Blood Ulmer, Terje Rypdal, Hubert Sumlin, Wes Montgomery, Kevin Shields, Dr. Know, Adrian Belew, Neil Young, and so on) seems to me to be simply another expression of the depth of a very particular and peculiar cultural myopia—a blinkered partial view, quietly (but forcefully, and with unintended consequence, I think) imposed on listeners by mirrored/myriad reflections of a not-necessarily-unified post-corporate/hypermarketing type of perspective . . . or maybe that's just "human nature" at work? Hmmm. It may be that the thrust of this imposition—if one chooses to accept my supposition—is actually enforced by both listeners and guitarists/musicians alike. The guitar still inspires a wandering in me. . . . The many iconic roles of the guitar—guitar as soul-soother, as wooer, as accessible "voice-of-the-people," as soothsayer, as sword's edge of (occasionally subliminal) sociopolitical outcry—are still present, though the fulfillment of these roles may be held in check by an increasingly globalized approach to life that focuses on orderly conduct, and some handy-dandy compartmentalization and specialization to that end. The guitar still reminds me of the cutting beauty of life's thunderbolt, of wholly interdependent reality, of the dream of an earth that rids itself of the ignorance of injustice in its multifarious guises, of love, of the truth of emptiness, of snowdrops and compassion and jasmine and sex and history and espresso and dirt and flames and righteous anger and warmth and humanity's trail of tears and (to quote my good friend Hector Castillo) "sandpaper and honey," and the truly uncontrollable soaring flight of the unwittingly indomitable human spirit.

The guitar still speaks to me. . . . I hear a humming in its desire to move forward, to not become the most quickly classicized instrument ever. The players are present—many, indeed, living from the underground—and the masters of the luthier's craft are there to present and to assist musicians' motion, their assistance necessary to the evolution of the expression and recontextualization of the guitar. The new luthiers are available, have no doubt: the Kleins, Steinbergers, Teuffels, and Kolls of the world. . . . Oh yeah, they're available, all right, their sharp ears to the envelope, coaxing it along, even when, as parallels their musicianly counterparts, their work might remain underappreciated or barely validated during their working lifetimes; the trickling, filtered effects of their work spill deeply and silently across the ensuing span of the guitar's life. The guitar still engenders both hope and its motivation in me. . . . I hope for guitaristic

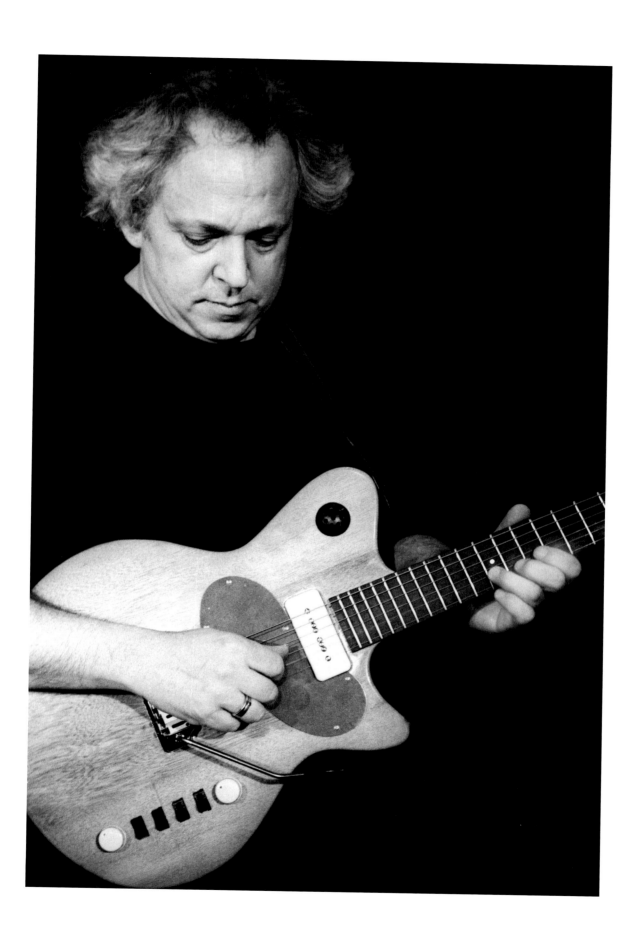

developments that provide for the fostering of integrative processes. More subtle and sophisticated techniques for actually playing, manipulating and massaging the electric guitar's amplifier—at least 50 percent of the electric-guitar experience—directly from the guitar, itself, might be developed; these could include controls for some previously marginal (and originally "user error"-oriented) electric guitar/amplifier techniques, like, say, the three cursorily explored forms of feedback manipulation. (One might see my Koll and Teuffel guitars for functioning examples of minor application of an integrative approach.) Also not to be missed are methods that integrate secondary instruments, such as both "live looping" (sampling and resampling, as employed and developed by guitarists as disparate as Robert Fripp, myself, Andre LaFosse, Matthias Gröb, Bill Frisell, and Robby Aceto), and postprocessing; some odd one will plant seeds for techniques/technologies that truly marry such approaches into unified instruments via newfangled manual/mechanical controls . . . and there are the many players and instruments that employ multiple string configurations, resonating strings, flexibly "preparable" instruments, instruments that bond old (oud) with new (gtr) (see Hans Reichel, Derek Bailey, Dominic Frasca, and others). These ideas are not at all *outré*, nor "whack." . . . They are birthed of players' real musical needs and intentions, and they do truly serve to "feed" the reality of a possible future for guitar. The guitar still brings dreams to me. The guitar has been with me for most of this life; I truly love the instrument in all its forms, in all its idiomatic expressions. I revel in its past, and struggle to continue learning from both past and present masters: players, luthiers, and amplifier designers alike. I look forward to the day when I'll hear that absolutely fresh guitarist whose music and context so move me, and whose playing and sound simultaneously so confound me, that I'll be heard to say: "Good lord, how is this music even *happening*?!" For that, I remain absolutely giddy with anticipation; it's on the wind, right now.

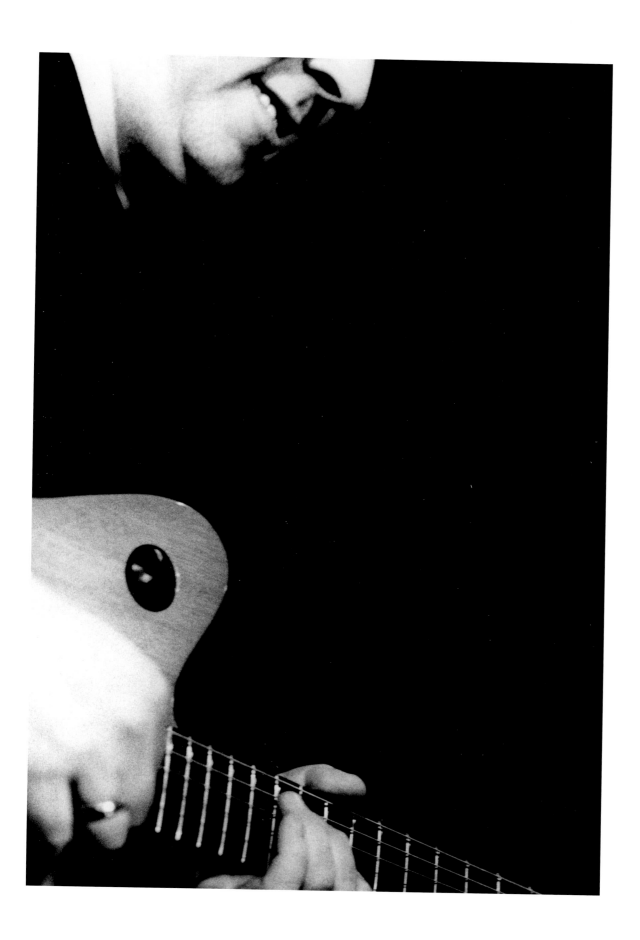

Wayne Krantz

I've been interested in playing for a long time, since I was thirteen. I feel lucky that I still care about it. For years it was all I could believe in and it sustained me. Now I have more in my life, but the music still wakes up with me, strong as ever, and I'm grateful for it. I like the guitar, too; it's a good tool, and I respect it, but I don't confuse that with what the playing is connecting me with—though whether that is myself, everyone else, or something else again, I don't know. Yet.

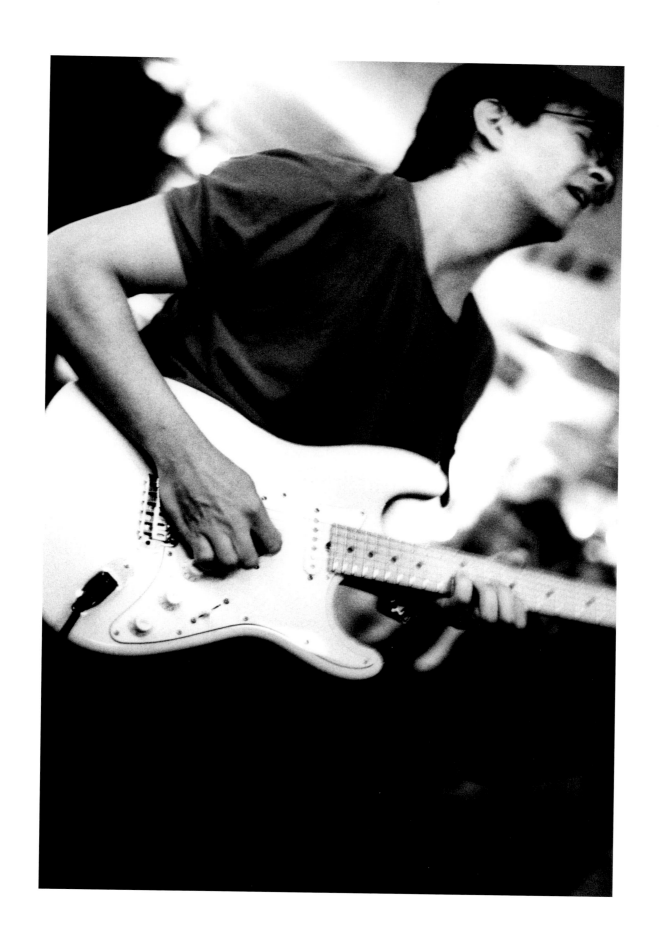

Dominic Frasca

After many years of soul-searching, countless stacks of prescriptions for Prozac, and a thousand hours listening to Tony Robbins, I have finally come to the conclusion that my happiness is directly related to how well I am playing the guitar. When I look back at the worst periods in my life, they were without a doubt the times when I had focal dystonia, a condition that completely shut my hands down, making it impossible for me to do even the simplest of things on the instrument. The irony of the condition is that it was caused by overpracticing. Everything else in my life was going pretty well during those times. I was living in the city I loved; I had a great girlfriend; I had great friends, but I was miserable. I never felt so lost. It was as if someone had taken my identity from me. Nothing could make me feel happy.

But when my hands are working well and I feel in control of the instrument and am playing somewhat close to the way I want (I never quite do), nothing can really bring me down. My girlfriend could come home and tell me she had sex with Earth, Wind & Fire, and I would just think, "Well, that's OK because my arpeggios sound like a machine gun." The funny thing is, I have played concerts where I performed so poorly, yet the audience would go crazy, and I have played concerts where everything went right, I executed everything the way I wanted, and the audience did not respond at all. In the end, I am always in a better mood when I feel I have played well.

Growing up, all I ever wanted to be was a great guitarist. Hendrix, Van Halen, Townshend—I never wanted to be like them because they were famous, got chicks, and had fancy cars; I wanted to be like them because they were monsters on the instruments. Although at this point, I think I might trade some dexterity for a Lamborghini and Valerie Bertinelli at twenty-three.

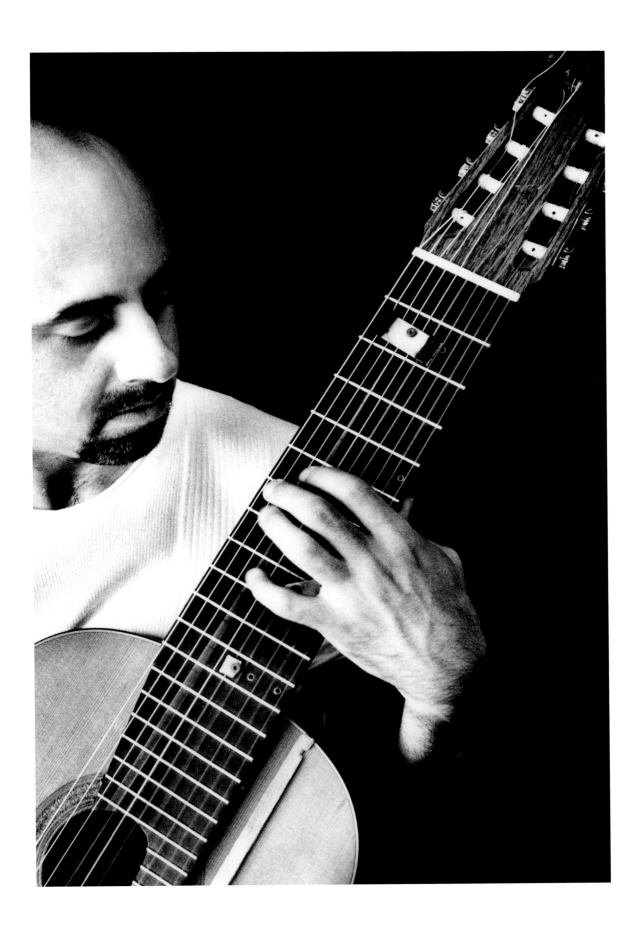

Ben Monder

The guitar is an unwieldy beast, one with which I am in perpetual battle, and one which often emerges victorious. Yet its potential seems to make the struggle worthwhile. It offers an unlimited array of riches, if one can find a way to unlock them. There is almost no texture, sound, or nuance of feeling that can't be expressed through the medium of the guitar. Beethoven has called it a miniature orchestra, and it is nothing less.

Those rare instances when I feel that the instrument and I are one, when I experience an unbroken path of energy from strings through fingers through mind and back again, keep me tied to this block of wood, for there are few experiences more intoxicating.

Like most pursuits of infinite depth, its study can be all-consuming, leaving little energy for anything else. This is a pitfall of which one should be vigilant; art cannot remain vital in a vacuum. But who's to say where the line falls between aesthetic calling and obsession? I won't hazard an answer; suffice to say I have thrown myself into the riptide of commitment, and will try to see it through until I either emerge or drown.

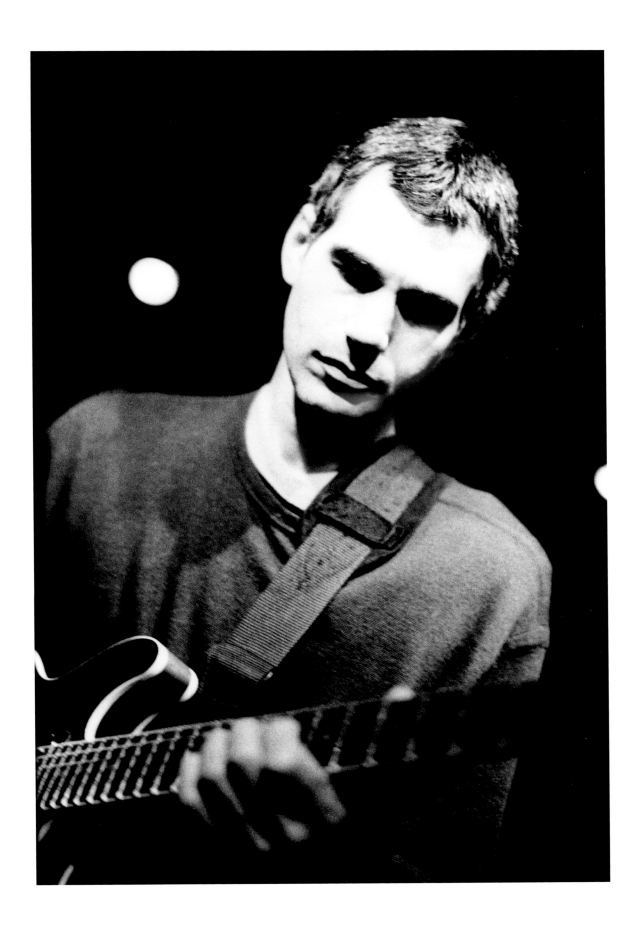

Elliot Sharp

My life as a child in the 1950s revolved around sci-fi: time travel, UFOs, space exploration, the atomic bomb, dinosaurs, mutation, and vague intimations of the infinite. With puberty came rock and roll in the form of the Yardbirds, and the guitar found resonance in my existence (though I was yet to get my hands on one—I was studying classical piano, then clarinet). The Beatles and Stones were there first, but it was Jeff Beck's outrageous guitar within the Yardbirds' supercharged proto-psychedelic rave-ups that really got to me. Appearing soon thereafter and taking full center stage was Jimi Hendrix. As a young geek (and ham radio operator), I was conversant in circuit design and building and by 1967 was beginning to make my own germanium transistor fuzz boxes, which I first applied to my clarinet and then, in 1968, to a Hagstrom III, my first guitar. The summer of 1968 brought me to Carnegie Mellon University in Pittsburgh for a National Science Foundation fellowship. I spent the better part of my lab time perfecting my fuzzes and experimenting with delay on a seven-head Ampex tape deck and spent my nights from midnight to 4:00 a.m. as a DJ on WRCT, a station whose library was packed with wonderful weirdness. I devoured (and transmitted) Xenakis, Albert Ayler, Hapshash & the Colored Coat, the Fugs and Holy Modal Rounders, Györgi Ligeti, Ali Akbar Khan, John Coltrane, Terry Riley, Watazumido Doso, Sun Ra, Karlheinz Stockhausen, Cecil Taylor, John Fahey, Harry Partch, Hamza El Din, Ornette Coleman, and blues of all hues, from Charlie Patton and Skip James to Albert King through Howlin' Wolf, Sonny Boy Williamson, John Lee Hooker, Muddy Waters, and more. I could only play a few chords, but I could feedback for days and "prepared" my guitars with various objects and used any techniques I could muster to generate sounds for my improvisations. The guitar was the instrument, but I was not yet a guitarist. I did know early on that I needed to travel, and I knew then that the guitar was my spaceship, my time machine, my window into an alternate universe of mathematical and sonic abstractions. I embarked on the path of ears and fingers to acquire specific techniques and general knowledge. As my ears opened, so did my fingers. Along the way to trying to hear my own internal sound and manifest it, I learned the sound of many others in an attempt to channel their fingers through my own. There were periods when I was a guitarist, but gradually I began to hear and became a composer, a listener. It was then that the guitar truly began to be a vehicle.

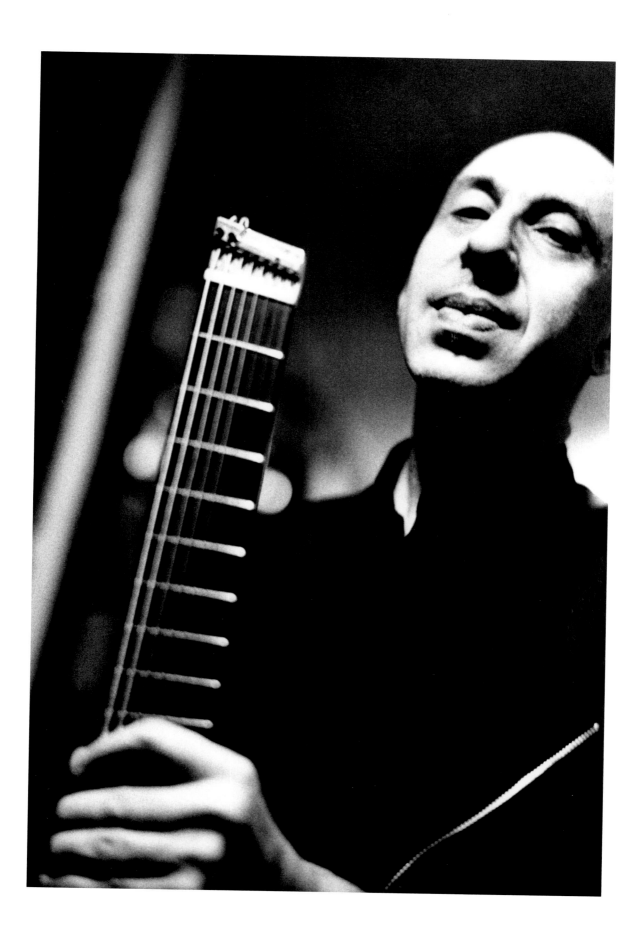

Dom Minasi

The very first time I saw a guitar being played was in a Roy Rogers movie. One day my father and I visited an older cousin, who picked up a guitar and strummed some chords. Every day I begged my father to get me a guitar. After three years of begging, I finally got my first guitar at the age of seven. Soon I began lessons—and soon after that I wanted to quit. Why? Bad teacher! But that's another story.

A few months later, I started with another teacher. My first lesson was like magic. Joe Geneli became a second father to me. By the time I was thirteen, I was practicing up to twelve hours a day during the summers and six on school nights. I never brought in a bad lesson, and I stayed with Joe till I was fourteen. It was Joe who introduced me to jazz, but it was Johnny Smith and his enormous talent that showed me how much I needed to learn. Since then, my quest for musical knowledge hasn't stopped.

My first year in high school, I joined the school swing band. These guys loved jazz, and they loved to rehearse. Besides rehearsing at school, we would rehearse at someone's house at least once a week. It was at Mike Simonetti's house that I heard Johnny Smith for the first time. He played the *Moonlight in Vermont* album for me. I just flipped. When Johnny was playing at Birdland, I begged my father to take me. We sat in front. I was mesmerized by his playing. I knew then and there what I wanted to do with the rest of my life!

Unlike other avant guitar players, I am not into electronics and noise. I use a traditional archtop guitar with heavy strings and a fat, round jazz sound. I am into lots of notes and tone clusters, unusual triads, double-stops, quarter tones, and wide-angle intervals. I play hard and I dig in. It is not unusual for me to wear out three to four picks in one tune and up to fifteen picks within a one-hour set.

My biggest influences, besides the early great guitarists and other instrumentalists, are Arnold Schoenberg, Alban Berg, Anton Webern, Béla Bartók, John Cage, Igor Stravinsky, Thelonious Monk, Duke Ellington, John Coltrane, Eric Dolphy, Albert Ayler, Ornette Coleman, and Cecil Taylor.

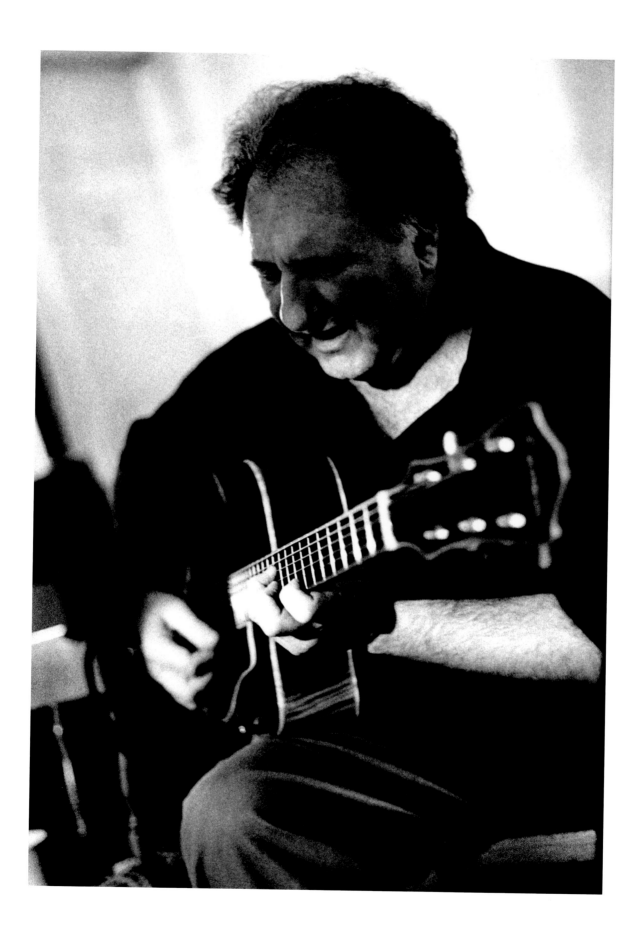

David Fiuczynski

Much of my musical inspiration comes from nonmusical sources: paintings and East Asian and Arabic calligraphy and architecture. I love the colors of Matisse, Van Gogh, Gauguin, the Fauvists, and German Expressionists, and the delicate restraint of Taoist poetry. I really admire musicians with a unique and fiery sound, like Eric Dolphy, Nina Hagen, and Don Pullen, for example.

My new guitar, the "FuzeBlaster," is a double-neck fretted and fretless guitar built by Johan Gustavsson. This has given me a fresh palette of colorful new sounds. I can experiment with traditional melodies of Asia, dances of Eastern Europe, Arabic calls to prayer, Indian invocations, and fuse them with the music of my own background, which is based in rock, funk, blues, soul, jazz, and elements of electronica. It lets me rock out, play wicked blues slides, but also invoke plaintive, longing meditations and Eastern slurs and bends. This guitar lets me be raw, emotional, and violently lyrical. The fretless neck also lets me play microtonal lines that I use for Turkish *maqams* and experiments with quarter- and sixth-tone lines. Microtonal music is something I'm very excited about. The consensus is that in art everything has been done. I disagree. Here's an area where one can truly be Captain Kirk and go where no one has gone before.

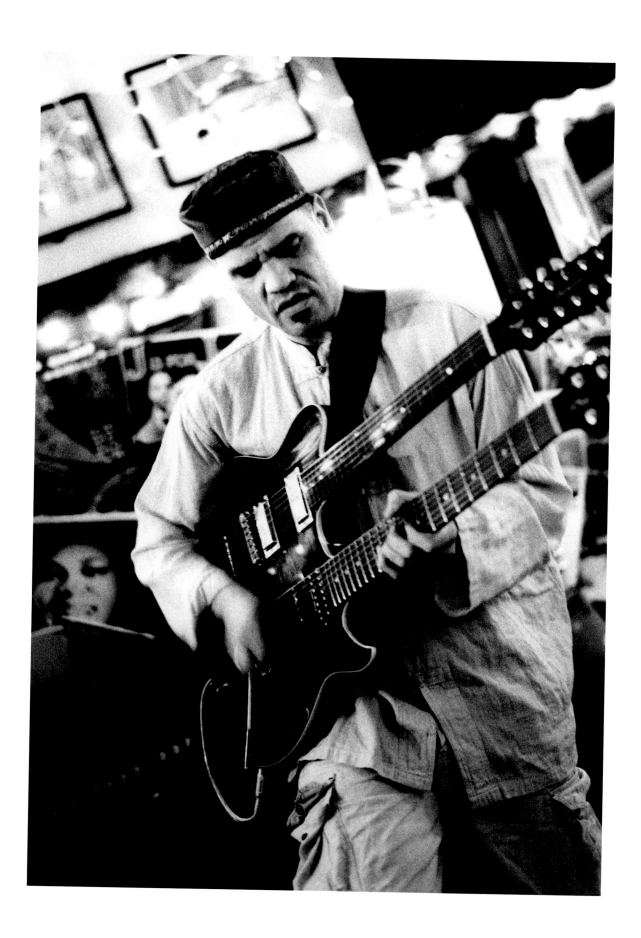

Henry Kaiser

I think two of the things that I value most in life are having fun and experimentation. I have discovered those things the most in the guitar and in the practice of improvisation. Good things happened in the process of these pursuits: new friends, new experiences, sharing my discoveries with the audience, and a new career as a research scuba diver in Antarctica.

Improvisation was always the key to all doors, both of perception and of access. Everything musical that I do is improvised. I discovered this from the first note that I played. I began to play guitar at age twenty, with no prior musical experience of any sort. My direct inspirations were my favorite guitarists at the time: Derek Bailey, Sonny Sharrock, Elliot Ingber, John Fahey, Ry Cooder, John McLaughlin, Joseph Spence, Bill Harkleroad, Jerry Garcia, Robbie Basho, Sandy Bull, and Hubert Sumlin. I had acquired eclectic tastes beyond guitar that were honed by the noncommercial and free-form radio, which was flourishing here at that time and brought world music, free jazz, blues, and contemporary classical music into my brain. My ambition, the day I brought my first guitar home, was to play what I play today—though I had no idea that I was to pursue that as a lifetime career. What made that happen was figuring out right away how to have fun with the guitar: improvising with friends, experimenting with new sounds, and trying to transfer distinctly nonguitaristic ideas onto the guitar. Cecil Taylor has said, "Why do it if it's not fun?"—and I agree. After four or five years, I was making a lot of records and playing gigs all the time. Eventually I had played all over the world and had appeared on nearly two hundred albums. That granted me sufficient prominence in my field that I was given a National Science Foundation Antarctic Artists and Writers Program grant to record in Antarctica. Since I got my foot in the ice there, I have been returning every year as a scientific diver. Upon reflection, I concede that I have always thought of guitar as a kind of science-fair project. This naturally led to the ultimate place on earth for science: Antarctica. I still get to play guitar there too . . . between dives, when there's time.

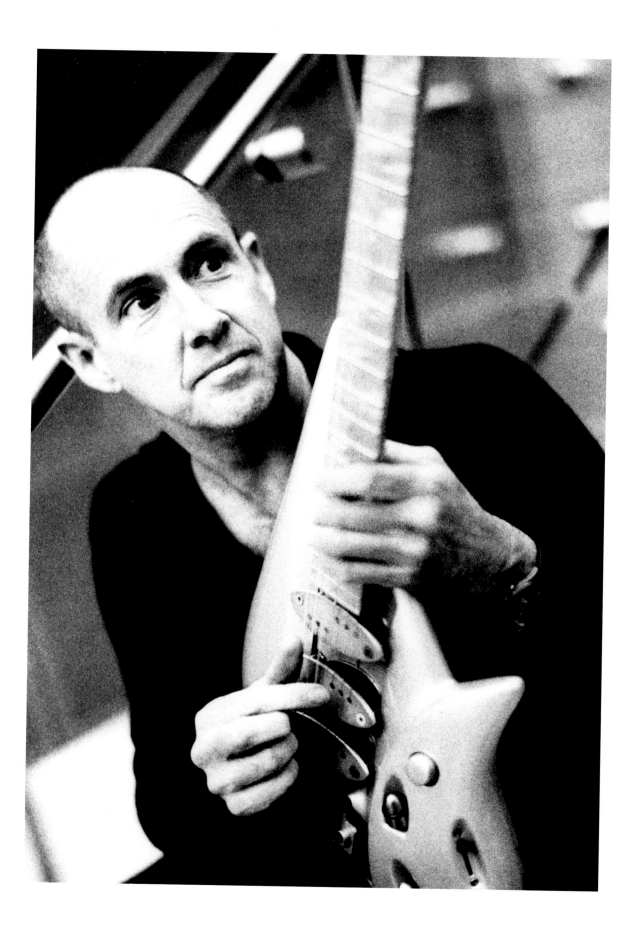

David Tronzo

My love affair with slide guitar started thirty-seven years ago when I heard this strange and wonderful sound on recordings. I thought it was steel guitar, but it was actually bottleneck style.

When I heard it I was completely enthralled, and then my father cut a bicycle handlebar into slides for me, and I started to teach myself. I had the vision, from before I began to play, to expand the vocabulary of slide to allow me to play in more modern and adventurous musical situations. I was in love with modern music of all kinds, and I wanted to bring the slide guitar forward into all these forms. I could hear it, feel it, and even see it. So I gradually developed all these extended techniques and concepts that went hand in hand with the ideas I needed to play, and that journey has continued to this day. My relationship to guitar, therefore, has been one of invention, constantly forging new sounds and techniques, always solving some impossible problem. I love the work, the effort, and the evolution. I get up with the fire for it in my belly virtually every day. Sometimes I despair over it; sometimes I delight in it. It teaches me many things.

I love a lot of things about the guitar, but slide guitar is my passion. I get energy from just picking it up. It gives me hope.

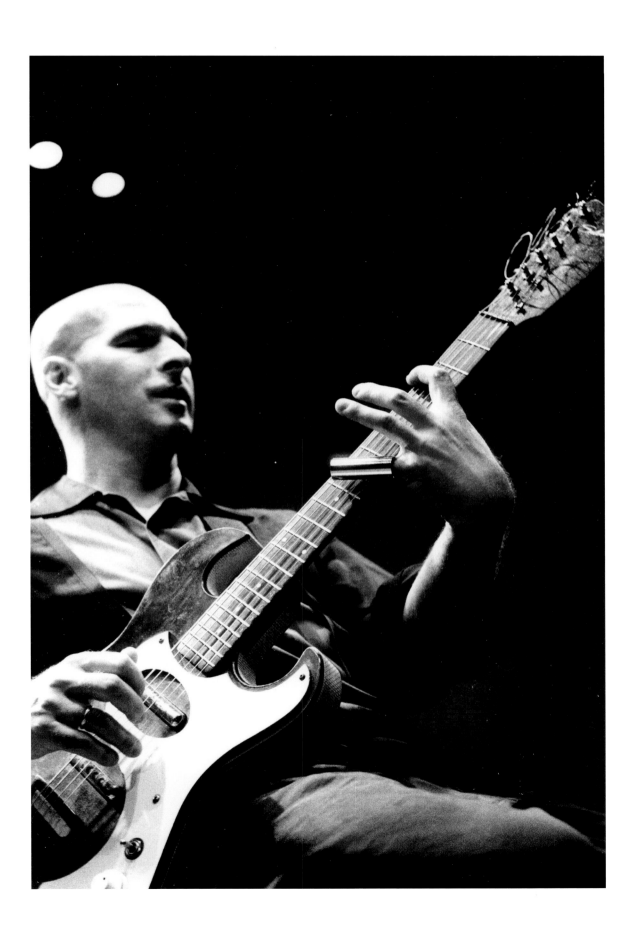

Gyan Riley

There's something about the tactile sensation of playing the guitar that's completely and totally addicting. I've been hooked since day one. But it's more than just a simple pleasure. It helps me to clear my head and feel temporarily outside of myself. It's the closest thing to a religious experience that I know. And when I put the guitar down, the music on my internal stereo doesn't stop, and new ideas often keep coming. That's usually when everything else around me gets put on hold, and I try to keep up with the flow as long as the muse allows. I think that music making (or all art, for that matter) is largely about that ability to latch on to whatever thread of inspiration passes through you before it's gone, and enjoying the ride while it lasts.

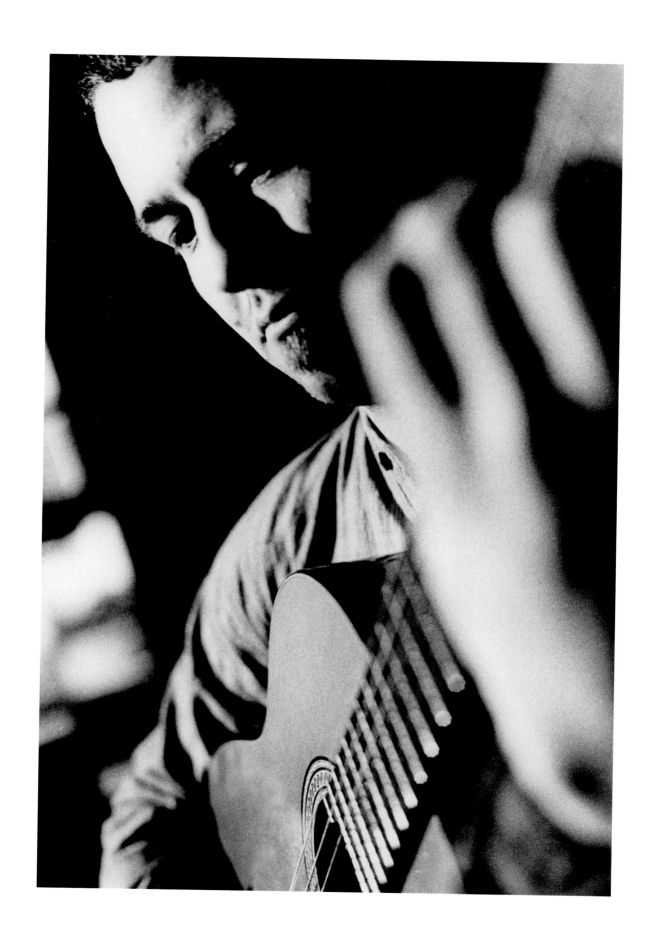

Antoine Berthiaume

Derek Bailey was once asked: "Why are you playing the way you do?" "Because I am curious to find out what the instrument can do," he replied. Reversing the quote, you could also look at how interesting it is to discover what human beings can do.

The primary step to innovation is to break a rule—to overcome/surpass what has been done before you. Every revolution fights an oppressing system. Yet in today's Western culture, most rules have been broken, and most oppressors have been hanged. I once saw a video of an artist who attached a guitar behind his truck and amplified it so you could hear the bouncing instrument responding to the bumps of the field he was driving in. I then realized how much you had to go through to keep the evolution of the guitar going. Some people practice ten hours a day for fifteen years . . . some people just have great ideas.

Igor Stravinsky once said, "Composition is frozen improvisation." So, in a way, the impulse that I have to play this one sound at this one exact moment is as valuable as it would be if a composer had spent hours writing it. I was so fascinated by this thought that I mused I might reverse it: I transcribed one of Bailey's solos from *Drop Me off at 96th* and composed a piece for fifteen musicians out of it—something an improviser like Bailey may not have approved of!

Because the conceptualization and construction aspects of Bailey's work are so strong, he was able—through music—to give a profound and mystical aura to the human instinct. He elevated "instant composition" to its dignified nobility. What made Derek a genius was that he managed to encompass the whole history of the instrument when he played the guitar. Yet his playing was so singular that it was comparable to nothing. I enjoy subjecting myself to change and variation, life for me being a long evolution. Let us transpose our story into our music. I take great pleasure in doing whatever I want, whenever I want to. Ironically this should be a privilege of long years of work, but in a world ruled by major labels and starving audiences, many players will end up playing the same character at different paces to satisfy them. My approach to music is to avoid any automatic twitches, tics, or bag of tricks—so that I start afresh every time I touch the guitar or compose a piece.

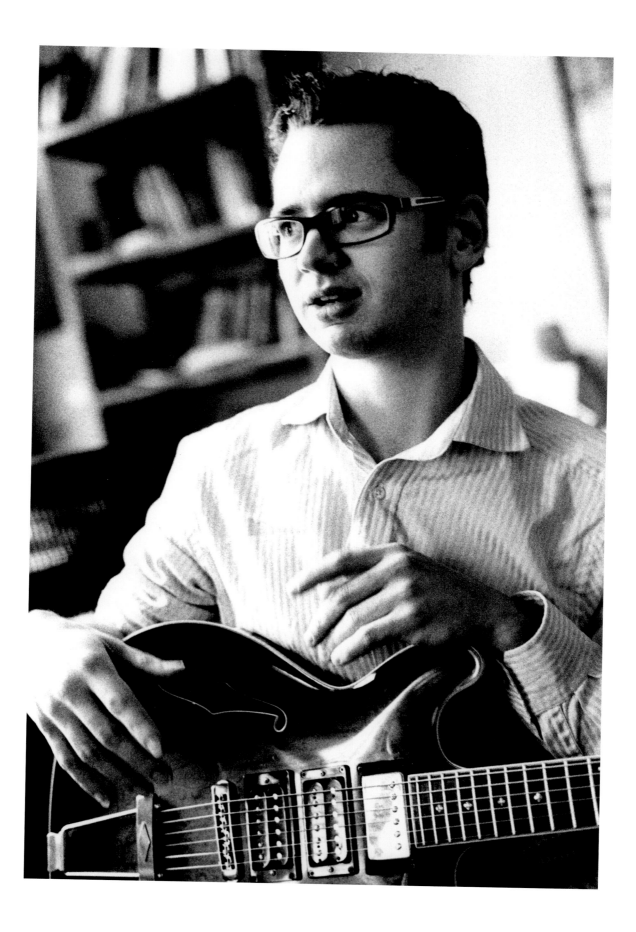

Ben Verdery

Thanksgiving

It's about 9:15 a.m., and I pick up my guitar case, lift it onto the bed, and undo the locks. I am very pleased with myself because I figured out recently that I can unlock two of the latches at a time. Case opened, there lies the guitar (a Greg Smallman and Sons), not quite silent, as there's a slight resonance of the open strings from the opening of the case, as if preparing to be played. I look around my little three-foot practice area, between my bed and the window, for my "guitar rest," a device that allows the guitar to be higher and rest against my chest. I attach the device to the guitar and sit. Without thinking, I play a descending A minor scale starting on the C of the first string. The scale twists and turns and ends on an arpeggiated F major chord with an open B and E on top.

So much happens in these few seconds of playing. My whole body is transported, altered by the feeling of the string landing between my nail and flesh, my left-hand fingers pressing down on the strings with my thumb, balancing them in an opposing motion, the bass strings resonating against my chest, and the overall sound of these notes being played and felt by "self-powered hands." Playing a guitar is a form of acupuncture. The touch and the sound act as healers to the body and soul. It is for this reason that I become irritable after about three days of not playing. I reach for my tuner on the music stand in front of me. I don't quite grasp it properly. It falls on the ground; the back opens up, and the batteries fall on the ground. (I love it when that happens.) I bend over, almost squishing the guitar between my chest and my knees (not smart) and pick the tuner up, then put it together.

Before I begin tuning, I think of how lucky I am to be a twenty-first-century guitarist. So much has been made easier for me. So many to thank, from the courageous soul who tied a vine between two fixed points and plucked it, right up to my current students who become, in their own way, my teachers. Instrument in tune, I commence playing the Prelude to Bach's Forth Cello Suite. The question arises, "Is it music I love or the guitar?" It is, of course, both. We, as interpreters and composers, use all the instrument has to offer to bring the given piece to life—every shade of color, from extreme *ponticelli* to lush *tasto* sounds, in addition to all variants of *vibrati*, articulation, and dynamics. It is often said that the classical guitar is a miniature orchestra. You do hear woodwinds, strings, and percussion all emanating from the magic box. Throughout history, guitarists have demanded more from the instrument by adding an extra string, as well as by employing alternate tunings. Both of these things transform the instrument and offer new artistic possibilities. The guitar's chameleonlike quality will inspire composers for as long as space remains to enter any musical neighborhood and bring beauty.

Like a child whose small fingers brush the open strings, I am filled with wonder and delight as I play this glorious Prelude. Guitar and music are my teachers, healers, and friends. I thank all those past and present, known and unknown, who have brought me to this moment.

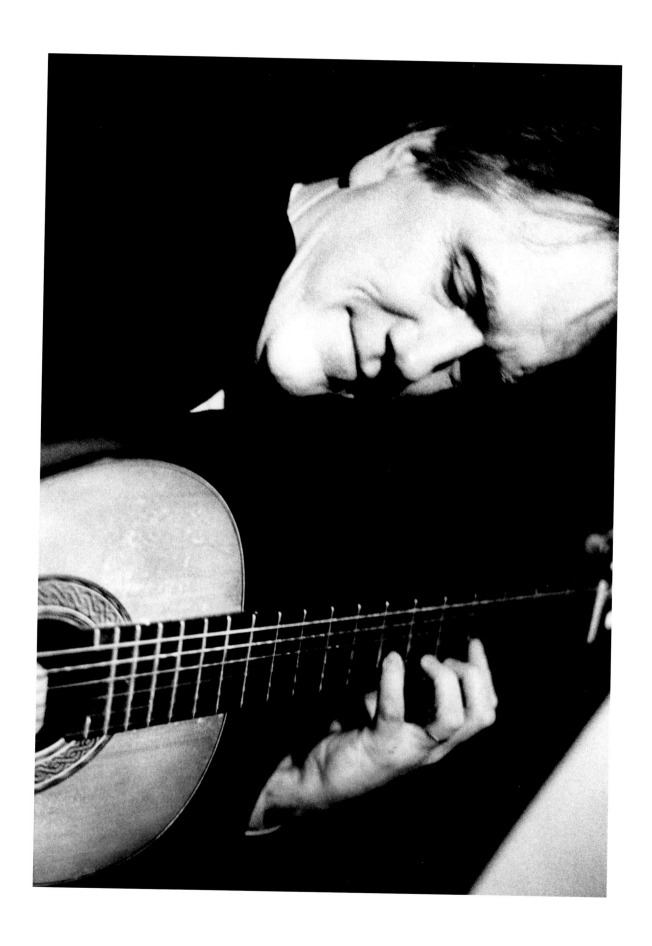

Badi Assad

I had the luxury of being born into a very musical family. When I was a child, all I remember is my father playing his bandolim, my brothers playing guitar with him, and my mother singing to help the housework go by.

Maybe because music was always around, it took me a while to actually pick up a guitar and try to play. My childhood wish was to be a dancer, and I think this first passion helped me to express myself as a guitar player. When I first picked up the guitar at fourteen, I had already been part of a dancing school and could apply what I learned there to the instrument. I would play, thinking my fingers were dancing over the strings. The guitar became an extension of me, of my heart and mind.

This freedom to express what is inside is something not easy to explain. It turned into a mysterious sort of a free dance. Later came the voice and the pleasure to discover what I could do with it! The body is really a magical thing.

The stage is where I bring my guitar and voice to explore sides of me that otherwise I never would. The guitar dreams under my arms as I learn more and more to become one with my music.

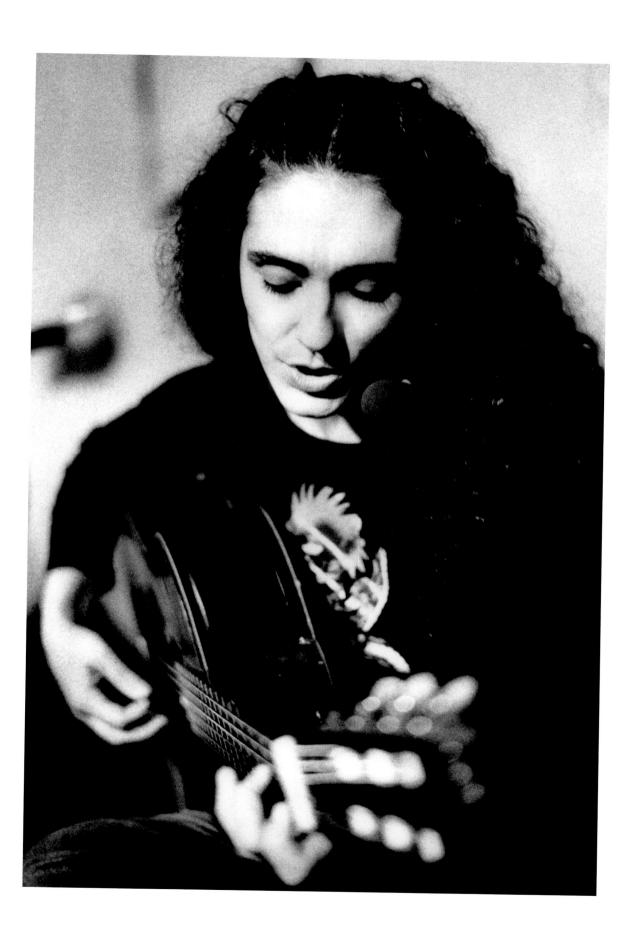

Larry Coryell

The guitar is like an old friend—we are comfortable with each other. I still have to work on the relationship, of course, because friendships require hard work and attention. Sometimes my friend and I make some real music—and it's nice when it happens.

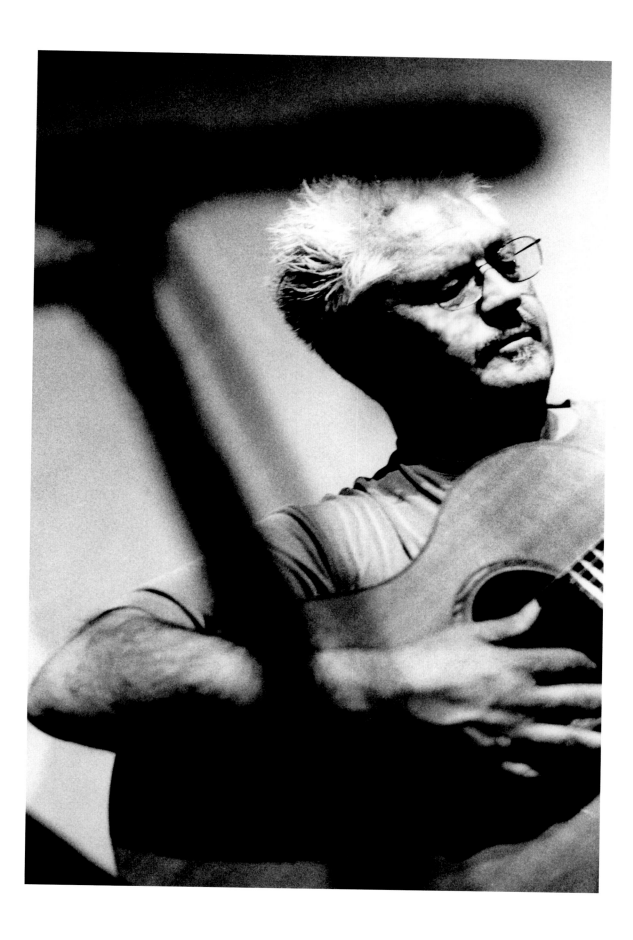

Kurt Rosenwinkel

The guitar: at once the most simple and complex instrument. Anyone can pick it up and strum a few chords, but venture past the first position, and you find treacherous waters. Its looks are deceiving—its fingerboard is not just a simple x-y graph. There's a fault line that runs across it diagonally and confounds logic. The guitar is a mysterious instrument; it is not sturdy and dependable like a piano, always there—ready and waiting to be played, offering its gifts so generously. No, the guitar's secrets yield only to the most dedicated, the ones who take the journey to discover its treasures. That journey requires the cultivation of a delicate relationship between human and instrument. The guitar is like a wild animal that must be lived with patiently. Little by little, we enter into its world and understand its nature. But we always know that at any moment it can bite back without warning. I don't think anyone has ever tamed it; the ones we remember only took it for wild rides, their life always hanging in the balance.

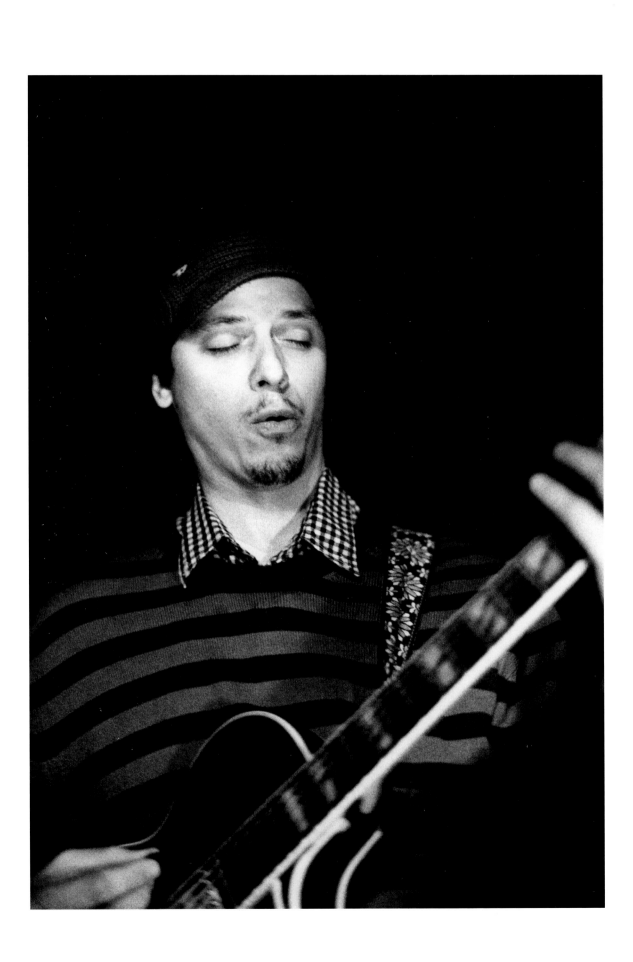

Vinicius Cantuária

When I first heard the riff from "Satisfaction" by the Rolling Stones, I was instantly as hooked as the first time I listened to João Gilberto playing Tom Jobim. I can't describe just how happy I am to wake up each day surrounded by these incredible instruments: six-strings, twelve-strings, acoustic, electric, authentic sculptures that produce sound.

At fourteen, I finally laid hands on a guitar, an acoustic borrowed from a friend, and for the first time in my life I felt the urge to keep something that wasn't mine. It was very hard to return this precious object! Months later, I owned my first guitar, a Brazilian Del Vecchio electric.

The Beatles, João Gilberto, the Byrds, Mão de Vaca, the anonymous musician playing at a corner bar—all were important in my spontaneous formation. Jimi Hendrix, Jeff Beck, Paco de Lucia, Laurindo Almeida, the Assad Brothers, Dino 7 Cordas, Rafael Rabello, and Zé Menezes, among others, played a big role in my conscious formation.

The acoustic Brazilian guitar has a major influence on my way of playing and composing. Guitarists like Toninho Horta and Hélio Delmiro are sources of inspiration not just for my music but for the very harmonic formation of Brazilian contemporary music. The ingenious strumming of Dorival Caymmi and Caetano Veloso, the African groove of Jorge Ben Jor, the open-string guitar of Gilberto Gil, and the sophisticated chords of João Gilberto—all touch my music and my heart.

From recent experiences with the atmospheric guitar of Arto Lindsay, the classic and experimental approach of Marc Ribot, to the loops and sounds of Bill Frisell, I've come to see the guitar as a spaceship of sorts. But despite all this modernity that I form a part of, I find myself returning more and more to my Brazilian Giannini acoustic guitar—where I search for inspiration and new chords.

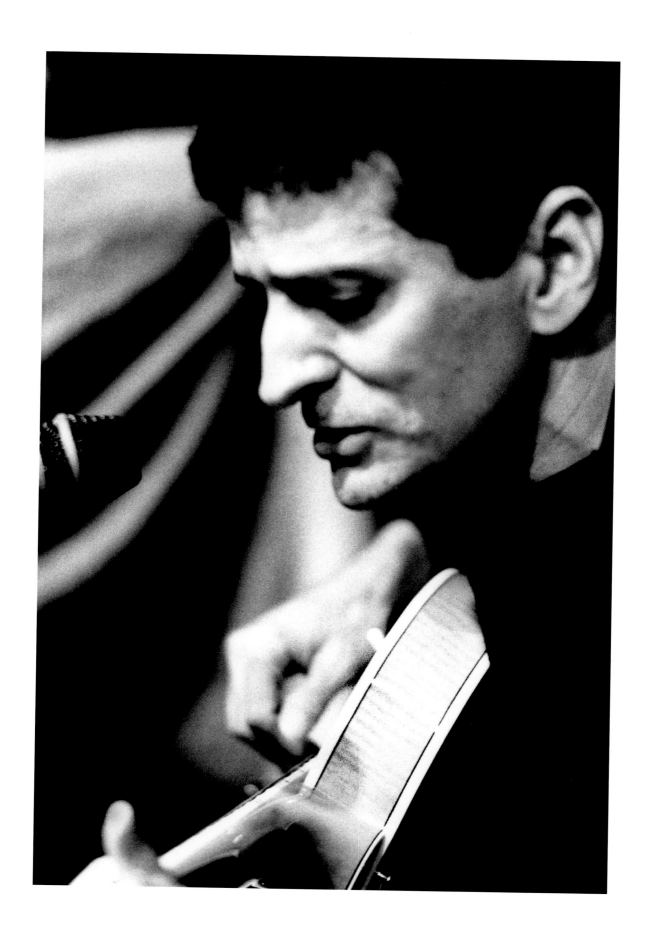

Michael Gregory

The guitar has been my voice since I was a child of seven. It has been both refuge and sanctuary. My music has been an outlet, an inlet, and a source of strength, commitment, and courage. Music has revealed to me an ever-widening pathway, a conduit, expressing joy, rage, sadness, tenderness, and all other emotions.

Playing guitar can oftentimes be frustrating, but it also affords me the deepest sense of peace, wonder, and profound fulfillment. To play is to laugh, scream, cry, dance, protest, stumble, fall, get up, and constantly learn.

When playing, I improvise to create and manipulate space. Multiple textures of sound are made by utilizing tensions, dynamics, and velocity. I employ tones, noise, melodies, intervals, colors, and densities to form musical-fabric atmosphere. Time and rhythm are malleable, liquid, and elastic, and I enjoy constantly shifting the perspective from which to play. This usually involves setting up several conceptual zones or parameters from which to operate simultaneously. Often these zones exist independent of each other, allowing movement freely to and from, in and around, and back again, as I choose. These zones might also imply or include both an essence and possibly a direct reference to history (filtered through personal life experiences). It is a challenge to make deliberate, spontaneous, and persistent explorations into newness.

Listening intently and responding to other musicians, I support/comp, join in, or build on their ideas, use them as a springboard, play to contrast, or take an opposing position. I feel the audience, and sometimes play off of or to their energies and responses. Functioning intentionally, starting from a meditative approach and/or consciousness, enables me to be free . . . present, in the moment, alive, agile, playful, fertile, and open.

I love playing the guitar.

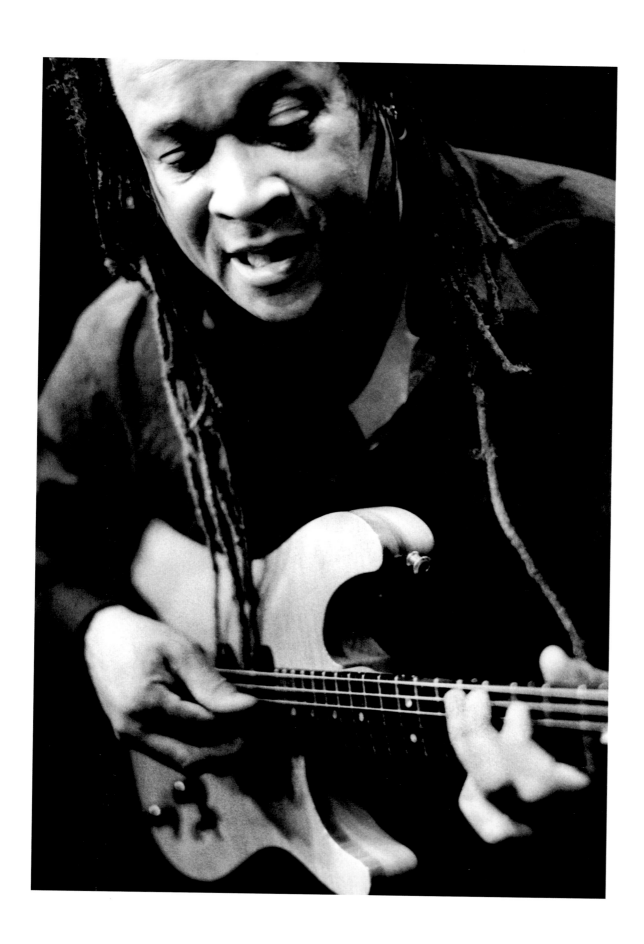

Vernon Reid

I've always looked at the guitar in varying ways: as my close friend and companion, my empathic emotional accomplice, my cruel tormentor and thief of hours. Most of all, I see the guitar's fret board and strings as a grid of possibilities yet to be realized. I love it anytime I hear someone playing well and reaching for the best of who we all are. I love it when someone, either by sheer will, physical effort, or deviously clever sound-design, creates a moment that I've never heard or felt before. Because we are by nature imitative and competitive, the fret board is also a field or dreams where flags of all nations are flown and fingers of all colors run, skip, and gallop in amazing and astounding ways to the cheers or jeers of audiences in places ranging from nearly empty bars to sold-out stadiums. The shallowest expression of the value of guitar for me is that of an untouched, "mint" fetish object of investment, hoarded and gambled over. A fine instrument is meant to be played.

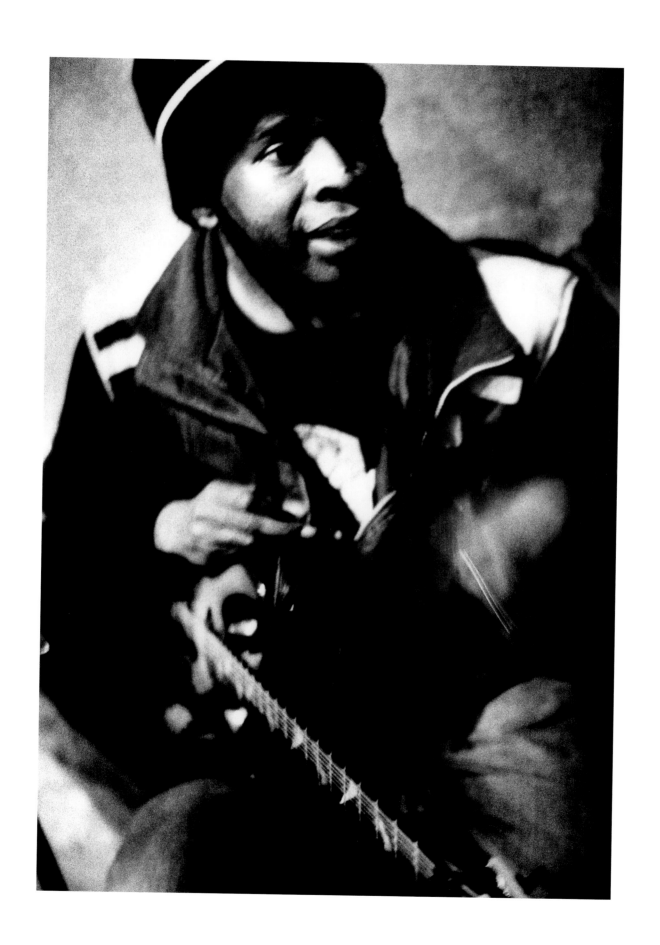

Fred Frith

I started violin lessons when I was five. I always had a pretty difficult relationship with the violin. I was never going to be any good, and I knew it. When I was ten, we moved to a new town, and I didn't get along with my teacher. It was a big step backward, or maybe sideways. A couple of years later I found a guitar lying around at school. It was an intense moment of recognition—hey, *this* I can do! I tried my hand at everything— the Shadows, John Dowland, Bert Jansch, Pete Townshend. When I was sixteen, my girlfriend taught me to play clawhammer style, and I never looked back. In 1968 exploration went hand in hand with experimentation—how can I make that weird note coming from the left of my left hand louder? First I used pirated phone mouthpieces and taped them to the headstock. Before long, electric guitar started to make more sense. The pickup that a friend installed over the first fret has been there ever since. My techniques have pretty much all developed from that point—an electric guitar has become not just "the thing in my hands connected via the pedals to the amp," but a bipolar instrument with pitches stretching out in either direction from a midpoint, a mapping of the fret board, requiring a different sense of topology and a different use of hands and feet. After a while, experimentation led to abandonment—what has this got to do with a guitar? I thought I might as well be playing a slab of wood with strings stretched across it. So that's what I did—built crude instruments that I felt more comfortable abusing. After a few years, though, I missed the guitar. Rediscovery! I liked the feel of it in my hands, my physical relationship with it, the instrument as an extension of the body. I didn't want to avoid that; I wanted to embrace it. And I actually liked the fact of being connected to an instrument with a rich and diverse cultural history. I liked being a guitarist and a performer; I wanted to tell stories. So I was lucky enough to have my moment of recognition all over again—hey, I can do this. Traffic continues.

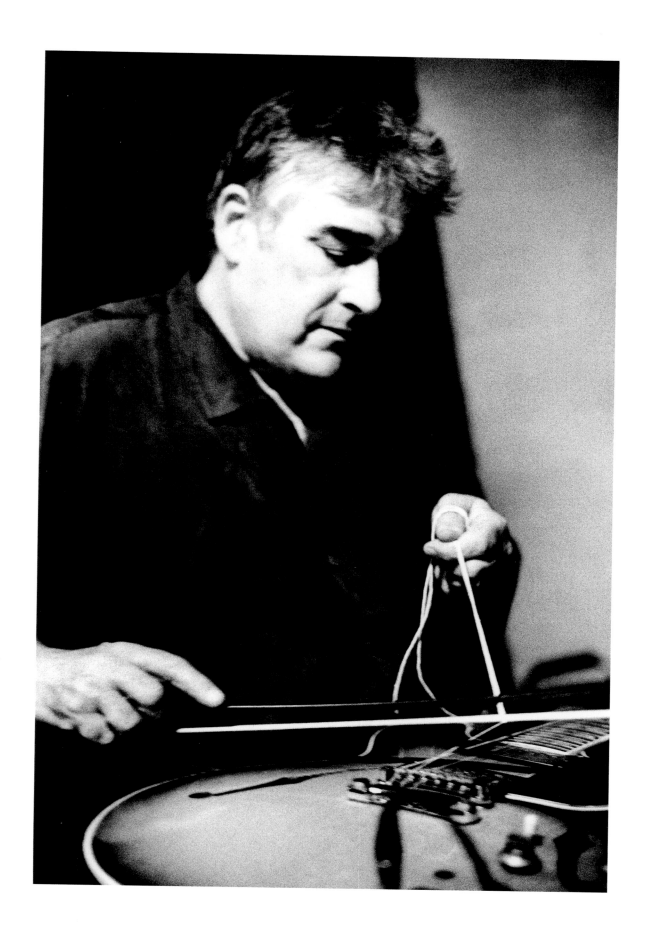

Sheryl Bailey

For me, the guitar is my singing voice, and since I compose mostly on the guitar, it's another type of mouthpiece for my emotions—a mechanical diary of sorts. I started when I was thirteen with the very logical idea of becoming a rock star. I loved blues and heavy metal and led my own bands playing Black Sabbath and Hendrix tunes. Somehow I stumbled across a jazz radio station and heard Dizzy Gillespie and Charlie Parker and fell madly in love for the rest of my life.

In my career now, I've come full circle and play as many shredding-type gigs as I do swinging ones, and I absolutely love the madness and joyfulness of that. My philosophy of approaching harmony is based on finding out about how much things have in common as opposed to focusing on what is different about them, and it's also how I feel about playing in different genres, and it's how I feel about life on planet Earth, and that's what is behind every note that I play. We're all part of one big beautiful sound, not really so different from each other when we find the things we all have in common.

Music is the heaviest peace movement on the planet, and I'm blessed and proud to be a part of it.

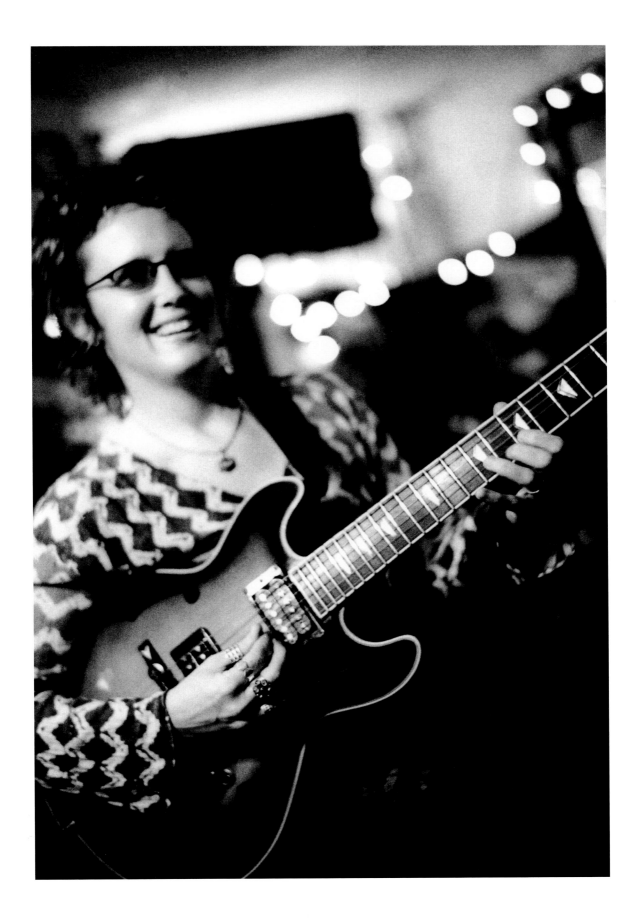

Marc Ducret

Very few instruments share the peculiar characteristic of being, like the electric guitar, divided into totally separate parts: the body of the guitar and the amplifier. From this comes a slight schizophrenia. The body, which we hold against ourselves, which we touch and slap, with which we dance, is connected by a cord (umbilical) to a *tête* in French, a *head* in English, or a *cervela* in Italian, which determines the quality of sound produced. This causes a complete disconnection between the work on the instrument and its real sound—a strange situation for a musician, something a trumpet player could never understand, for example.

The task of the guitarist perhaps consists of reuniting these two elements and finally making the "head" sound like the "body."

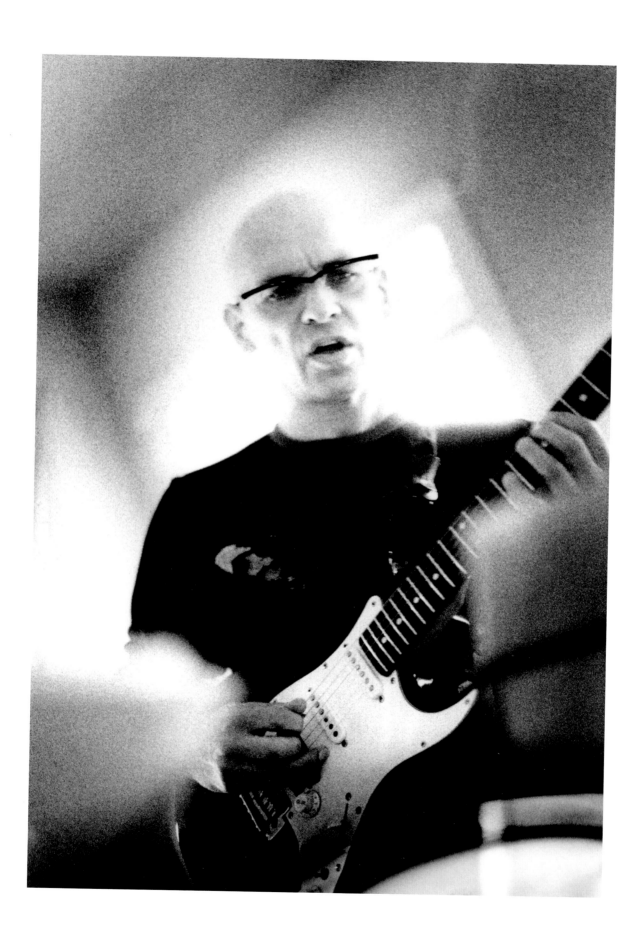

Jef Lee Johnson

I don't have a page worth of text about me or anything. All I can say is that the music chooses you, you do not choose it. There is a sound like a siren in every musician's body, and they are drawn irresistibly to it. *Why* is irrelevant . . . the sound in me is guitar, and it defines me.

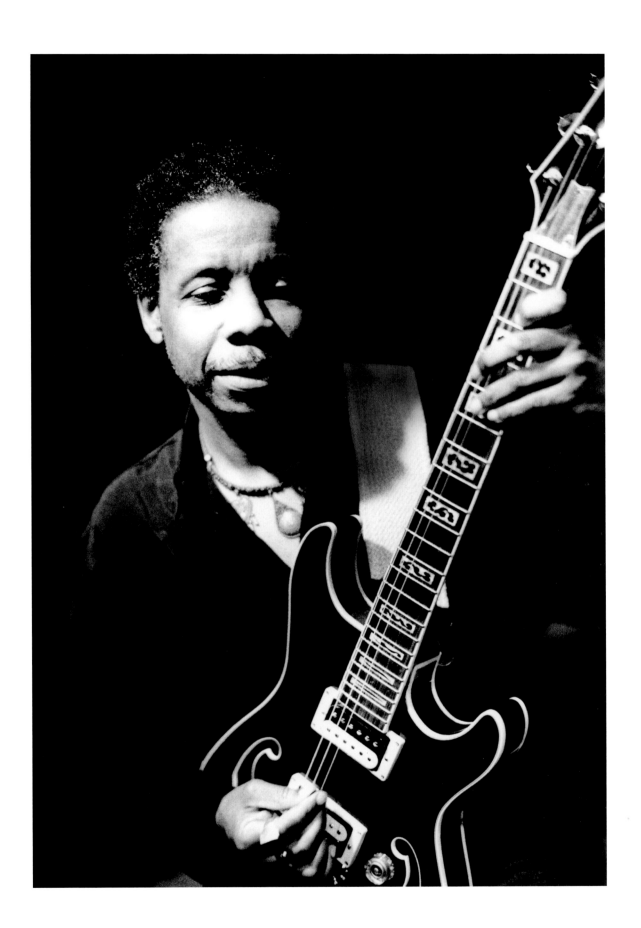

Amanda Monaco

Music and guitar would be a continual love fest if it weren't for things that make it frustrating and miserable.

The good times: the discovery of something new during a practice session or the completion of an intriguing melody; the interactions with great players; the audiences made happier, writing me notes from places as far away as Iraq about how my music keeps them sane or reminds them of home; performing in faraway towns and cities.

The bad times: club owners who treat the musicians like dirt; drunk patrons who think my guitar is sitting on a stand during the set break so that they can play it themselves; lackadaisical publicists and ignorant journalists; men who say, "Don't take this the wrong way, but I've never heard a girl play guitar like that before" or the guy on the street who harasses me with "Hey, can you play me a song, honey?" as I walk by; people who are surprised to hear me play the way I do because of how I look.

But that doesn't really have much to do with music and the guitar, does it? If music is coming from a pure place, it is worthwhile; if not, it ceases to be music. My eight-year-old guitar student playing a solo with two notes is making music, at the beginning of a journey of learning how to play and exploring music on her own terms. It is that kind of "beginner's mind" that I strive to keep in my own playing. Music is a beautiful thing—powerful, personal, and bigger than the people who play it. As a musician, I think it's important to remember that. Otherwise, the bad times can easily overshadow the good.

My relationship to the guitar is a physical one—playing calms me. It also makes me really happy whenever I sit down to play or practice or work on new material. I'm the kind of person who gets "sucked in"—once the guitar is in my hands, I completely ignore everything else until I'm forced by the "mundane" (errands or business stuff or something of that nature) to put it down. Even then, I find myself cursing whatever it is I have to do under my breath, because it means that I have to stop playing the guitar for a while. When I was a teenager, I brought my guitar on every single overnight school trip; all of my classmates thought I was nuts. (Even now, I rarely leave home without it, even if I'm going someplace where I don't "need" it.)

There's also the cerebral aspect of music. Writing excites me: coming up with something new, messing around with it, letting it flow, and not being too judgmental so as to allow the ideas to "breathe" a bit. Most of the time I'll write the name of the tune

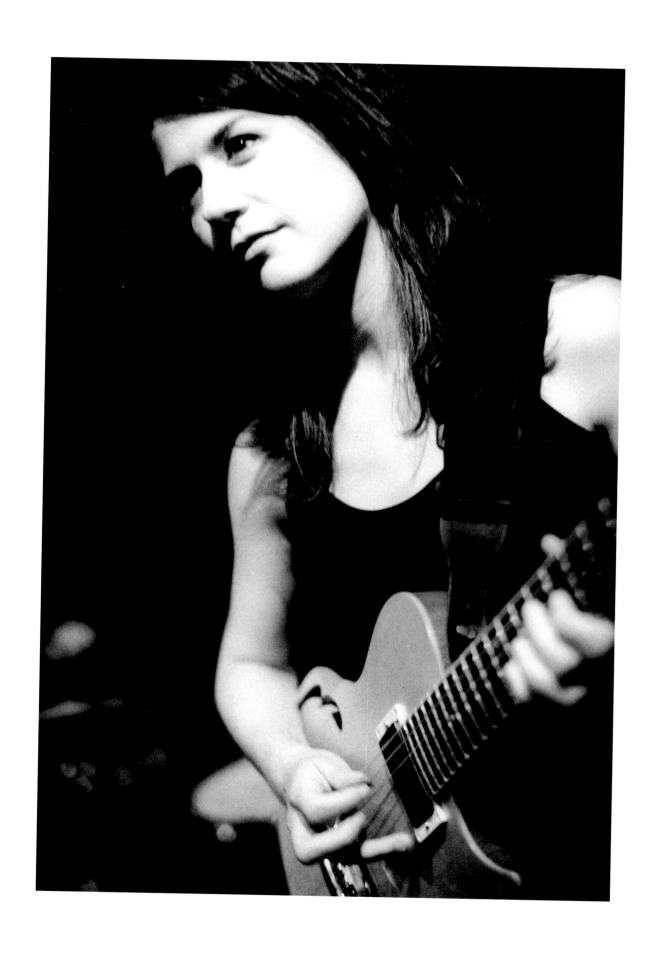

before the tune itself; a passing mention of something in a conversation will make a song title come up in my head. Or I'll play around with little "limitation" exercises, such as taking one note and harmonizing it a lot of different ways to see what I come up with.

Guitar, to me, is very social—playing with others delights me. So many of my friends are from guitar camp or high school. Many of us still play music together, and live within a two-hour drive from each other. It's been great seeing how far everyone's come, since we all grew up together playing this beautiful music called jazz.

Most of all, my relationship to guitar and music is a spiritual one. Considering the myriad ways of tapping the potential of this gorgeous instrument, and hearing the way others interpret its sounds, inspires me. The wildly creative and constantly evolving harmonic interpretations of Jim Hall! The blistering, spiritual lines of Mahavishnu John McLaughlin! The rich, luscious, angular arrangements of Ralph Towner! The fierce, swinging octaves and block chords of Wes Montgomery! I just love it.

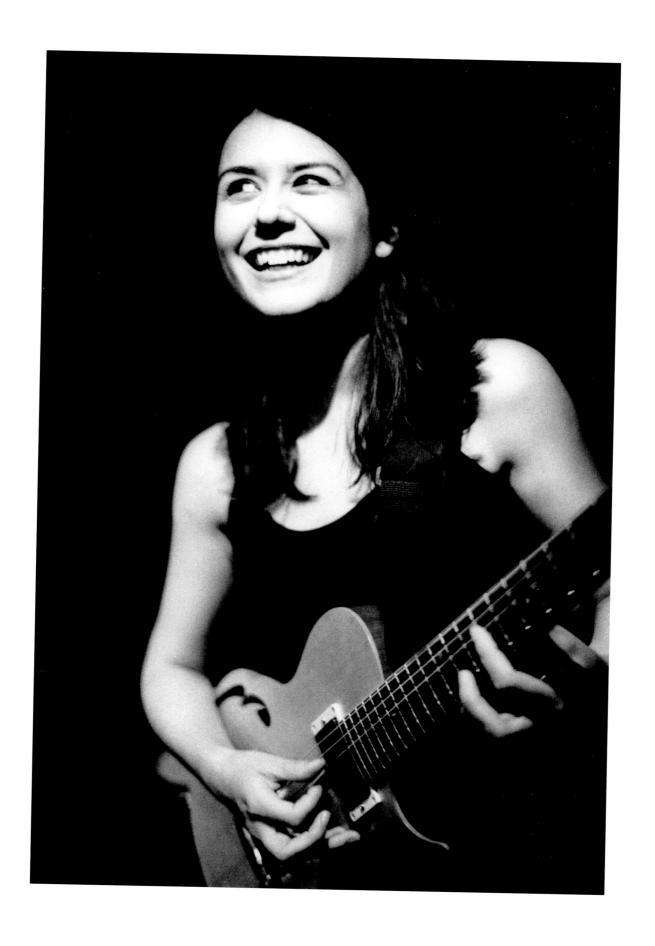

Nels Cline

At first it was surf music: the instrumental twang and roll, spreading out all over Southern California in the mid-1960s like a tidal wave of hot-meets-cool. Then it was folk rock: the chiming beauty of the Byrds, Buffalo Springfield, striped boat-neck shirts and Beatle boots on the Sunset Strip, unattainably far away for a ten-year-old boy in nearby West L.A. Next, psychedelia: the ultimate mind-bending, color-saturated, androgynous Valhalla in the life of a barely pubescent lad. About this time electric guitars started popping up in department stores and at Thrifty Drug—Teisco Del Reys, Melodys, Penns, Baldwins. I first plugged in Pat Pile's uncle's Crucianelli hollow-body bass and ran my hand up and down the neck senselessly while Pat and my twin brother, Alex, played Pat's drum set along with the Rolling Stones's "Aftermath" and "High Tide and Green Grass." . . . Pure intoxication! Electricity! Mystery! Coolness! When I heard Jimi Hendrix, the deal was sealed: guitar for life.

What it all comes down to is simple: a love of sound. Pure sound. Impure sound. This love of sound, of expression, of things both organized and chaotic, both intimate and grand, has led me on a zigzag path through early pure drone/noise improvisation, which led from rock to more progressive/transgressive forms, almost always instrumental. Then my brother and I heard John Coltrane and Miles Davis, and we were never the same. From there, it was all groping and stretching, seeking and finding. It led me to great music and to great guitarists. Truth be known, I just love the guitar. I love to play it, and I love to listen to it. It's not a requirement, but it's still a joy, an infinite world of sound, of possibilities, my life just one tiny life . . .

I still feel a total immersion in sound. At times the guitar can address my fixation on harmony, at other times it can shriek in mortal agony, float like voices from another world beyond this one (as Daevid Allen said, "Imagination is the key!"), summon searing, roiling dread and annihilation. It can whisper and caress, evoke sweet sentiments, tears of rage, joy, and crushing imperfection. I probably love the damn guitar more than the world, and the world really loves it—lucky me!

Gentle comrades, many thanks to you.

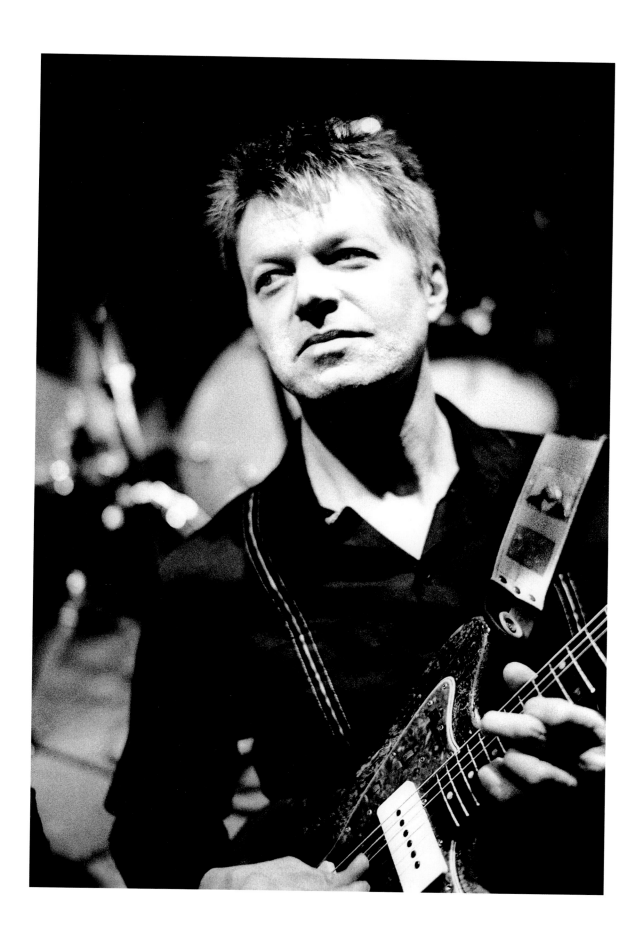

Tisziji Muñoz

Heart-Wood for the Fire

My heart-strings sing the whole song,
the true wood's song
of the Heart Fire Love I freely bleed,
Fire to Heart, Heart to Love,
Love to note, note to finger,
finger to string, string to string,
all strings to all beings.

My first string resonates the obvious fact
of my burn-earned self-realization.
My second string demonstrates this profound recognition
and ultimate significance of being
and playing what is, simply True.
My third string resonates what the blissful love-wave,
my whole song, as Heart-Fire Sound,
is to all other Spirit-Sound hearing beings.
My fourth string demonstrates that the paradox of no self
is the root of my unobstructed all-burning Fire-sound.
My fifth string resonates as the all-sounding
no-sound silence of pure love,
who, loving only love, is the ultimate music;
who, by devotional love, is the ultimate melody;
who, for unchanging love, is the ultimate lyric;
who, in masterful love, is the ultimate rhythm and
who, from victorious love, is the ultimate rest.
My sixth string demonstrates ultimate creativity,
which is ecstatically spontaneous,
heart-full, love-full, soul-fully blessed,
real, free and catastrophically true.

Yes, I am called the guitar—father of purple music,
always centered in radiance above the head,
felt everywhere within and without the body-mind,
already beyond the world,
forever deep deep in the cave
of transcendent heart-being.

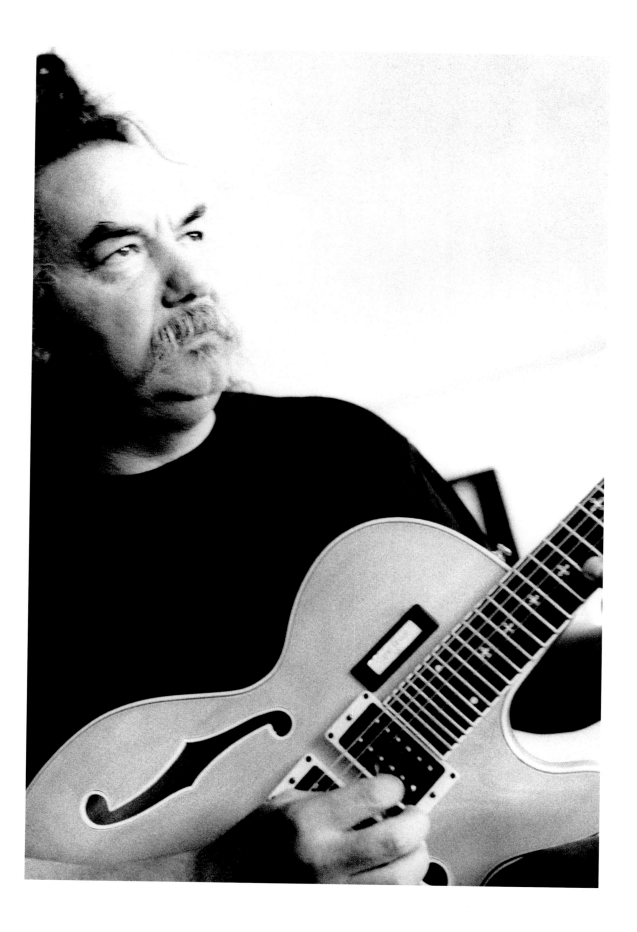

Ralph Towner

In my early twenties, during which time I was finishing university in classical composition and slowly attempting to clone myself after Bill Evans in the piano practice rooms, I met a psychology student who played the classical guitar, and my first reaction to the instrument was how similar it was to the piano in its harmonic and polyphonic capabilities. After graduation I managed to find my way to the Vienna Academy of Music and Dramatic Arts, rented a cheap room far from the center of town, and started from scratch with a great professor of classical guitar, Karl Scheit. So one year later, after ten hours a day with no break, and a very sore posterior, I had my guitar driver's license. (After another year in the States I went back again, with a few classical concerts and a long fling with Brazilian music under my belt.)

So I basically backed into the guitar world with little knowledge of all the lore the instrument carries with it. This might have also been a blessing in disguise, as my motivation was to make music on this new (to me) vehicle, which happened to be a guitar. I had a painful lesson to reinforce this hierarchy of music over instrument. I finally had scraped the money together in New York City to buy my first top-grade instrument. I had a lovely old Ramirez for about three months before it was stolen and gone for good. I called the police to report the theft. Two officers came to my apartment in the Village and eventually got around to asking for a description of the purloined guitar. I said, "Well, it's brown with six strings on it," and that about sums up the description of every classical guitar ever made. They left with a hopeless shrug of their shoulders. I borrowed a sixty-five-dollar guitar from a drummer friend and played that for a time, and discovered that it improved as a result of being played regularly. This brought me to the point where I realized that my musical input was more critical to a performance than the instrument I was playing.

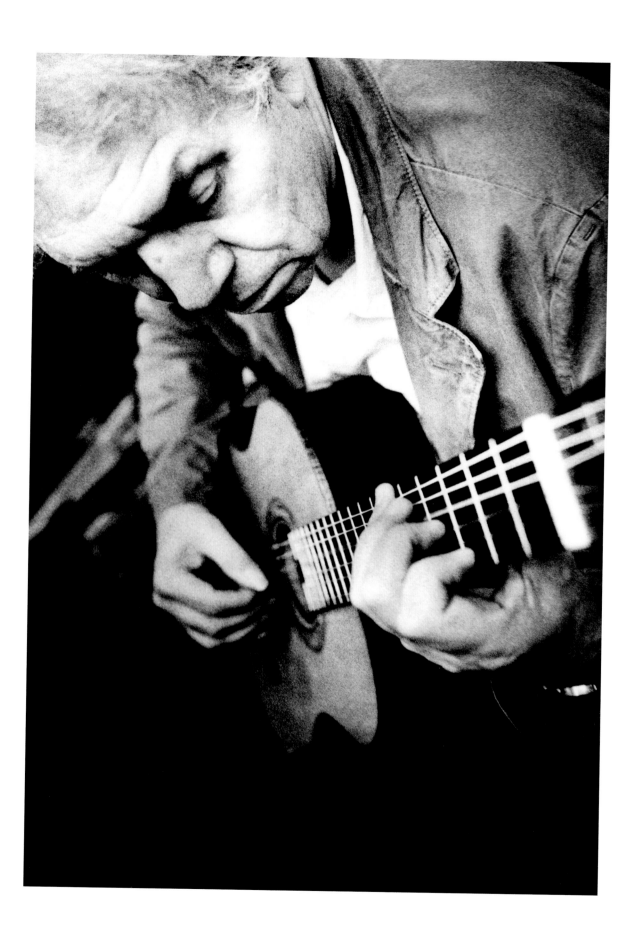

John McLaughlin

It's very interesting to see how people are drawn to different musical instruments. For example, I began my musical life with the piano, but at eleven the guitar found its way to me and changed my life forever.

The wonderful thing about musical instruments is that they go back to the dawn of civilization, and the sounds they produce belong to our collective subconscious memory. Whether it's a drum, or a box with strings on it, or a flute, it is from prehistory, and at the same time in today's world.

I am very fortunate to have had a mother who was an amateur violinist, and elder brothers who introduced me at an early age to the world of different musical cultures. Between the ages of twelve and fifteen, I was exposed to the Mississippi blues players and singers, the world of flamenco guitar, the music from India, and finally jazz music. By the time I was sixteen, I was a hard-core jazz fan.

By the 1960s, the world had changed again, and there was rock 'n' roll. At first I was your average elitist jazz musician looking down at those poor rock 'n' rollers, but Elvis and the Beatles changed all that; and then there was James Brown, Sly and the Family Stone, and many more. What was common to all of these performers was the guitar. The guitar was behind the social-musical revolution of the 1950s and 1960s. I arrived in New York at a perfect time: January 1969. Miles Davis, one of my all-time heroes, was looking for a guitar player, and he hired me.

Today the guitar continues to have a mysterious attraction in the musical world in general, and in the rock-pop-jazz world in particular. How could I have ever imagined what the guitar would bring to me in my life?!

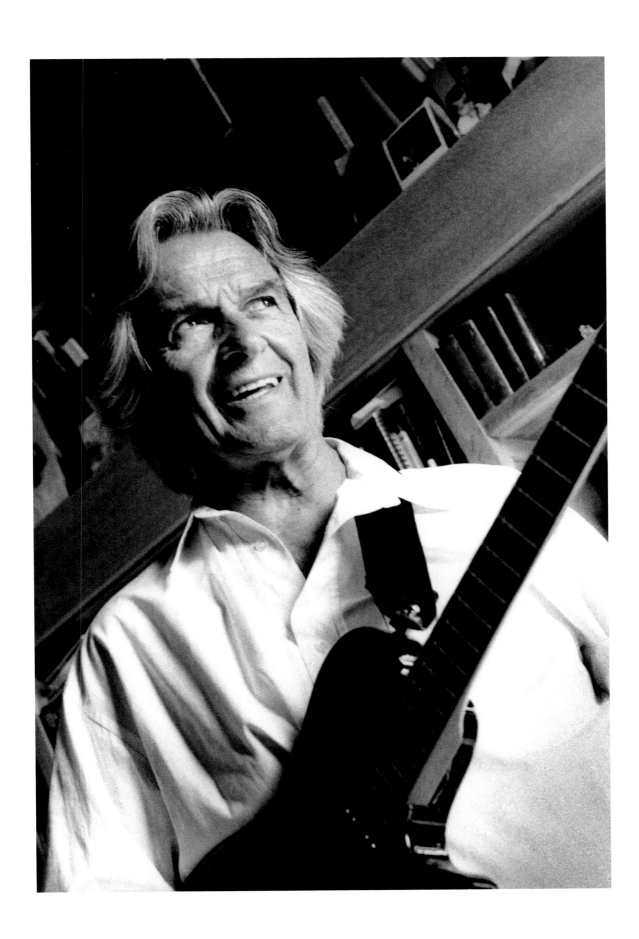

Marco Oppedisano

My father always had an acoustic guitar in the house. My first recollection of playing was when I was six or seven. I'd stand in a rock-star pose, wielding a guitar twice my size, strumming the open strings randomly and loudly.

Later on in my youth, I was obsessed with all things guitar, practicing hours upon hours each day. You couldn't pry it out of my hands. However, there always existed an experimental side, such as playing with effects, and a fascination with getting the most unusual sounds I could muster. Sometimes after many rigorous and frustrating practice sessions, I would crank the amp, bash chords, and listen to glorious feedback. I would maneuver the guitar in the air, listening to the primal and unpredictable swirling sonic variety. This created a feeling of empowerment, rebelliousness, and chaos, all the while canceling out any trace of conventional practice, playing, or sense of technical limitation. Cast aside was concern for being the next guitar hero, leaving in its place a pure fascination with sound. These were wonderful and influential moments that I relive often. It wasn't until later in life that I chose to order and arrange these electric guitar sounds into compositions.

For me, there was never just one way to play the instrument. The electric guitar, along with being a beautiful instrument in and of itself, is a wonderful and limitless sound source. This, compositionally, allowed me the freedom needed in order to express myself best with the instrument. From the serene, pristine, and elegant, to the raucous, noisy, and brutal, the electric guitar encompasses the most expressive spectrum any instrument can offer in sound.

My approach to guitar and composition is related; the idea of total control, craft, and discipline in combination with allowance for the random element of surprise and the unrefined. Even with many years of serious music study in the conservatory and having played all kinds of guitar styles, I always find myself returning to my roots and earliest explorations. My electric guitar has been a constant companion, and like any long-term relationship, my intensity and involvement with the instrument has varied and continues to vary. However, I never go long without picking it up, and my love for experimentation has never waned. Sometimes I still feel like the kid who is picking up a guitar for the first time, bashing those open strings. The electric guitar has been a lifelong friend, and I still think it is the coolest instrument out there.

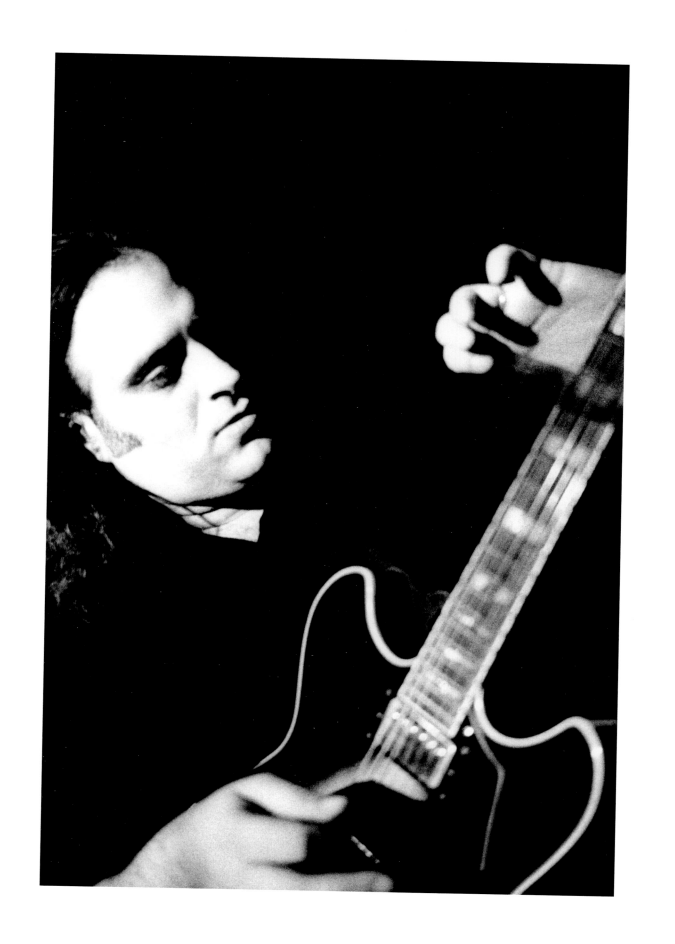

Tim Miller

I have always been passionate about music and fascinated by the guitar as the instrument to create it. This passion and fascination has grown with me throughout the years.

The guitar is my vehicle for expressing what I cannot express in words. For me, the guitar represents freedom and fearlessness. It allows me to express abstract, free thought in the form of music. The challenge lies in gradually unlocking its mysteries and secrets, slowly uncovering its layers of complexity to find the sounds that I imagine.

The guitar is the instrument that I use to express my musical voice, and I cannot imagine doing anything else. The future of this ever-evolving instrument looks very bright, as there is so much yet to be discovered, and I am glad to be along on this journey.

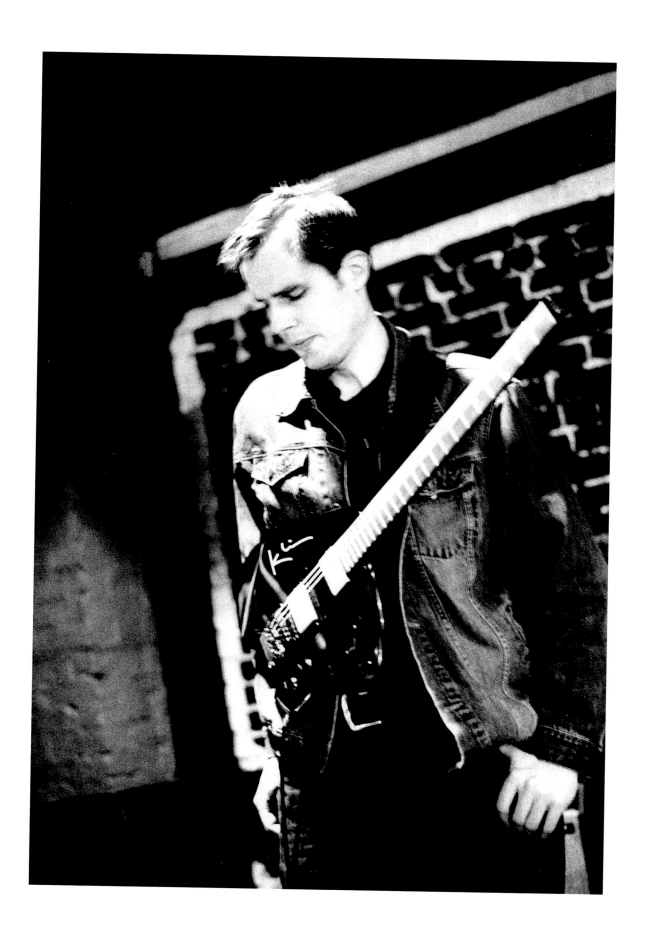

Gene Bertoncini

My dad, who was from Italy, always loved the guitar and played for the family. I just took to it, and at the age of seven was playing and singing myself. I realize now that this was all part of the gift given to me, and I am so thankful for it.

Soon I was taking lessons and listening to radio broadcasts of Benny Goodman and later George Shearing. I just fell right into jazz playing. I began playing standards with my brother Renny and playing gigs, dances, weddings. . . . As a teenager I worked at clubs in the Bronx with alumni of the Stan Kenton band and with pianists Richie Levister and Bobby Scott. Later, Mike Mainieri and I formed a guitar/vibe trio with bass. My early influences were my teacher at the time, Johnny Smith, and the recordings of Tal Farlow and Barney Kessel. Later Chuck Wayne (the original guitarist with George Shearing) was my teacher. He exposed me to the classical guitarist Julian Bream. I fell in love with this music and that type of guitar.

My studies and the classical guitar led to performing jazz arrangements of standards and improvising with the classical technique, a lot of this with the bassist Michael Moore. At that time the *bossa nova* hit New York, and I was able to use the classical guitar for that as well.

I believe that this guitar has really made a big difference in the way I think about music—the idea of working out arrangements as if they were little pieces and coming out with concepts, a story for each one.

The warmth of the classical guitar is also very appealing, and the "little orchestra" that it is opens the door for solo performances. This quality has also made accompanying people an option. The support that is possible using these techniques is very complete for the artist you are working with, be it an instrumentalist or vocalist.

All in all, I feel extremely fortunate to have the desire and the gift of a talent and this amazing, complex, beautiful vehicle to express it on. Segovia said, "The guitar is the only instrument you caress." What a great start!

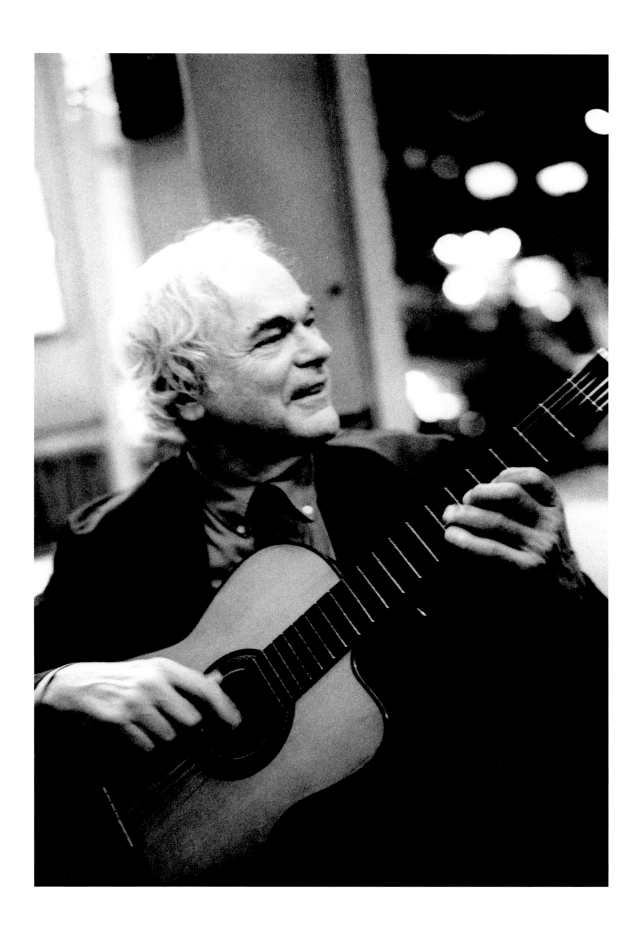

Alan Licht

My life has been marked by a duality, the desire for solitude and the desire to be part of a collective, and the one activity that has unified these two desires is playing the guitar. In order to be able to express yourself on the instrument, you must wrestle with it alone, and I enjoy performing solo, but I ultimately prefer playing and collaborating with people, whether in rock bands or in free improvisational contexts even more. In other words, guitar has been both a social tool for me as well as a private pleasure.

Before I was ten, I abhorred pop music and listened only to classical. In fact, I hated the sound of the electric guitar (too twangy) and the sound and image of an early '70s singer-songwriter earnestly strumming an acoustic folk guitar. I loved the density of an orchestra, but resisted my mother's attempts to get me to take up an instrument because the sound of an orchestral instrument by itself would not be expansive enough (besides, I would rather spend my time drawing or running around outside). The piano was originally meant to be a kind of mini-orchestra, and the guitar originally meant to be a portable piano; however it was only with the solid-body electric guitar that a solo instrument was invented that could approach the volume of an orchestra (with the help of amplification and various effects). I used to listen to classical music, particularly a recording I had of Tchaikovsky's *1812 Overture* with real cannons, at top volume.

And it was only after seeing a reproduction of a painting of Paul McCartney and Wings onstage (the gatefold sleeve of a live album), awash in colored lighting and laser effects, that I had any interest in taking up the guitar—because a guitar could put me in that breathtaking visual context, not because I really liked the way it sounded. That would come later. Although I started off renting a classical guitar to take lessons, by the time I heard Jimi Hendrix on the *Woodstock* album and saw Pete Townshend in *The Kids Are Alright*, both in the summer of 1979, it was clear that I was going to play electric music.

I enjoyed playing chords, but I was never content to be a rhythm guitarist. I also enjoyed playing solos, but although I admire (and possess, to some extent) the ability to construct a concise solo that has a beginning, a middle, and an end, I'd rather let my nervous system do the talking, leave the scales in my subconscious, and not worry about how many bars I have to say what I want to say. These days I often play the instrument's electronics (and even hardware) more than I finger the fret board—making it an inverse sound sculpture, where the latent sonic possibilities lie in the strings themselves rather than in the wood or metal.

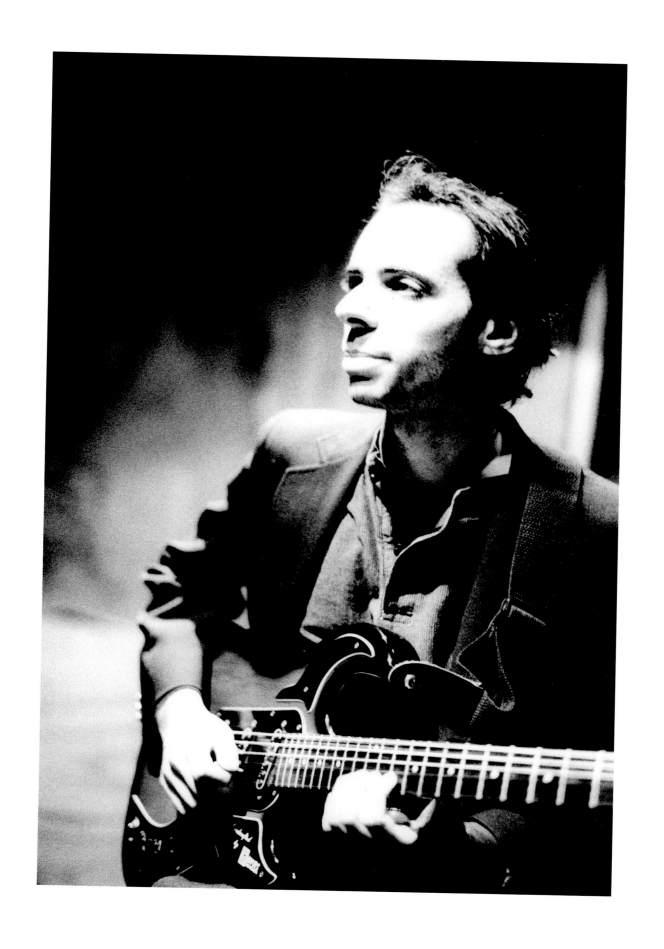

Uwe Kropinski

My wooden voice

It may sound strange, but a piece of wood with six strings really can occupy one's whole life. I have been playing the guitar for forty years now. There was no chance of getting away from it anymore, so I gave up trying! First I played rock music, from age fourteen to twenty-one. Later I studied classical and jazz guitar, played a lot of free improvised music. My first guitar was an acoustic, but in my early years I mostly played the electric. It had to be loud enough! You can play the electric guitar very loud with an amplifier, but it seems to me that it's only the electric energy that you hear and not the physical energy of the player.

The electric guitar is the more intellectual one; the acoustic is more physical—it brings your musical ideas out more directly and has a lot more sounds to offer, but you have to put all your energy into it to get something out, no less than 100 percent is requested. For me, the electric is only half of an instrument. I always hated that situation: having the guitar, but no amplifier available and no chance to play with other musicians. So over the years the pendulum went more and more in the acoustic direction, and for the last five years the one electric guitar I kept was sadly hanging on the wall, waiting for better times. But the other half of the truth is that in the majority of my concerts I play my acoustic amplified. The reason for doing that is obvious. There are so many concert venues that really don't fit for just sitting on a chair and playing acoustic. Amplification is a big help to uplift my wooden voice to the actual situation. In comparison to the electric, it takes a lot more effort to amplify an acoustic guitar in a proper way.

Theo Scharpach, the great luthier from Holland, built my guitars. Actually I use one steel-string guitar and two nylon-string guitars. My guitars have a bridge pickup and two mics inside. I often play percussion on the guitar body; the mics pick up everything I do on the instrument. The fingerboards have thirty-nine frets, giving me almost twice as much working space as on a regular fingerboard. This gives me the chance to explore new chords and sounds, but—unfortunately—it demands a lot more practicing! Fortunately I like practicing. After all, if you put all these components together, take your wooden voice, get on stage, play your music, it may happen that one critic writes about you: "Kropinski is not a guitar player—the man is a guitar." What a liar!

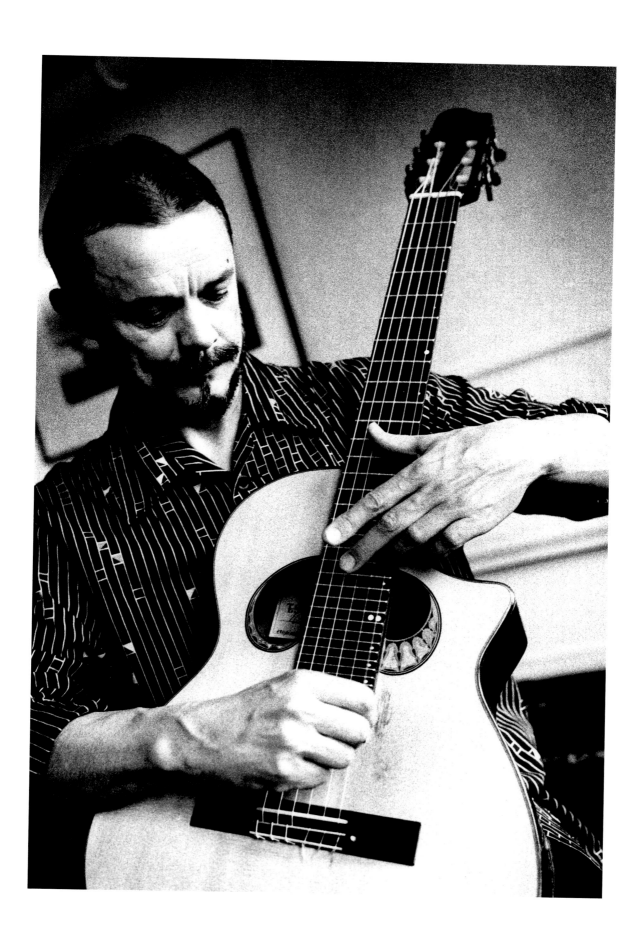

Arto Lindsay

My guitar is blue. At times I think that ought to be enough.

My guitar is like the wind. Don't stand too close, or it will run you down. I've always been partial to the phrase "guitar stylings." To my taste, there aren't enough of these clichés left.

My old friends don't like me anymore because I don't know what I am doing on the guitar. And here I thought that was the only reason anyone liked me. I guess most people don't really want to hear a herd of horses as bad as I do.

Isn't it funny the way we just don't hear instruments after a while? Someone stands up there playing something, and we just don't even hear it.

You may not like what I have to say, but you have to admit I sound like a guitar player.

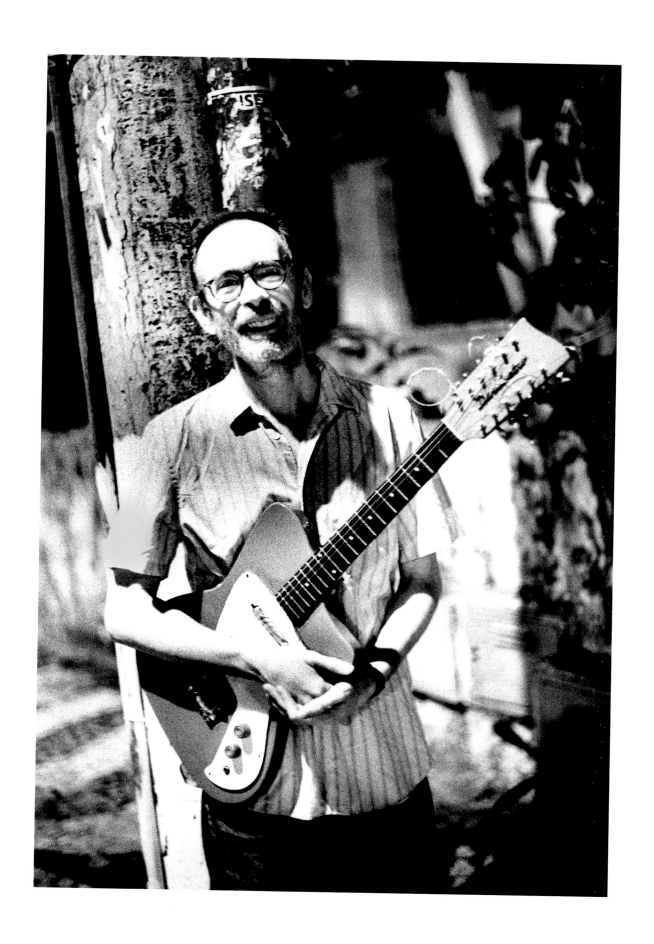

Lou Reed

My Guitars

My first guitar was a Kent with very thick strings, very hard to play. I took a guitar lesson at the local music shop, and they gave me a little book from which I was to learn "Twinkle Twinkle Little Star." I never went back. I spent hours playing along with the radio and 45s—single recordings. I eventually moved on to a Harmony guitar and later a Gretsch. I was very lucky because music at that time was based on three chords I could play. I loved the electric guitar but knew nothing about amps other than you turned on and plugged in. My amp was of an unknown lineage other than to say small. I played in the high-school variety show as a backup guitar player with my three chords. Later I played in bands, again as the three-chord guitarist. I had a white Gretsch through my college band days. Same chords, bigger amp.

When I made it to New York City, I started becoming aware of guitars from a different point of view. I started learning about necks, tone, and woods from a man named Dan Armstrong, a very serious player and luthier. I had so much to learn, starting with tuning for instance.

Later on I realized how deep my love of the instrument was. I was in love with sound, and the sound of the guitar was my sound home. This love led me into the giant world of custom guitars. I was not a collector and didn't have the money for it anyway. But there were new and exciting instruments being made by some very talented people, Spector, Carl Thompson, Dan Armstrong's plexiglass . . . the great Fender copies from Fernandez. Pensa-Suhr's, Steinberger and Schecter . . . a world of new and sonically gifted luthiers making wondrous guitars. I would stand on 48th Street looking through the windows of Manny's and We Buy Guitars, Rudy's . . . looking, looking, looking at the jewels in the window; I loved the vintage sound, but I wanted a new guitar with a new voice and a neck I could call my own.

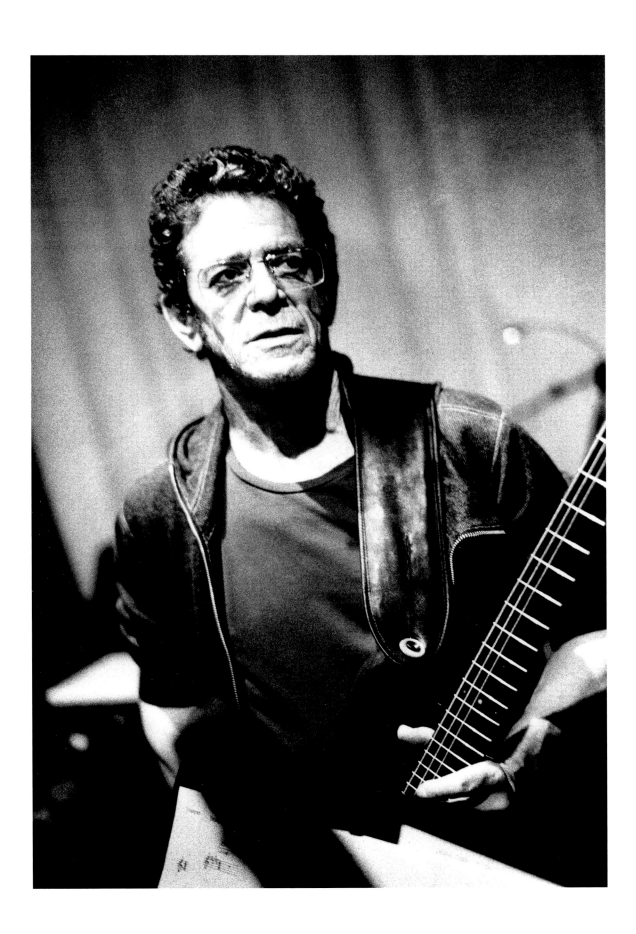

Mary Halvorson

Everyone plays the guitar. It's a great instrument to play because it is not genre-specific; it can be heard in contexts from classical to folk, to jazz, to rock, and beyond. One's options are wide open when playing the guitar, which has been crucial in my search for creative self-expression because I do not feel locked into one genre. It is also a challenge: how do you say something that millions of other people aren't saying?

I grew up learning jazz, and after several years of studying, including a year in a jazz institution, I started to feel severely restricted. My discouragement lasted until I remembered that there was much more to guitar than jazz. So I bought several effects pedals and began exploring. Somehow the pedals renewed my faith in the instrument.

I remember sitting in a practice room in jazz school one afternoon, and suddenly my fingers started moving in a different way, and I realized I had begun to find my sound; I had a blueprint in front of me and knew what I needed to do. Once I had freed myself from the confines of tonal melodic jazz, I was able to tackle intervallic approaches, dissonant harmonies, and new approaches to form.

I explored free improvisation until I grew tired of that. Then I pursued rock music and a variety of experimental music. To this day I am exploring, and I will be until the day I die. I am happy to move in any direction as long as I feel like I am doing something creative and not idiomatic or derivative. I want to express something different; otherwise why play music?

I would also like to point out that my main influences have not necessarily been guitar players. Maybe this was an unconscious decision in order to avoid imitating them! Instead of deciding on a few favorite guitarists and taking a little bit from each of them in order to weave a new patchwork for myself, I aspire to channel great things from all the music I've ever heard and loved, as well as my reactions to all the music I hate, and somehow combine it all into a sound that is a mixture of so many things that to name one specific influence would be impossible.

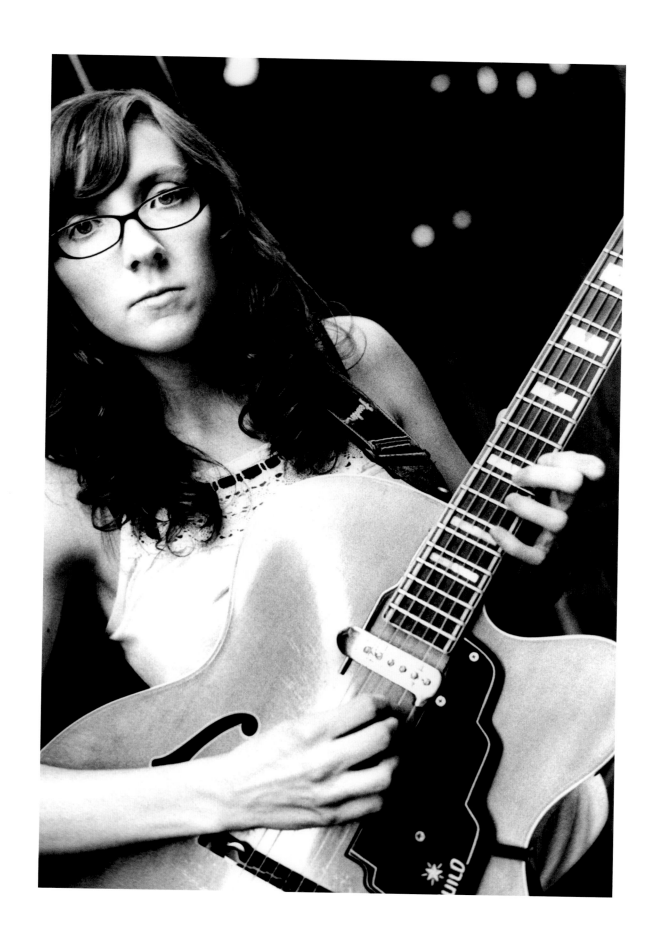

Adrian Belew

For years I wanted one of those big, fat, orange Gretsch guitars. I finally decided to buy one and contacted a friend who owns two vintage guitar stores in California. He had just what I wanted: a 1962 Gretsch Nashville in stunning condition. It was my first (and only) vintage guitar. When it arrived at my house, I took it out of its case and without thinking began playing what would become the song "Six String":

I saw you the very first time
built so pretty, you looked just right
it was love at first sight
I looked real close, I touched your arm
my heart went off like a fire alarm
I was amplified

something happens when I hold you in my hands
I'm a different man
something happens and I lose all sense of time
I can almost fly . . .

every time I go to pick you up
I feel a little spark in my fingertips
I'm electrified
magic touch, you feel so good
the way you respond to everything I do
I'm magnetized

something happens when I hold you in my hands
I'm a different man
something happens and I lose all sense of time
I can almost fly . . .

I love your back
I love your head,
but I love it best
when I run my fingers down your neck.

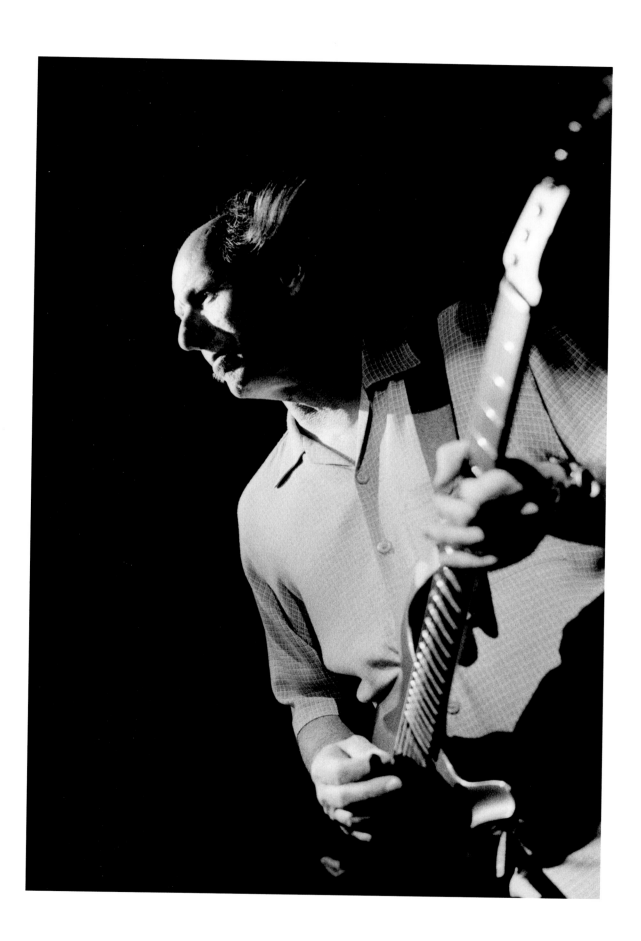

James Blood Ulmer

Jazz is the teacher. . . . Funk is the preacher.

I'm busted . . . I'm a guitar player. But music and playing the guitar are two different things. You have to decide whether you want to play music or play the guitar, and I want to play music. I didn't choose to play guitar, that's one thing for sure. My daddy started me off playing at four years old. He had a gospel group, and he taught me to play. I was also in a quartet and singing.

I'm not a blues player; I sing the blues. Blues is definitely the freest form of music I know about. If you do blues instrumentally, it is entirely different than if you do it vocally.

I do music out of necessity. People need music. It's the updated news about their culture. Without music, there would be more depression.

For me, the basic harmolodic form of music is the blues, instrumental blues, not a song. We are all victims of harmolodics.

Lots of people play, and there's no music coming out of their guitars. You try to find the music. I respect the original maker of the instrument. The instrument maker will in his way allow you to find music on the guitar. People don't give the maker credit. He makes it so you could express what you are playing.

People ask me if I'm a jazz player or a blues player. I tell them that I don't play blues, I play gospel, and I love harmolodic music.

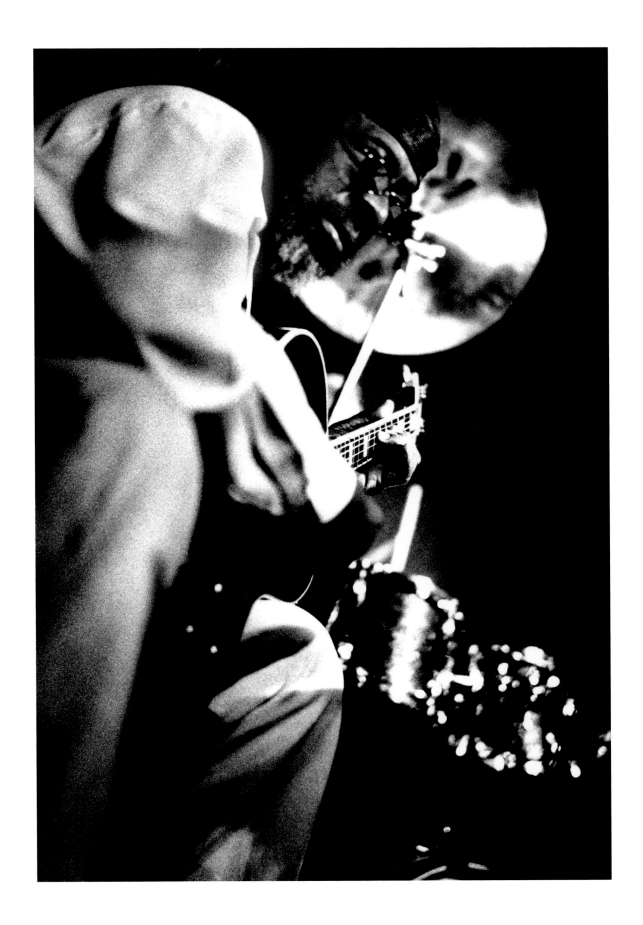

Charlie Hunter

The guitar is anyone's and everyone's instrument. Its vernacular has shaped and been shaped by almost every culture on the planet. Probably has to do with that first E major chord everybody learns.

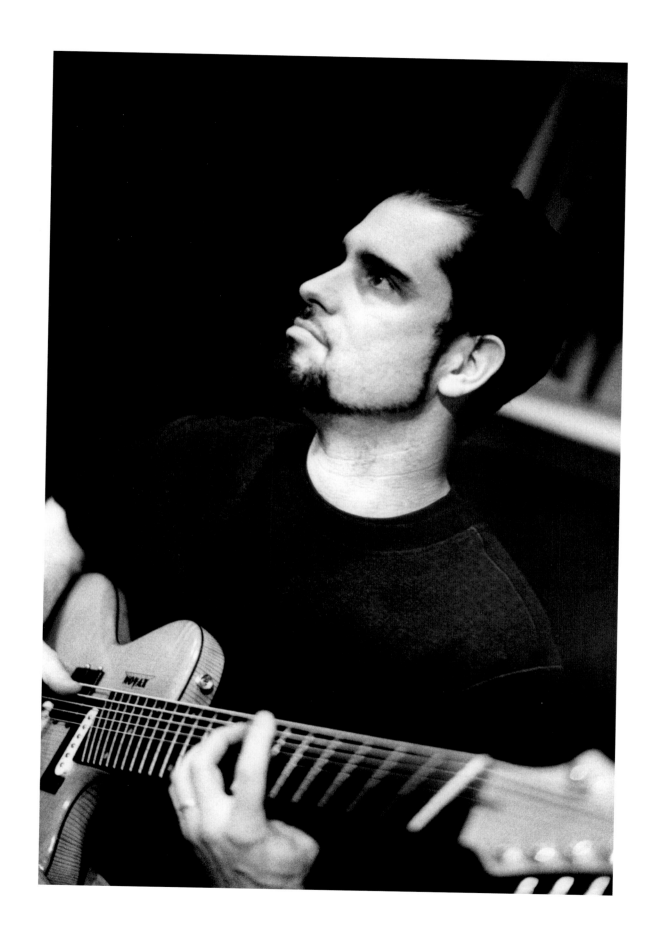

Michelle Webb

Fragments on my relationship with the guitar

Four key elements:
- my grandfather
- Sonny Sharrock
- fretless guitar
- the creation of a completely new instrument

It started as a mistake . . . pointing to the store window where all the guitars were, telling my grandfather, "That one, Papi . . . that one." The guitar he came out of the store with wasn't the one I had pointed to. (Was it to much money?) I think I had pointed to an electric bass, maybe an acoustic guitar. Could I have been pointing at both, and my grandfather just made a decision for me?

That was the beginning of never being able to choose and always wanting both, but I have only two hands. . . . Taking it home and immediately breaking two of the strings . . . My mother was furious with me over it, not understanding the regularity of that mishap. I thought to myself at five, I'm on to something! Although not having a clear idea of what . . . I always thought to myself, there's going to be this instrument that captures the energy and potential of both the guitar and the bass.

As I studied music and guitar in my teens with my first and primary teacher, Tom Newman, I investigated everything and anything that I could get my hands on as a young guitarist. One player that I got the chance to meet who helped in shaping my life on the guitar was Sonny Sharrock.

Always searching, always exploring . . . and intent was everything. I meet Sonny while in high school and was completely floored by his imagination on and of the instrument. He liked what I was doing on the guitar and encouraged me to stay free.

At the same time in my life I also saw a fretless guitar for the first time. It was in a guitar-player magazine article about Guitarist Tim Donahue. It was amazing, but I couldn't find any recordings of him or of any fretless-guitar players until many years after that. The image, and the potential of what I could do with an instrument like that, stuck with me for many years until I was able to get fretless guitars made for me and explore the possibilities further.

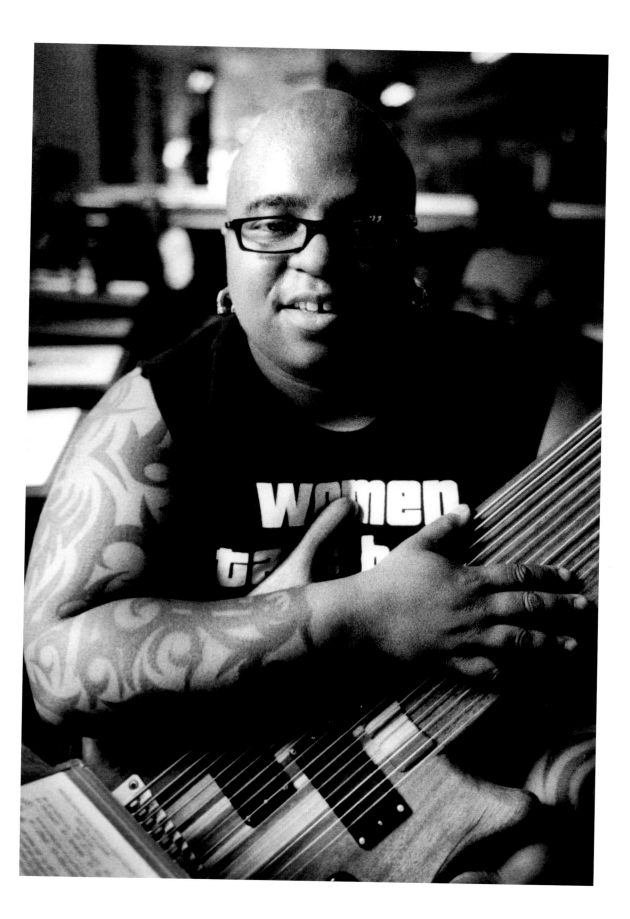

Raoul Björkenheim

As far as I'm concerned, the most powerfully moving sound ever unleashed on an electric guitar is the first long feedback note Jimi Hendrix plays on his "Machine Gun" solo with Band of Gypsies. I remember hearing that record soon after it was released, and Jimi's interstellar lines and spacey/funky sounds mesmerized me from the very first. I still get goose bumps when I listen to it. When I went to see the movie *Woodstock* with my friends, I was thunderstruck by Jimi's take on the "Star Spangled Banner." After I experienced sounds like that, the guitar became for me a source of unimaginably colorful and mysterious textures, an orchestra in itself.

I got my first guitar when I was thirteen, and soon found myself spending most of my time practicing and learning songs off of records by ear. I worked out the seven positions for playing the major scale long before I heard that those patterns were called modes, shredded them inside out, and played rock in a garage band: Zeppelin, Zappa, and the Stones. Mahavishnu and *Bitches Brew* came and blew my mind, leading me to discover jazz and especially Coltrane, whose playing had an incandescent quality like Jimi's, but which went even deeper. I started to emulate horn players, looking for a vocal quality in my own playing, and struggled to understand how the music worked to sound so free and yet inevitable. Gradually I realized that one just needs to really listen, and that's what I still work at the most.

One of the great things I love about the guitar is that it renders boredom obsolete. There are always lots of things to explore, new tunings, new chords, new intervallic strategies, new ways of touching the instrument, new sounds; there's hardly enough time as it is. Music keeps my attention focused and allows me to feel a sense of forward motion, if also of never quite arriving. The feel of the fret board on my fingertips is home, no matter where I am, and I love the peace of mind I experience playing in a pitch-dark room. Then I feel totally at one with the music; it's like I'm not even aware of the guitar in my hands. If I can share that kind of moment with an audience, I'm happy.

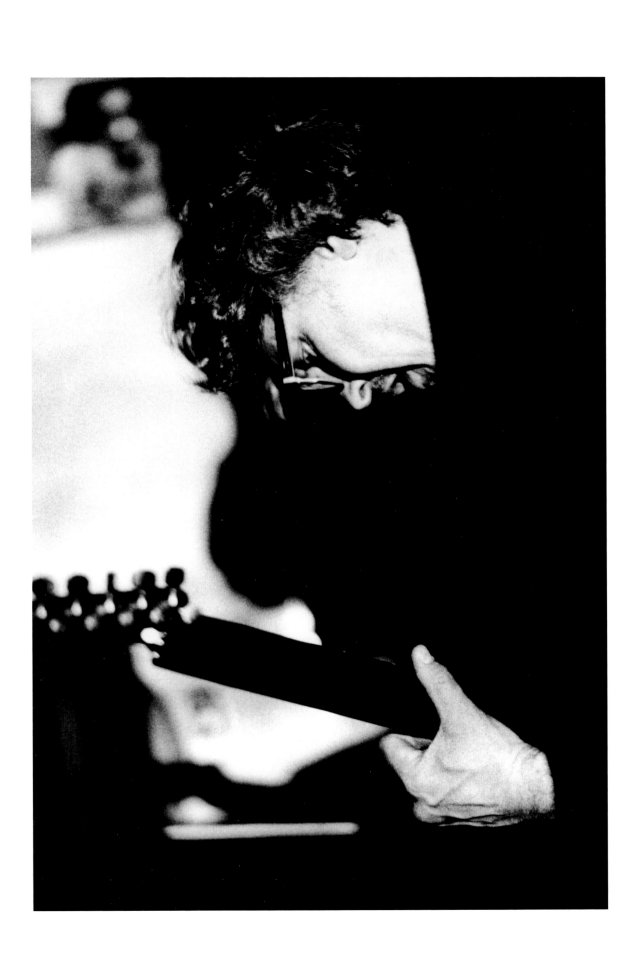

Ava Mendoza

I am a guitar player, composer, and sometime electronic musician in Oakland, California. I play improvised music/weird rock/original compositions. Improvised music was the first type of music I got vitally interested in as a classically trained teenager, and I suppose any musical roots I have are in free improvisation. That said, some of my music does not involve any improvising at all—I indulge the anal-retentive side of my personality by composing tape (fixed-media electronic) pieces, and also sometimes very through-composed instrumental pieces. Some of my solo guitar compositions draw a lot from early country and blues music, sort of reworked (or mangled?) in my own way. In the rock-bands-of-sorts that I play in—Mute Socialite and Bolivar Zoar—I like working with very tight, specific riffs or compositional ideas and then throwing musical monkey wrenches into them in performance, forcing them to self-destruct and intersect with free improvisation. I am an extremely curious person and love a lot of very different sorts of music.

I was introduced to improvised music when I was in high school, where I luckily met some socially ostracized kids who were into free jazz. At the time I was seriously studying the classical guitar. Not long afterward, my classical guitar mysteriously started attracting a lot of dust, and I began improvising on electric guitar. My first electric guitar was a Peavey Raptor, which is not a very good guitar at all.

Over the years since then I have gotten a couple of better guitars and have put myself in every improvising situation I can imagine. The results have been all over the map—some very exciting music, some music that did not really work at all, and some music that did not really work at all but was nevertheless exciting. In the last couple years I've had a little renaissance during which I've realized that a part of me is really fulfilled by playing structured music. Since then I've started composing more and playing in more rock-type contexts.

Along with improvised music, I have a parallel running obsession with early country and blues music that has developed through the years, and this has influenced my playing a lot. It seems that no matter what kind of playing situation I'm in, some sort of influence from these music styles seeps in. My ideas about guitar tone and phrasing—even when I'm playing the guitar with a magnet and a screwdriver—as well as my love for an austere and expressive of style of songwriting and composition, have been shaped deeply by my love of early American music.

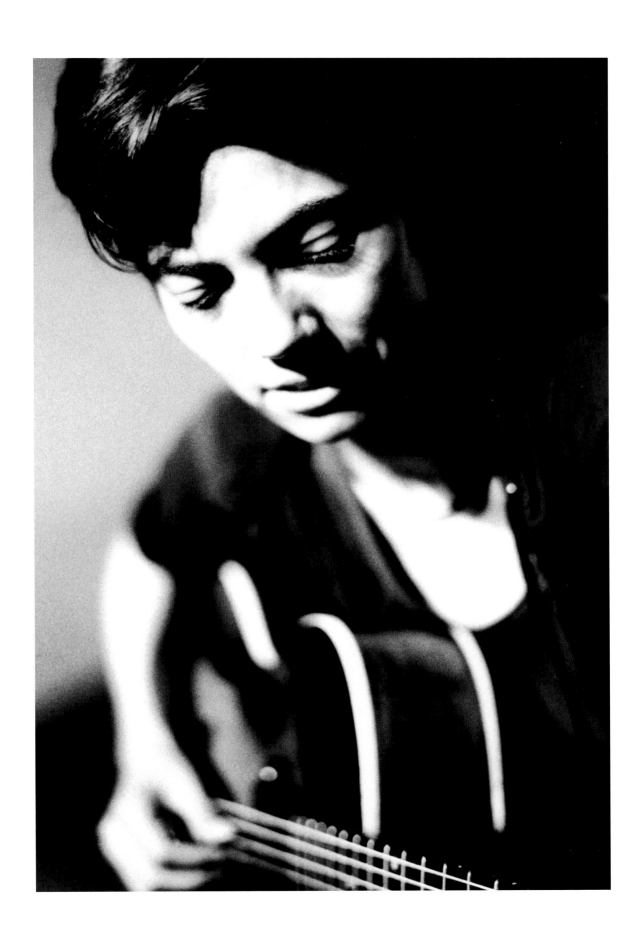

Mike Stern

It seems like I've been into music ever since I can remember. I was always running around the house singing, and I guess my mom could see how much I loved music. She started me with piano lessons. (She's a really good piano player!) I liked the piano, but when I picked up the guitar, I felt like that was it for me. That was in 1965, and I was twelve years old.

Around that time, the guitar seemed like it was everywhere, in different kinds of music; the Beatles, the Stones, the Beach Boys, lots of Motown, B. B. King, Buddy Guy, James Brown, Jimi Hendrix, Eric Clapton in Cream, Jeff Beck, classical guitarists John Williams and Julian Bream. Those were some of the people that I was listening to early on. All that music had guitar in it somewhere. I was also listening to music that didn't have guitar in it. My mom used to play lots of jazz records around the house and lots of symphonic classical music. And when I was nine years old, before I played the guitar, I sang in a church choir, and someone from the Opera Society of Washington DC, where I grew up, came to the church needing some boy sopranos for a real opera, and I was picked as one of them. So I had the experience of being in a very small part in a real opera, singing a couple of Italian words in the chorus (to this day I still don't know what those words mean). But I was nine years old, and the experience of being in a real opera left a big impression on me.

I suppose what I'm trying to say is that music, in my experience, has always come from a lot of different places. It wasn't unusual for me to be listening to a Jimi Hendrix record, a Miles Davis record, a Rolling Stones record, and finish it off with a little bit of opera (Leontyne Price in *Tosca* was a favorite). When I was about eighteen years old I began to really get into jazz. I loved the feel of the music. I was always checking out guitarists like Wes Montgomery and Jim Hall and lots of horn players like Miles, John Coltrane, Sonny Rollins, and many more. Although jazz is definitely some of my favorite music, I've always felt naturally inclined to include those earlier musical influences in my guitar playing. For instance, I like to try to make the guitar sing, even in a jazz context. I like to bend strings like B. B. King and Jimi Hendrix. It seems that kind of sound makes the guitar more vocal and expressive. For me, the guitar has always been a perfect instrument for including lots of different influences. It's a very cool instrument that way and a part of so many kinds of music that by its very nature it seems to blur the boundaries of many musical genres and styles. And I like that. The guitar has always helped me keep an open mind and an open heart. That's a good thing. On top of all of that, it's an amazing amount of fun to play.

I'm very grateful to be playing a lot of gigs, but I still practice quite a bit in a little practice room in my apartment in New York City. A couple of years ago my wife and I took a vacation, and I took my guitar. A friend of mine said I was just changing practice rooms. He turned out to be right. I can't take the damn thing out of my hands. I love to play the guitar.

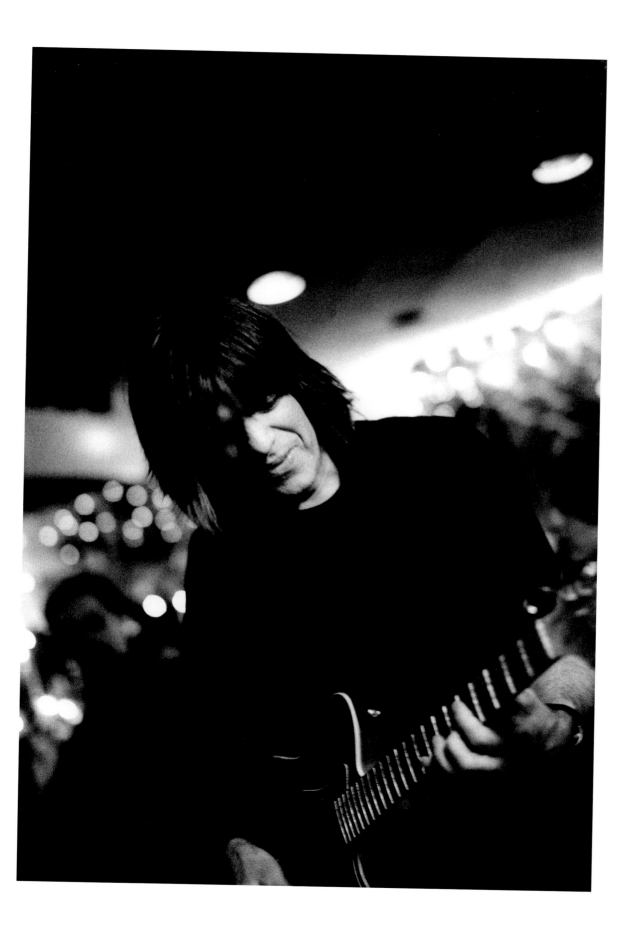

Simone Massaron

The guitar you play says who you are. Or, better, you are the guitar you play. When I was nine, I was attracted by guitars, as they were magnets: I would spend whole afternoons in music shops, looking at the Fender Stratocasters and the Gibson Les Pauls closed in the glass showcases. It was exciting to see them so close and to imagine playing them, and then to go back home dreaming of buying one someday. A family friend was manager of one of those big music shops, and occasionally he allowed me to play some electric guitars. This went on until the day I finally could buy an Eko. It was the early '80s, and Italian guitars were really bad quality . . . as were American ones, for that. My playing wasn't so good either. I have always been a custom maniac; I customized every instrument I had until it was really impossible to identify it. Every instrument represented what I was in that moment.

I remember a Strat with some hundred colors, tortoise pick guard, and fluo pickup, another Strat full of fake dents, and jazz guitars absolutely mint. I love guitars; I love everything about guitars, but most of all I love the feeling of having one in my hands— the strings under my fingers, the neck in my left hand's palm, the pick against my thumb. It's a physical connection, very intimate.

When you play guitar, other people think you're playing guitar and that's it. You don't have any psychological connotations, other than to be a guy who chose to play a very popular instrument that everybody can play. I wonder what would've become of me if I played bassoon, or clarinet. No, I could not play anything else but guitar. Now my favorite one is a Telecaster, a very good '52 reissue, very simple—the simplest guitar around, maybe, and because of that, maybe the most difficult. You play what you have to play, and she responds without mediation, in a very direct way. I like her because she gives me a much more true relationship with my music, and right now I need to be absolutely honest about music.

I play also a strange fretless guitar, a custom-made one that keeps me in closer contact with the most innovative part of me and of my music. Then I have some old Italian 1960s guitars. In those years, Italians built weird, bizarre guitars, trying to emulate the Americans. They built guitars with great naiveté, maybe without even realizing that they would become fantastic instruments just because of that. I love the guitar's world. I love to talk about it. I love to play guitars.

I'm lucky. I'm a guitarist.

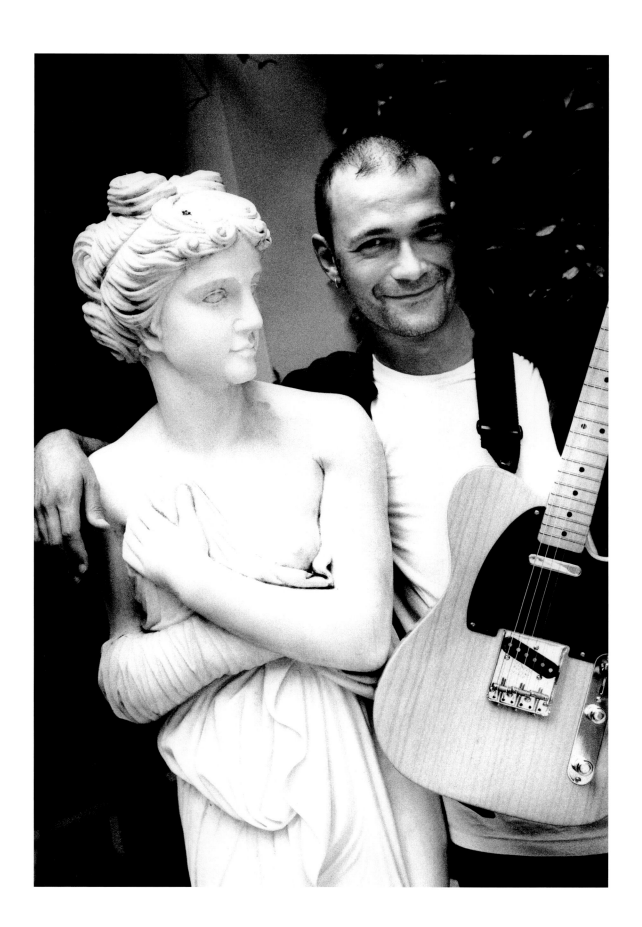

Leni Stern

We sat in a stretch limousine in front of my favorite Moroccan restaurant on a warm summer night. A friend of Brahim, my oud player, has a limo service; he was on his break.

So we all piled in and smoked Moroccan chocolate and drank tea and beer. We talked about musicians we love, especially oud players. The oud is the Moroccan ancestor of the lute, which is an ancestor of the guitar.

"There's nothing that can touch your heart like the sound of an oud," someone said. "Nothing can make you feel happy or sad like that."

"It's because of the double strings, the way they vibrate," said another.

"No, it is the eagle feather we use to strum it."

And after a long silence, Brahim said, "There is a genie, a small spirit, that lives in the oud. That's what they used to say in the old times. It is the voice of the spirit that makes us feel like that."

"I think there is a genie in my Stratocaster," I said. There is.

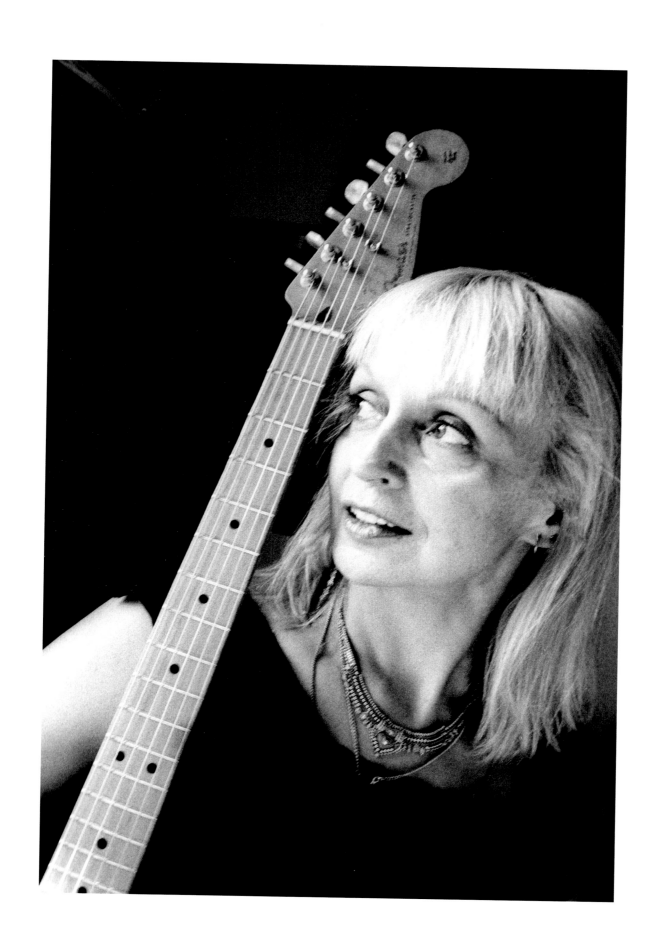

Bern Nix

My obsession with the guitar led to wanting to know more about the infinite world of music. This desire for musical wisdom has proven to be a complicated palliative that renders the slings and arrows of outrageous fortune often encountered in the real world somewhat bearable.

Hearing Charlie Christian at the age of fourteen set me on the path to becoming a jazz guitarist. This ultimately led to my attending the Berklee College of Music. After Berklee, I landed a gig with Ornette Coleman. My tenure with him made me aware of the metaphysical aspect of music; there was more to playing jazz than the musical negation of a predetermined sequence of the II-V-I progressions. The task was the simple yet daunting challenge of spontaneously creating musical forms that had the integrity of formal composition. Improvisation became an existential act that embraced all the meaning and possibility inherent in each moment of musical performance.

Immersion in Ornette's harmolodic theory instigated my ongoing struggle to synthesize his somewhat hermetic concepts with traditional notions about music through the use of such techniques as motive development, pedal point, and octave displacement. In the process of doing this, I find myself trying to update conventional ideas about the art and craft of jazz guitar without relying on the admittedly dynamic armamentarium of technical devices and effects used by many contemporary guitarists.

Lack of fascination with gadgetry might make it permissible to label me an avant-traditionalist who attempts to generate new ideas from the time-honored musical soil of history and tradition. Whatever the case may be, the need to make it new is always a paramount concern.

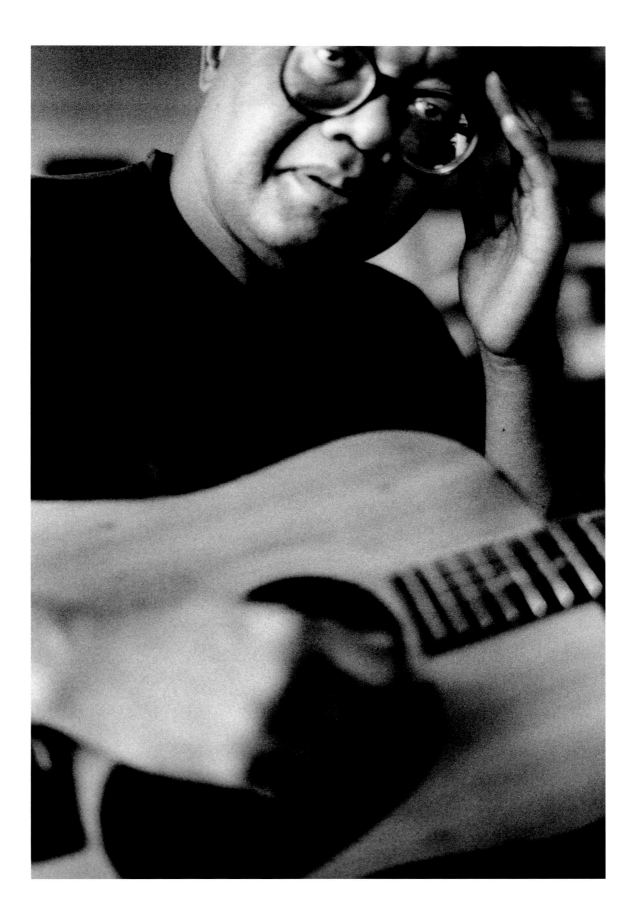

John Scofield

I've been playing the guitar for so long that I barely remember life without it. I don't recall much of what my early focus was, but I did draw a lot of pictures, ran around outside, and ate a lot of chicken. I don't do those things as much anymore, except maybe the chicken. At eleven, my world and inner consciousness changed forever as chords and notes and songs and what to do with my fingers filled in the space I'd held open for them. Even that has evolved over time as the guitar and I have become better acquainted—less about the applications and more about the philosophical. We have a deep and meaningful adult relationship that continually improves.

Most of my interaction with the world is six-stringed. As you may be able to tell from what I'm writing here, I do a better job of conveying thoughts and emotions musically. Guitars are capable of amazing expression and passion—with great range and flexibility. Just about anything I experience and want to convey to others is best narrated by my trusty sidekick. Guitars are tremendous communicators and speak with a voice that most people are familiar with and receptive to.

What can I say about guitar that hasn't already been said, that I haven't already shared somewhere? It's so much a part of me that even my body has conformed to its needs. Left arm up, right arm down, carrying the weight for so long that I have shoulders permanently warped and sloping—a Quasimodo badge of honor. I find it fairly impressive—some species take countless generations to adapt to the physical needs of their environment, but we guitarists (some of us anyway) manage it after thirty years or so. Not exactly Darwinian, maybe more like going to the gym for decades and working only one side of your body, but hand me my guitar, and it fits right into place.

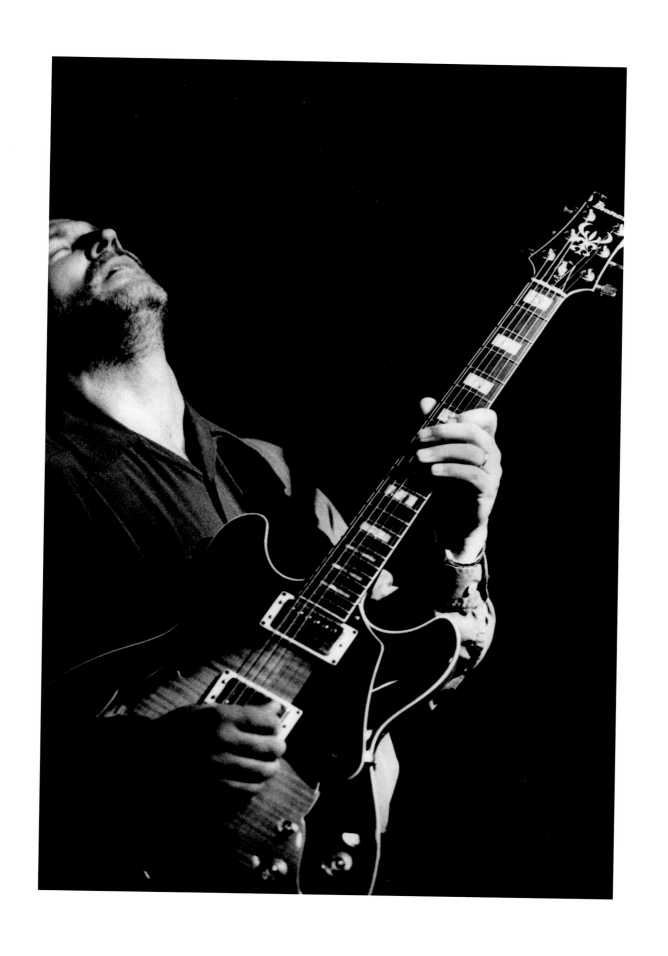

Hans Tammen

Why do I call it the "endangered" guitar? After occasional forays into electronics, I began to experiment seriously with it in 1989. Like many people, I started out using bombast reverbs and looooong echoes. You just play a note, the delay fills up the space for the next couple of minutes, and you might as well go to the bar to get a beer until the sound dies out. I got over it quickly, especially since everybody else on stage can't do that much with it and will follow you to the bar. However, the guitar wasn't endangered yet.

A while later I bought a bunch of loop pedals and harmonizers so I could create these massive walls of sound that were shattering the rehearsal space that I had rented, much to the dismay of the other people who had business in the culture center. The guitar, though . . . I probably could have done the same by just plugging a microphone into my effect chain. Those effect pedals aren't very flexible. They often do just one sound, or a little variation on it. But I'm interested in the relation between multiple sounds, placing them in order or juxtaposing them to create a sonic progression. But for that, and for the people you're playing with, you need to be flexible and fast. I figured the best way was to use all sorts of materials to agitate the strings—sticks, stones, screws, metals, motors, and the like—because a slight change in the position of the screw can create something totally different. For many years I couldn't pass by a hardware store, and the only thing I regret is that they don't let you in with a guitar and an amp to test everything.

Then I modified the instrument. Especially by using piezos, the guitar became a fancy percussion instrument, and in those years my music was all about the pulse I created with an extensive set of mallets. Soon I was dreaming of the universal stringboard with multiple string sections, pickups all over the place, various devices mounted on the machine—until I pulled back again. That was 1998, when the name "endangered" guitar was born. In 1999 I started programming on a laptop to replace my pedals and mixers. And since I'm lazy, I quickly realized I could even do gigs just with a laptop. I think it took exactly that one gig to figure out that the computer keyboard doesn't care how hard you bang it. So the endangered guitar was again rescued from extinction.

Meanwhile, my system is a hybrid of a guitar (still played with all sorts of things) and software. The guitar is the only sound source for my live sound processing, but the same sound is also used to control the software. In these years I have learned how my playing affects the sounds that I created a moment before, and how practicing and rewriting the software go constantly hand in hand. Now fast computers allow the use of comb/resonant filters, bit degradation, convolution, and all sorts of things at the same time, until I get to the point where what I feed into the system is irrelevant. It was very interesting for a while, but now I make sure the guitar can be identified as the instrument again (albeit an endangered one).

That's how it goes: back and forth, back and forth. Sometimes I think I should go play in a wedding band to give the guitar some rest. But I probably prefer the wildlife, with its dangers, over domesticated animals.

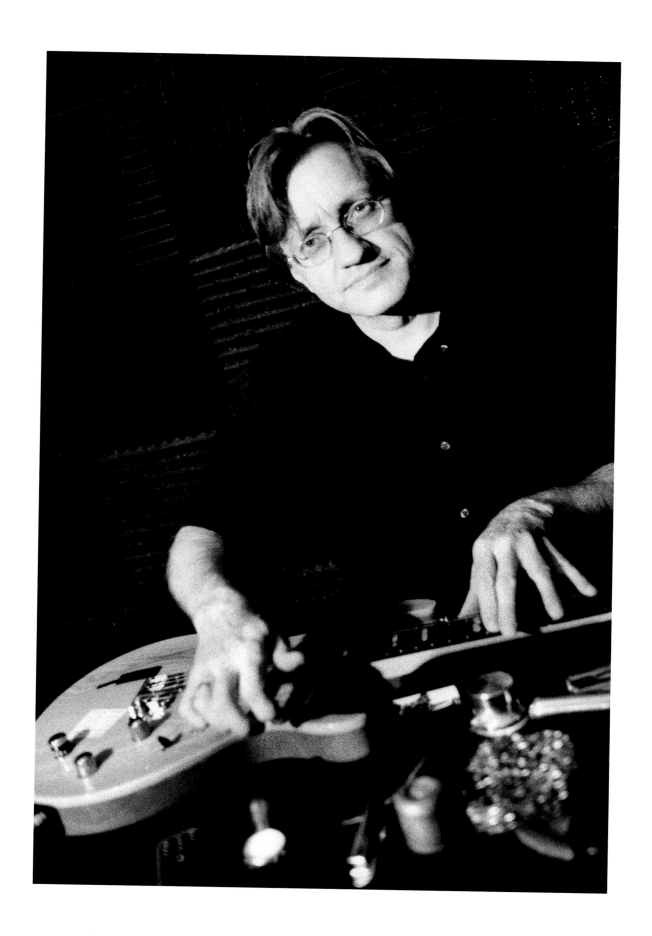

Terrence McManus

If it's possible that truth can come from knowledge about the absolute smallest components of matter, then I would think that a deep knowledge of vibration would be a pathway to some type of understanding of the universe.

Is it the vibration of the one note, the sum of the vibrations of many notes, the sequence of the vibrations of many notes? Somehow these vibrations are affecting us on a scale smaller than anything we can imagine. The vibrations from music are somehow mingling with the vibrations that compose our body. Maybe we don't need to know the specifics of how it's happening, but that it is happening.

I am bound to the guitar because, for me, it helps open the gateway to a larger world. Of all the external tools I have, and because I know it so well, it gives me the best chance to find the things I don't even know I'm searching for. The guitar is my lamp, shovel, and lifeboat. But it isn't only for me. Through the guitar I hope to project these discoveries to others, so they may benefit in some way from what I am attempting to understand myself.

To me, the two musical worlds of melodic-based (I consider harmony just stacked melody) and pure sound are not so different. Both are vessels. I think maybe the sound-based world might be a bit closer to uncovering something, because, in it, music is generally being reduced to its most fundamental elements, namely vibration. In that state, the music has the ability to penetrate us deeper. The truth in it can be more easily absorbed. It doesn't need to interact directly with our intellect; it can pass on and affect more important areas of our being. It also gives us a chance to feel it affect us, and maybe induce some much-needed introspection. This may happen less with melodic-based music because so much more information is being emitted, and the brain's natural response is to take over, so the vibrations from the music never get much further.

Often I think that the sounds I am compelled to create may be something similar to what could be heard happening throughout the universe, if there were air in space for the phenomenon of sound to occur. It is my way to connect with all of the events that are happening out there, because there is a great chance that I can never hear it directly. It lets me experience a sense of what's out there, something much larger than myself, and it brings me comfort. I can hear the engines of creation.

I think about this stuff a lot, but not too much. I want to know more, understand, but I want the chase to continue. In the end I'm just trying to get things to vibrate: the guitar . . . the amp . . . the floor . . . the walls . . . the chair . . . the air . . . me . . . you .

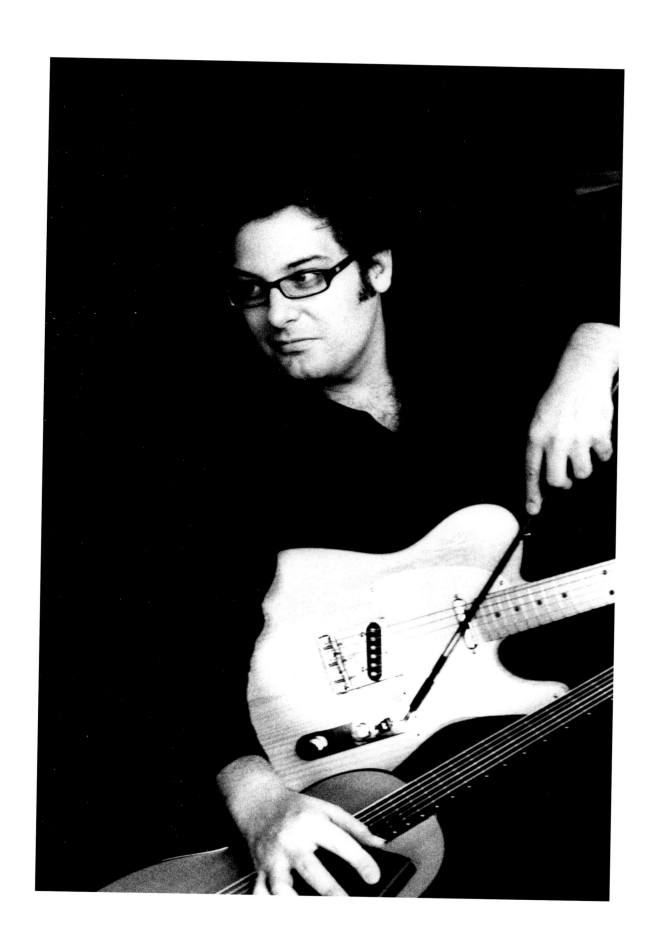

Reggie Lucas

In my life, the guitar has been a constant, more a state of mind than an instrument, and my primary mode of transportation through changes, harmonic and psychic—a vessel of endless dualities, wood and metal, abstraction and clarity, acoustic and electric, ephemeral and eternal, Miles to Madonna. I will stand forever in awe of the elegant simplicity of its power, a humble practitioner of the art of that which vibrates from the touch of a hand to the rhythm of the heart. Six letters and six strings, I ride the waves unafraid and unashamed, my head bowed in praise of the Creator of all things. And till the end of my days I will remain a sonic soldier, a guitar-slinger in the realm of strings and electrons, silicon and soul.

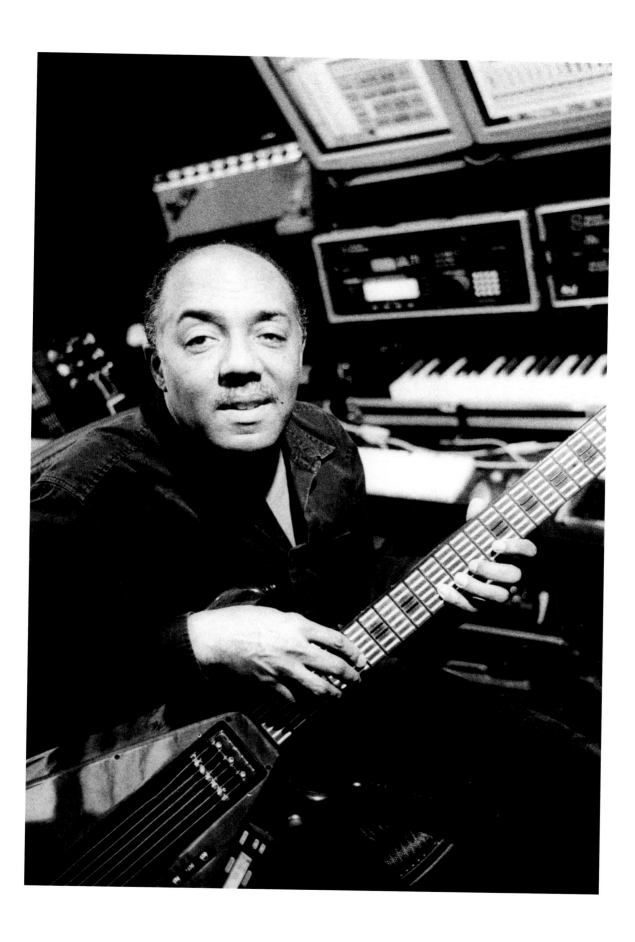

William Brown

I like to surprise myself, to discover new musical territories every day. The guitar is my tool for creative investigation and expression.

I like to begin my journey among a musical field of possibilities within which I choose avenues of rhythm, pitch, shape, and texture, constantly appreciating and acknowledging each rivulet and crevice of inquiry, mixed with laughter, heart, and passion.

I want my music to emulate nature in all its myriad splendor, searing, searching lines breaking across boundaries and bar lines, clouds of mystery and storms of passion with rhythmic and harmonic abandon—a tool of redemption and discovery, fulfilling my desire for exploration, purpose, and meaning, riding whorls and swirls of energy guided by curiosity and communication.

Guitar is a challenge. Since the sound doesn't fill your body with breath, you have to imagine yourself becoming one with the sound, melding this connection of mind, body, and heart into your music of the now, transmuting flesh, sound, and electronics into one. I like working the guitar, using my arms, hands, and fingers to sculpt out sounds, shapes, and textures that express my feelings and ideas about nature, possibility, and living.

The physical effort and the continued quest to grow, thrive, and expand my ability fill me with hope, purpose, direction, and a desire to share these discoveries and spread the gospel of sound.

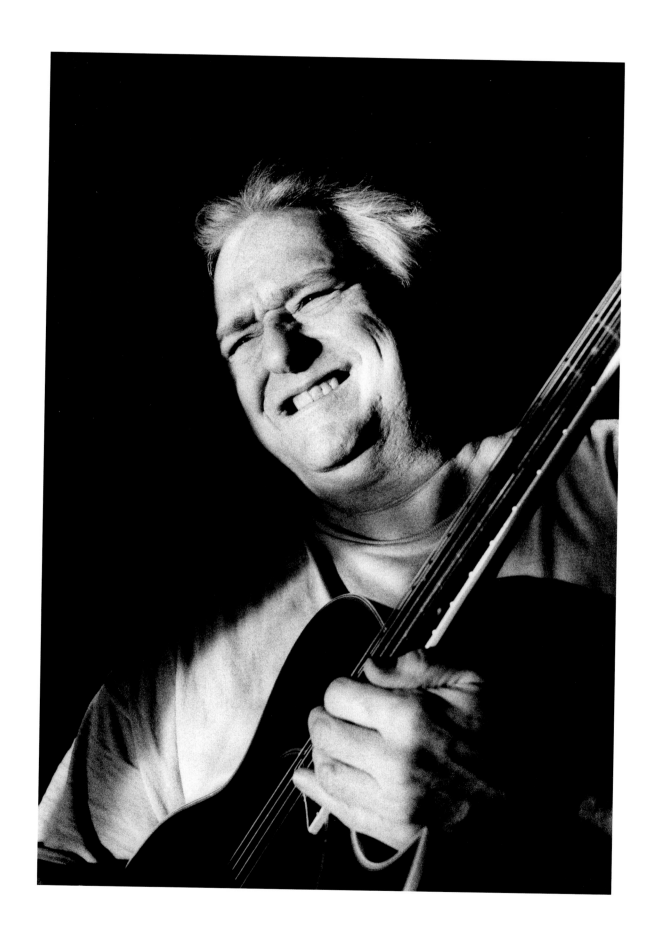

Wolfgang Muthspiel

With every note we play, we create a reality that surrounds us. So we can influence what we are surrounded by, what we invite. Herein lie both endless freedom and responsibility. Sometimes we manage to create something that feels so comfortable that we can live in it. When we hold on to it and claim it as ours, it dies. In that and many other ways, the inner workings of music are the same as the inner workings of life. Music is the teacher. It allows only what is real.

The guitar is by nature an instrument that can easily be chatty. It is relatively easy on the guitar to play something fast, or to let the fingers take over.

I am interested in the harmonic possibilities of the instrument, in polyphony and counterpoint. Unlike other instruments, the guitar still seems like a vast planet that has not yet been fully explored. The openness of it has always attracted me, and also the fact that so many people play it, from the folk strummer to the metal head, from Paco to Holdsworth. In Bach's Lute Suites, it reached a first climax of complexity.

Writing about it now makes me want to play. And here is the voicing of the day, from the top: E B G F Db Ab . . .

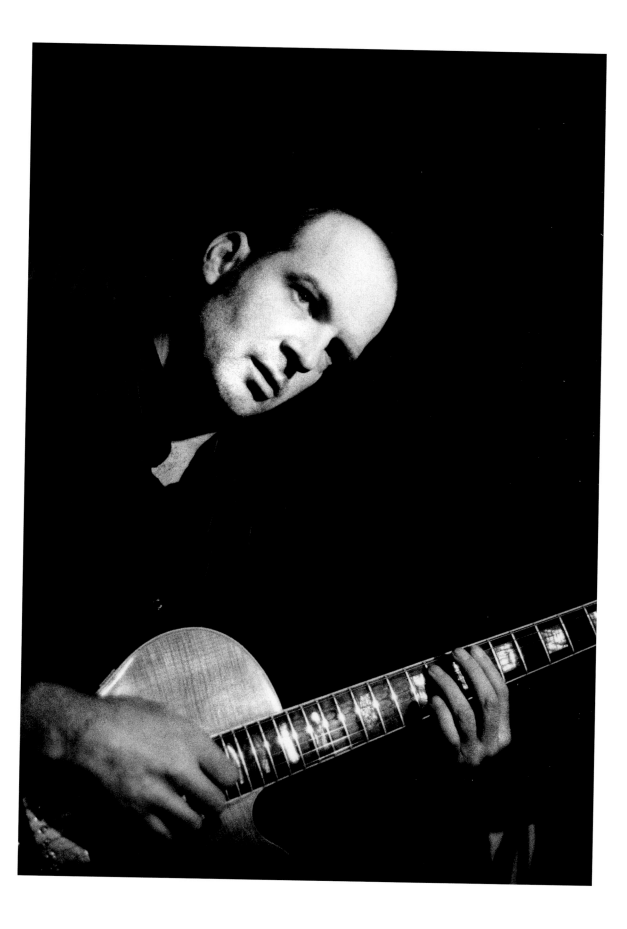

Trey Gunn

As my tool, the guitar seems to be as alive as I am, evolving with the needs of the music to manifest itself in ever-changing forms.

When I was a young player, the first inclination I had that the guitar could change to suit my own vision was with its tuning. I remember the moment when I realized the traditional tuning of the instrument—based in fourths—was holding me back from finding my own voice. I immediately thought "fifths like a cello, that's what I should do." I retuned and, instantly, a whole body of music was no longer accessible to me. I was forced to forge new terrain. That was twenty-two years ago.

The next reinvention was when I picked up the Chapman Stick—a fifths-based, stereo instrument with both bass and guitar strings. The Stick was designed to play two-handed tapping style with the fingers of both hands gently hammering the strings on the fret board. This was where I first felt the presence of music molding the instrument in my hands. As soon as I picked up the Stick, I realized *this* was the instrument that I had been unconsciously preparing for. Everything I had been trying to articulate on the guitar, the keyboards, and the bass was actually meant for this kind of playing. And yet, I needed all this preparation on these traditional instruments to lay the groundwork. It was a small miracle, if there is such a thing.

The next evolution was the Warr guitar. This guitar took the idea of two-handed tapping and focused it more specifically to my own needs. Mark Warr's craftsmanship and his ability to listen to me as a player brought forth several new creations. Each new instrument, in turn, brought forth a new kind of music. The eight-string guitar gave voice to a new kind of soloing that I discovered while performing with the improvisational King Crimson ProjeKcts. The ten-string guitar honed my abilities to cocreate the music of Crimson during the 1994–2003 period, as both a bass player and a soloist. And finally, the fretless, nylon-string bass, aside from giving me a very cool bass sound, also helped usher in the next evolution of the instrument—the horizontal tapped guitar.

In 2002, while on tour with King Crimson, I felt the urge to play the guitar horizontally like a piano. I was horrible at first, but one day it clicked for me. I found a melodic sense that I hadn't had before. Since then, I have come to the conclusion that the next stage of this two-handed tap playing is with the instrument laying flat out in front of me. I am super excited about it, and, no doubt, new music is on its way.

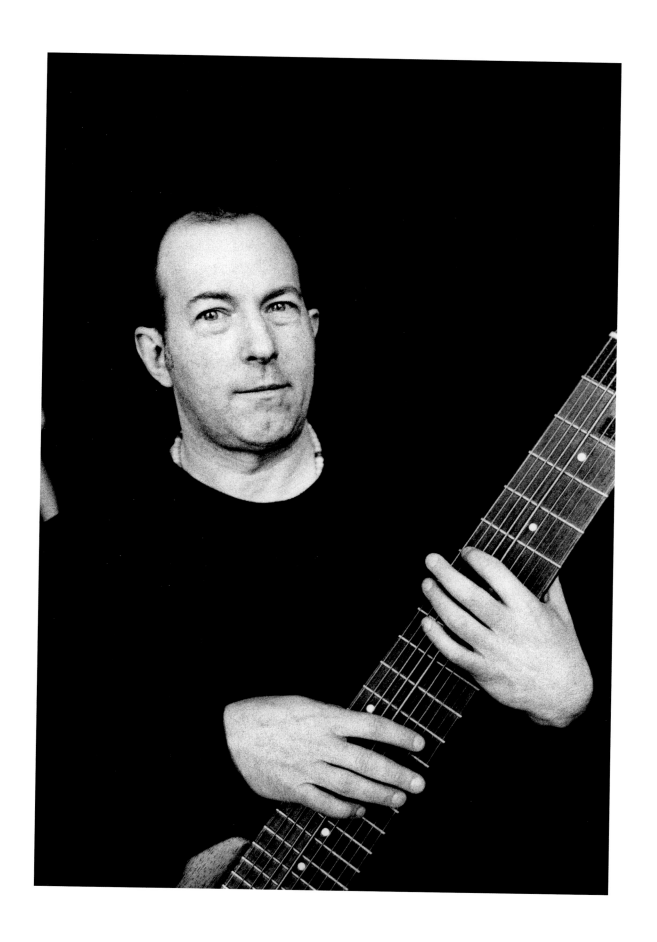

Chuck Zwicky

As someone who works professionally making records for other artists, I am inexorably compelled by the freedom of playing spontaneous improvisational music. These performances exist very much outside of the conventional music-industry paradigm; there is no tangible artifact for sale here, nothing being composed, packaged, and presented. Pure ephemera, this music is born at the moment of performance, vibrates the air briefly, and disappears, hopefully resonating in the hearts and minds of the audience. If you contemplate the journey of a work between the anchors of "intention" and "perception," you will see that all music is ephemeral to some degree, a fleeting experience defined by the contextual intersection of the piece and the listener. Some may argue that this intersection, the conceptual place where the listener first encounters the piece, is in fact the moment of creation, and that this unique contextual conflation is the actual birth of the piece for an individual. I have always liked the definition of art as a resonance between the work and the observer of the work. This can also explain the power of a seemingly inert object of art, like a sculpture, painting, or photograph. Without this resonance, it's merely a thing.

When a piece of music is spontaneously generated in a live performance, it allows that intersection to remain in a mutable, plastic form. It takes as much from the environment as it gives back. The performer, environment, and the audience share equal roles in the event.

Why did I choose the guitar as the voice of these improvisations? For many years I avoided the guitar, I ignored it, stored it away. . . . I broke with the convention of technicality as the key that unlocks expression. I explored electronic music, keyboard instruments, pursuing anything "modern" or "cutting-edge" . . . until one day I was humbled by the realization that the noblest artists of any era had used the simplest tools available, and so I reinvented the guitar for myself, altering its tuning to create an instrument for which, though I had an acquired technique, suddenly I had no habits. I applied to it all of the lessons I had learned in my time away. One observation struck immediately: The guitar is a truly tactile, polyphonic instrument. It combines the intimate expressive capabilities of a wind instrument, the harmonic immensity of the piano, and the textural immediacy of primitive hand percussion. The guitar has endured every fad and innovation of design and has outlived every populist narrowing of technique and application. The guitar, for me, is the embodiment of musical discovery, a multitude of definitions in simultaneity.

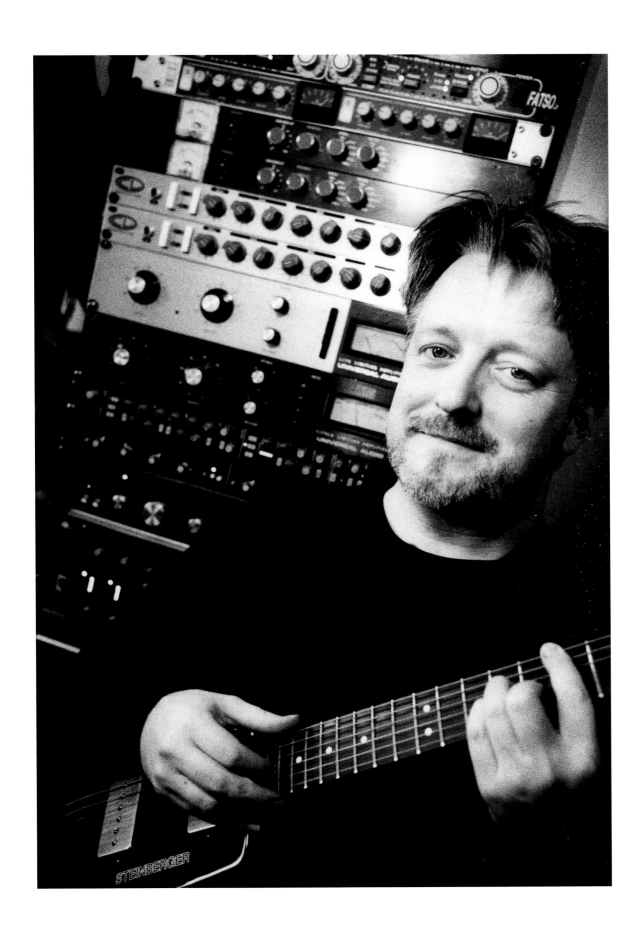

Mick Goodrick

When I was ten years old, Elvis happened. I attached a belt to a tennis racquet and had my imaginary "guitar replica." I would cavort in front of the full-length mirror that was on the closet door at the front of our living room, miming/lip-synching along with Elvis Presley while "Hound Dog" and "Don't Be Cruel" were spinning on our record player. I asked my parents for a guitar. They could see what I was up to . . .

They declined on the guitar, but said they would get me a ukulele instead, to see how I did with that. I was disappointed, for sure. The uke didn't look so good in the full-length mirror. Fortunately, I still had the tennis racquet.

My father (who played a bit of stride piano) helped me learn some chords on the uke. It wasn't great, but it was OK. When I was eleven years old, I accidentally (?) sat on the uke, crushing it. Shortly thereafter, someone from the grade school that I was attending called my mother to see if I was interested in music lessons. Mom asked me what instrument I wanted to play. I said guitar. Finally, I got my wish.

My first guitar was a very cheap Stella steel-string acoustic student model. The strings were about a half-inch above the fingerboard. But there was that smell, that new guitar smell . . . filled with excitement, anticipation, curiosity, and wonder! During the first couple of weeks, I practiced so much that my left-hand fingers bled. Eventually, I developed calluses. Eventually, I phased out the tennis racquet.

By the time I was fifteen, I was performing professionally with different small groups as well as doing some teaching on weekends. I even joined the local musicians' union. (Had to lie about my age. You were supposed to be sixteen.)

I can remember my dad saying that I would probably be better off working on chords rather than working on lead playing. His rationale was that, as a guitarist, you spent much more time playing chords behind other musicians than soloing yourself. I remember that I disliked this advice, and felt a sting as if I were being criticized. As it turned out, it was some of the best guidance I ever received!

In looking back over my life in music and as a guitarist, it has become very evident that whatever success I've had has been due primarily to my skills as an accompanist. I guess my motto (for a long time) has been: "If you can help other musicians sound good, maybe they'll hire you again!"

Although I've never been able to play the guitar as well as I would like, I do feel that I've come pretty close on more than a few occasions. Since it seems that I still continue to learn and improve (even after more than fifty years of playing), I think I'll give myself another ten years to see what happens. If it doesn't work out to my satisfaction at that point in time, I guess I'll just "hang it up" (and get back to that tennis racquet with the belt on it).

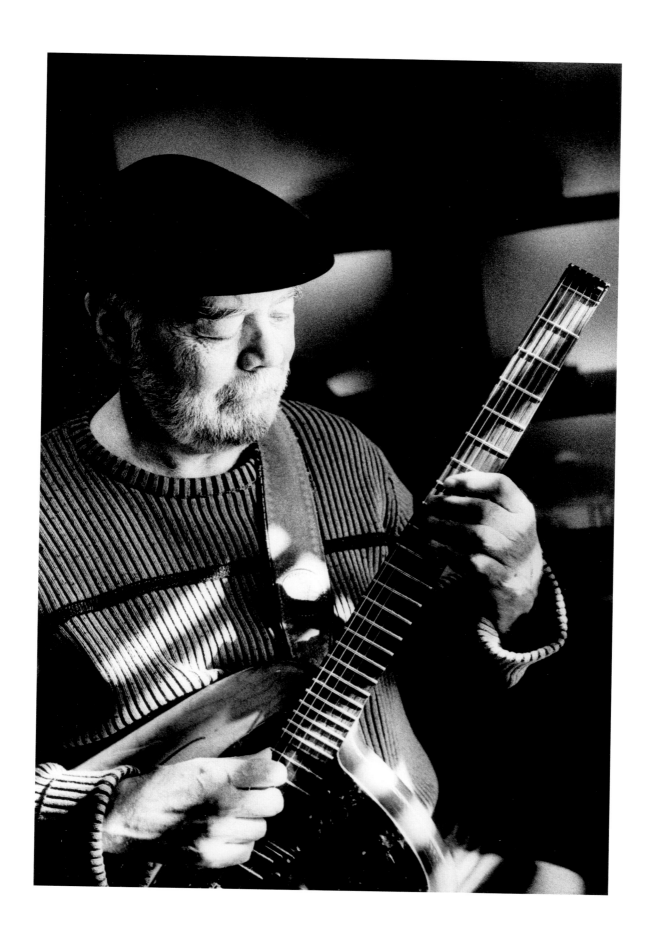

Apostolos Paraskevas

I came to composition through improvisation, and to improvisation through the guitar. I still remember the burning feeling when I discovered that I could fake my first guitar composition and give it a title and proudly place my name next to it, "Wishes for a Beautiful Life." I was fifteen, improvising on my barely existent music thoughts.

Many years later, having one of my orchestral music pieces performed at Carnegie Hall by my friend and mentor conductor-composer, Lukas Foss, I knew that this orchestra was just a big guitar for me. My fingers, dancing on the fret board, were those flutes, the strings the percussion, the harp.

My relationship with the guitar, the one and only, is respect and devotion. She will respect me as much as I will respect her back. The more time I give to her, the more pleasure I get back. There is nothing that gives me more pleasure in this life than to put my hands around this little piece of a miracle. I say this to my students, and they laugh as if I were joking. She took me around the world, materialized my dreams, she even served in the army with me and kept me company in the years of need.

The guitar helped me to find new ways to express an idea, a sound, and a feeling. My composition language comes in waves of guitar-improvisational note-cells that eventually find their way to the music staff. I follow my own path by following the maps that my music mentors have handed me. I always have one goal in front of my audience: to ensure that they will never forget me.

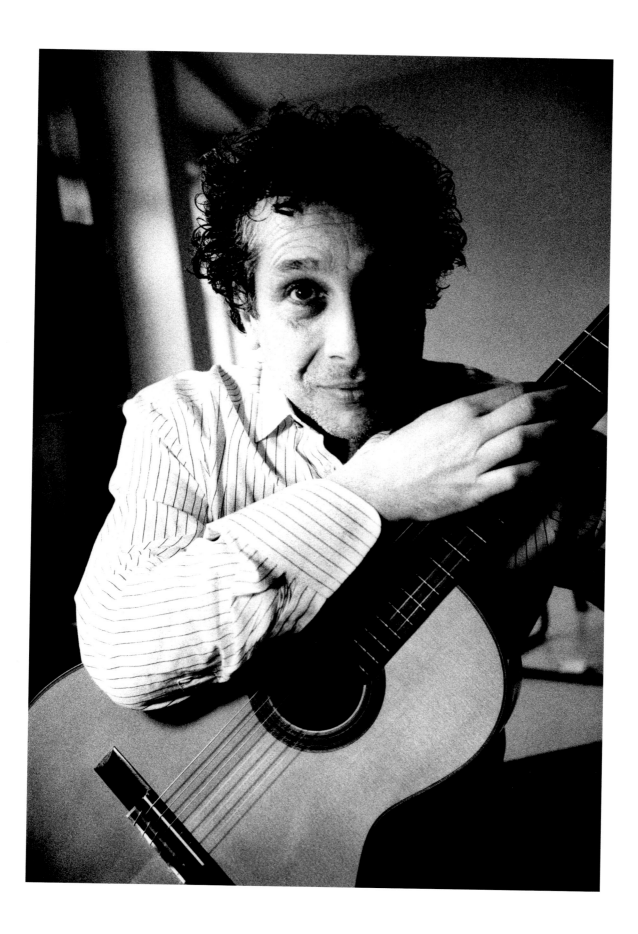

Rhys Chatham

I'm a classically trained composer from New York City. After I got out of conservatory, I was a concert producer at a place in SoHo called the Kitchen; I founded the music program there. After a number of years as a concert producer, I got tired of producing other people's music. I had heard an early concert of the Ramones and was inspired by it, so I picked up electric guitar and made a composition called "Guitar Trio" in 1976/77, which combined the minimalist tendencies within which I had been working with rock instrumentation and musicians.

Morton Subotnick introduced me to electronic music in the late '60s; in the early '70s I studied composition with La Monte Young and played in his group, as well as in Tony Conrad's early group. These guys are, along with Terry Riley, the founders of American minimalism; one could say that "Guitar Trio" is a bit like Tony Conrad meets the Ramones!

What I have always attempted to determine is how to best use the new sounds and forms available to us in a way that isn't mere appropriation through digital sampling or analog extraction, but that directly engages their source in a way that transcends original musical meaning while at the same time imploding it to such a degree that meaning is no longer possible or even desirable, but rather exactly the reverse: to initiate a rite of decimation of musical meaning and thought in order to partake of the fascination that results from daring such a thing. My personal formula for musical inquiry begins by taking a close look at seemingly disparate music and studying them, considering what would happen if I modulated their signification through a process of amalgamation and superimposition.

In the case of working with rock instrumentation, I didn't want to merely appropriate it, to filch from a form of music without actively engaging its source. It wasn't until after I had spent a year actually playing in rock bands, at places like CBGBs and Max's, that I felt comfortable enough to make a piece, a composition in the classical sense.

After working with three electric guitars, I upped the number to six, and finally in 1989 to one hundred electric guitars with a piece called "An Angel Moves Too Fast to See," which I have been touring around the world with ever since. It was composed in France, where I had moved that year. So I have been touring with an orchestra of one hundred electric guitars for almost twenty years now. And I still live in France.

My most recent piece in this genre was commissioned last year (2005) by the City of Paris for an all-night festival called La Nuit Blanche. It was for four hundred electric guitars. It was called "A Crimson Grail"; we performed it at the cathedral Sacré-Coeur in Montmartre in Paris. The concert lasted twelve hours; we had a blast! I'm currently working on another work for one hundred electric guitars, titled "The Secret Rose."

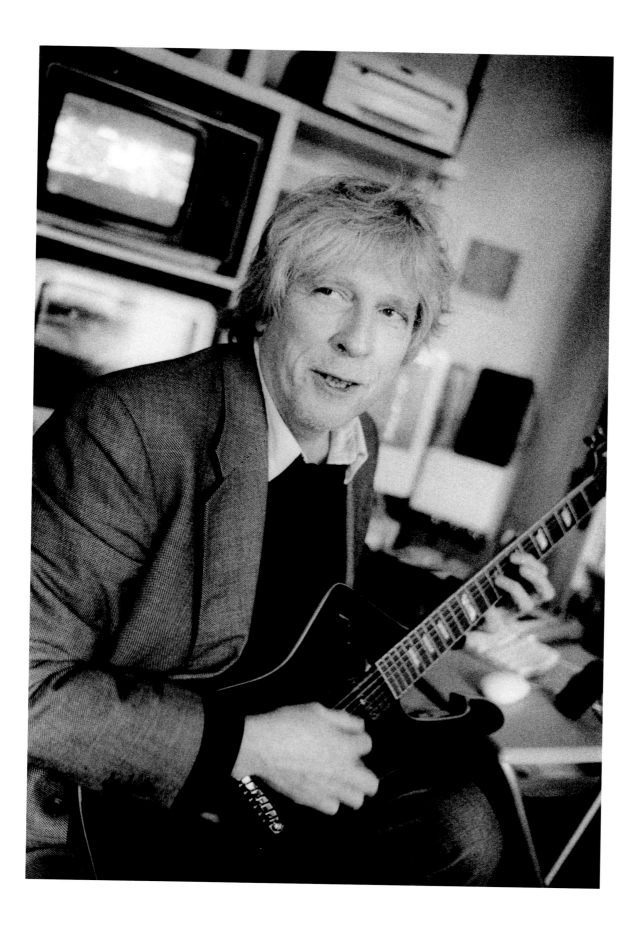

Keith Rowe

I guess what I did was to take the processes and agenda of painting and apply them to the world's most ubiquitous instrument, the electric guitar. In the world of the plastic arts, generally you do not have permission to make other people's work, in contrast with the music sphere. I was occupied with widespread emulation and appropriation, which, particularly in the world of the jazz guitar, was a normality; in fact, the closer you could get to imitating Wes Montgomery, Jim Hall, et cetera, the better you were regarded.

Thinking like a painter, I regarded the instrument as an object to be explored, dominated by the art-school questions of "Who am I?" and "What do I have to say?" I felt the need to develop a new language for this thing, "the guitar." Inspiration came via Braque and Picasso, with their reassembled objects of "guitar-ness." I also knew how important it was for Pollock, laying the canvas flat on the ground, which led to the break away from the European easel traditions in order to help found an American school of visual art.

Placing the guitar flat, first on the floor, then on the table, in an instant changed my relationship with the instrument. It was no longer an extension of me, an expression of my cares. Laying the instrument flat gave it an independence, more a reflection of the world, of the environment, than of my expression. Musically, longer sounds were possible, also the layering of different sounds allowed an "orchestral" approach, this coincided with [Michael] Graubart's theorem "that the long sound superseded the short ones" in the history of music. Pollock was laying the guitar flat. The radio grabs were Rauschenberg; the preparations intertwined through the strings were Duchamp; moving from one sound to the other was Mahler; Purcell the basso continuum, significance Rothko, the sound world David Tudor. . . . Abstraction, ambiguity, distance, music as time . . . all was possible.

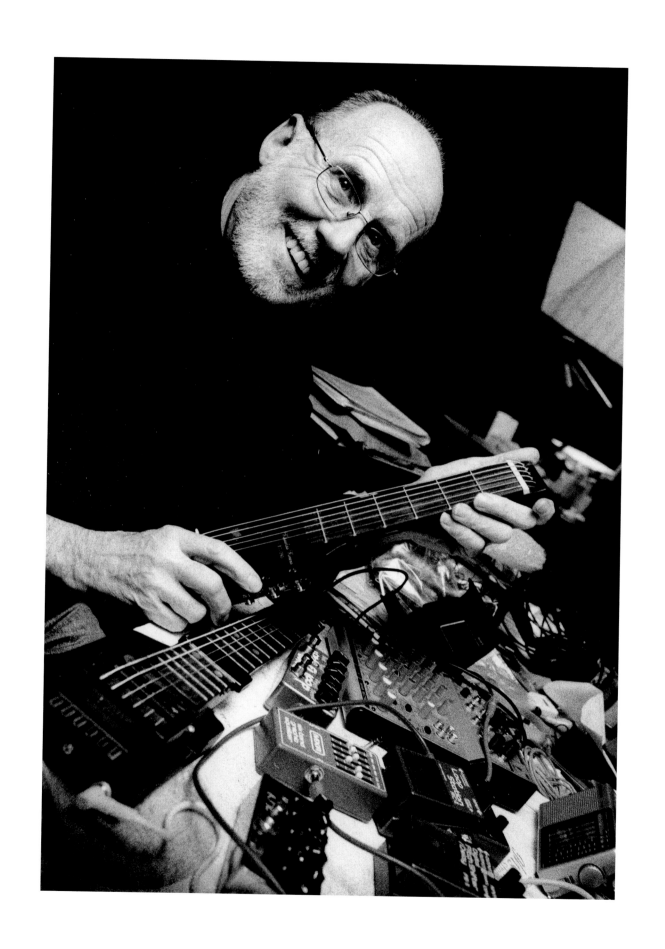

Thomas Toivonen

I have been playing the guitar my whole life. As long as I can remember, I have loved guitars and to play on them. I was self-taught from the beginning, which I think has been very important to developing a personal sound. There was no right and wrong; I had complete freedom to explore the universe of music without any boundaries. But then I went to a music school because I felt that I wanted to learn more to develop musically, but what happened was that I found myself trapped by rules. Suddenly I was practicing (which I hate) and trying to be disciplined (which I have never been successful at). It burned me out trying to fit in and to mold myself to something that I'm not.

Luckily I came in contact with the guitarist Andy Fite, who set me free again with two sentences: "You should never practice," and "You should never be disciplined." But he added, "But you should do your work." I also took some lessons with the pianist Connie Crothers during a visit in New York. She told me that "blues is not just one feeling, it's all the feelings in the universe, it's infinite." These ideas that were presented to me came from, or were inspired by, Lennie Tristano, who recorded the first two known free improvisations, "Intuition" and "Digression." And there it was, what I had been looking for: free jazz and free improvisation, the expression of complete freedom through music.

I don't have a favorite guitarist. For me, Jimi Hendrix, Charlie Christian, and Derek Bailey all had the ability to express what they had inside. According to the Sami people of northern Europe, a person whose *yoik* [traditional *a cappella* song] is remembered even after his/her death is still alive, because the *yoik* is not a song or a melody about, for example, the reindeer or a person—it is the essence of the reindeer or a person. So for me to internalize these great musicians by singing with their recordings or just by listening to their music, I have a little bit of these musicians in me, not by copying them on a superficial level but by feeling them, becoming almost one with them, and there I find myself.

After some years of exploring the universe of music with my teacher, I found myself trapped again and I realized that "doing the work" was not for me. I had to get rid of that too. It was time for me to move on and once again explore the universe of music without boundaries. Pablo Picasso once said that it took him years to paint like a child, and so it was for me, too, to find my way back to the state where I could play as a child, open to the universe.

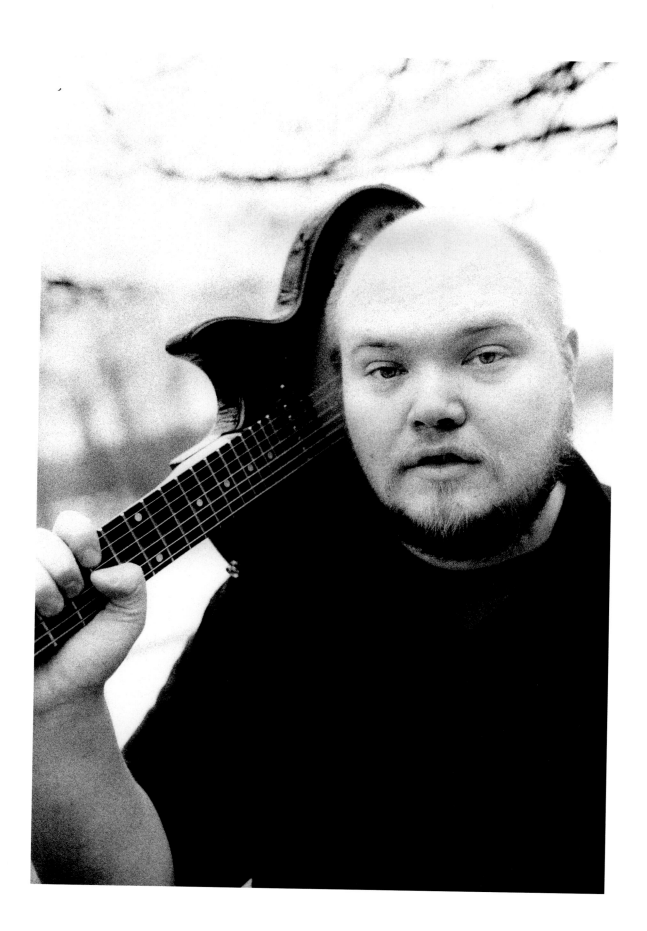

Philip Catherine

I heard and still listen to the magic notes of my masters, Django, Chet, Miles, Erroll, Winton Kelly, Coltrane, Paul Chambers, Paul McCartney, Scofield, Blakey, Jeff Beck, Robert Wyatt, Guinga, Paco de Lucia, Mahavishnu, Wes, Dinu Lipatti, Sviatoslav Richter . . . and year after year, concert after concert, where are these magic notes?

That's my life. In the very beginning, my guitar tone came naturally. I did not ask for it, did not even notice I had one. But one day it disappeared! Then I noticed something. This was many years ago, and then my soul screamed in silence: "Tone, where are you? What happened to you? What's wrong with this amp, this guitar? Please come back to me!" It was not the amp, the guitar, or the P.A. system; the problem was on another level. It's daily work not to lose the tone anymore.

I listen to my heart and to my masters. . . . Well, let's say I try. I also listen to my fingers. They have their little memory and their word to say. Isn't that strange? I put my fingers in relation to my brain, and they arrange things for me. Thank God I do not trust only my willpower. Masters, please guide my hands. I make plans also, try to understand the math of music. There's something there for me as well.

The next step, the most difficult one: listen to my heart—"Philip, guide my hands." Is there is a gift here? Then I clean the antenna that links me to music. If not, the hearing becomes so distorted. Sleeping enough, for example, cleans the antenna a bit. Harmony with my neighbors cleans it as well . . .

I would like to improvise as easily as a fish swims in water, free to go fluidly up, down, left, right, and stay on track with the groove and the tune. Django, Chet did it . . . Telling a story whose origin I do not even know, often I write melodies, I have to . . .

Improvisations, melodies, and interaction—that's my life. To reach that: daily and ordinary, simple discipline . . . A bag full of notes, full of licks, is traveling with me in the trains, planes of destiny; they all come from my masters, but they come out (of the bag) in a mysterious way—the listener hears something else. Some listeners find I am original! Isn't that a bitch! And all that finally with the help of a wonderful piece of wood and metal: a guitar.

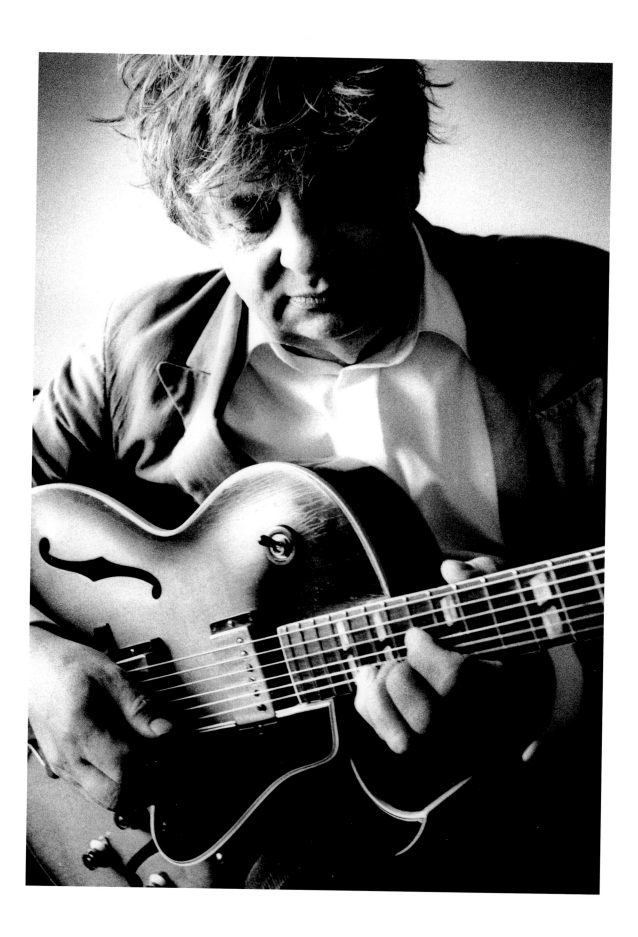

David Byrne

I'm not a virtuoso guitar player by any means. I learn a little more every year, but mostly I am content to play well enough to accompany myself and to use the guitar as a writing tool. Since different guitars sound very different when I fool around with the aim of writing, sometimes I am hugely influenced by the sound of whatever guitar it is I've picked up. (If I'm running the guitar through pedals, those push this audio uniqueness even further.)

Different guitars posit different sound universes. Some sound spiky and thin, others full and resonant, and others warm and muted. The kind of melodies I might improvise vocally will change depending on the sound of the guitar. I'll react instinctively with my voice, its tone and attitude, and I'll go so far as to unconsciously choose pitches that work best—or so I think—within the space offered by the guitar of the moment.

The sound-universe of each guitar, or guitar and pedals, restricts me in a good way—it says, *This is the landscape you can explore, but no further. These are its borders, and best if you stay within them.*

Later, after the melody is written and formalized, I might experiment with eliminating or changing the guitar—but during the writing process it can be quite influential.

This guitar was given to me by British DJ Fatboy Slim, who had recently returned from doing a set in South Africa and heard a guy playing one of these on the street. It turns out that the street musician's performance was also a kind of product demonstration—guitars like the one being played were on offer. If there was interest, the musician would unbox the item for sale and demonstrate its sound.

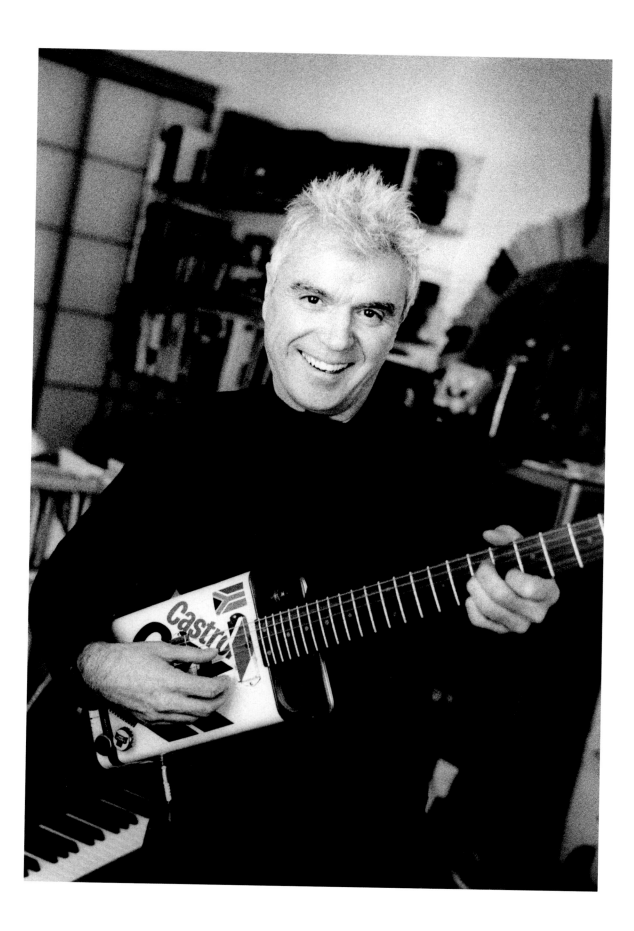

Bruce Arnold

As we spiraled into the twenty-first century
there is,
was,
composing and improvising
serial and twelve-tone music on the guitar.
Vehicles were needed to find original content without clichés,
transcending sounds that had become trite.
Systems of organization and
sound production that could release new forms and directions.
The new architecture required courage
to tear down the old
and rebuild
while still being mobile;
like a moving ship morphing as it changes from sound to sound,
composition to composition.
As you look aft you see that the base wasn't the lexicon
as you look to fore you see that like a fractal, the bigger picture
was the smaller picture.
(The whole of the composition was the smaller gestures!)
A process was required
where the composition/improvisation must first be present-at-hand,
reflected upon until it
becomes ready-at-hand
so as not to not interfere with the task.
Pitch Space needed an instrument that could be silent and loud.
Take on texture,
density,
expression without inhibition.
Interface with new tools and be an articulate but diversified controller.

Like a sage the guitar sits there ready,
moving through these changes. It always knew
from the beginning
that these things would come to pass.

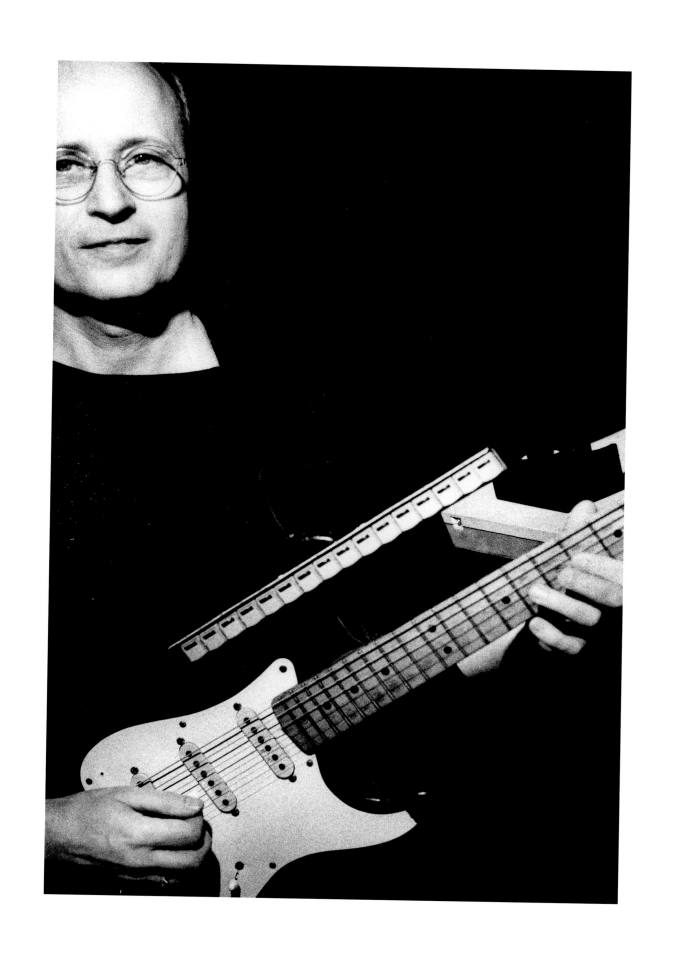

Al Di Meola

My absolute peace in life comes from the state in which I am in tune with my inner emotions. The guitar is my instrument for separating from the stresses of real life into the world of exploration and creative freedom. It's the link that the guitar provides for allowing expression from my inner soul to the listener.

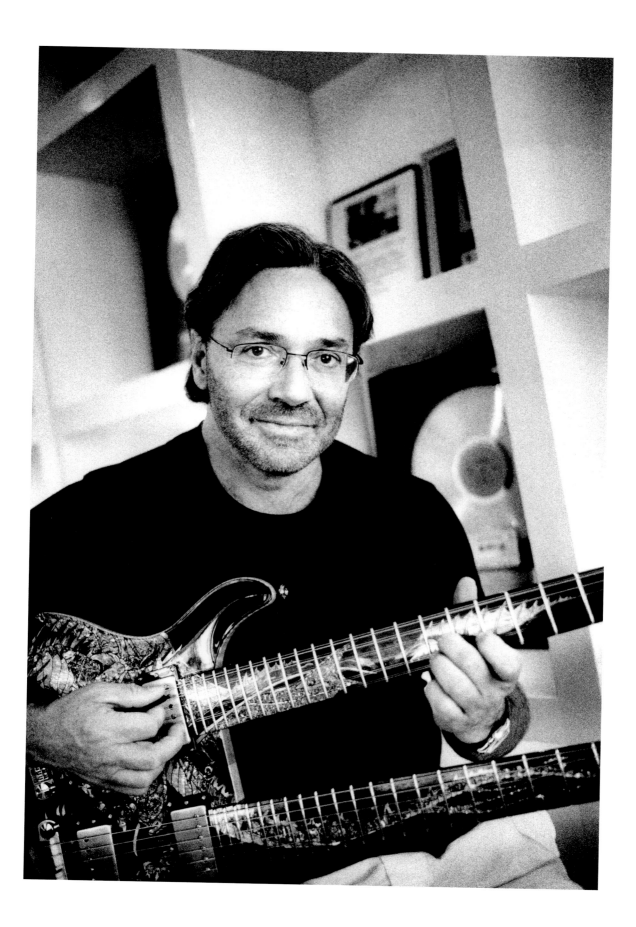

Loren Connors

You have to play what's inside yourself, and you don't have to make it sound any particular way. If you're not feeling very happy, your guitar can say happy things, just so long as what finally comes out rings true. Emotions all run gray anyway, so one moment it's this, and the next that.

Discover, don't search, when you're playing. If you can't surprise yourself, you can't surprise anyone else, either. It's not a matter of knowing, but of giving. No one wants to hear what you've learned. They want to hear what you're discovering right in front of their eyes.

It's like a photo I have of two women who've just seen a tragedy in the street, and one woman is in terrible pain, but the other is very much more so, and the first woman is holding her up. Music, when it's at its best, the sound of it, is like that first woman, but what's inside you is that other woman who would fall without your guitar's helping hand.

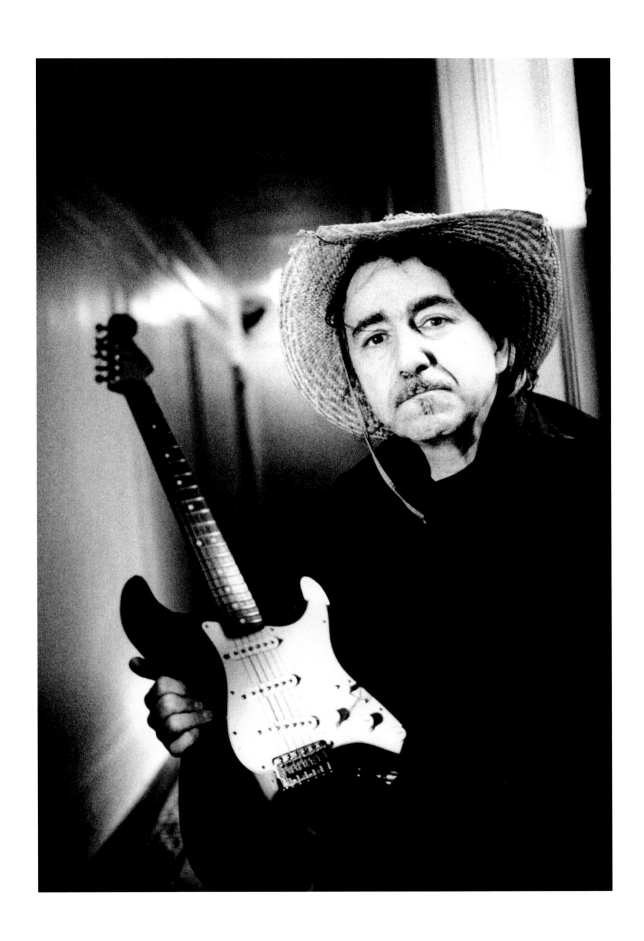

Jeff Parker

Rhythm was the first thing that attracted me to music. As a child, I liked to dance, and our family and friends used to have dance parties. We would turn up the radio or put records on the stereo, and everyone would boogie down. The music was soul music, funk music from the '70s: Stevie Wonder, Earth, Wind & Fire, Charles Wright, P-Funk, Cymande, Curtis Mayfield, and Gladys Knight are a few artists that come to mind. Funk and soul music are driven by the bass; a good song usually had a bass line that was as catchy as the melodic hook.

Consequently, when I started to play music on my own, I wanted to be a bass player. But I picked up my sister's acoustic guitar, and the first two things I taught myself to play on the guitar were bass lines: "Slide" by Slave, and "One Nation Under a Groove" by Funkadelic. When I finally got around to teaching myself an actual guitar part, it was the rhythm guitar line to "Reunited" by Peaches & Herb. After that, I really got into rhythm-guitar players, the cats who were in the background locking up with the bass and drums, chugging along, making the music bounce, making the heads nod, making the feet tap, making the music move. I love being a part of the rhythm section.

I almost became a bass-guitar player, but it was too limiting for me. My father took me to the music store when I was twelve years old to buy me one, but when I tried some of them out, they just didn't feel right. I began to appreciate the guitar for what it was and what it was capable of, and it opened up a whole universe of possibilities for me.

It's such an adaptable instrument: percussive, but also melodic and harmonic. For most every genre and style of music that we can think of, the guitar is there, and there's a totally different approach to playing the instrument that follows the music. Once the electricity gets involved, anything is possible: explosions and whispers, calm or chaos . . .

One of the greatest things about loving the guitar is the camaraderie it creates among guitarists. I've met so many wonderful people, made a lot of great friends who love guitars and guitar players, several of whom are included in this collection of photographs. We're almost like a secret society, a bright underworld. Go, go guitars!

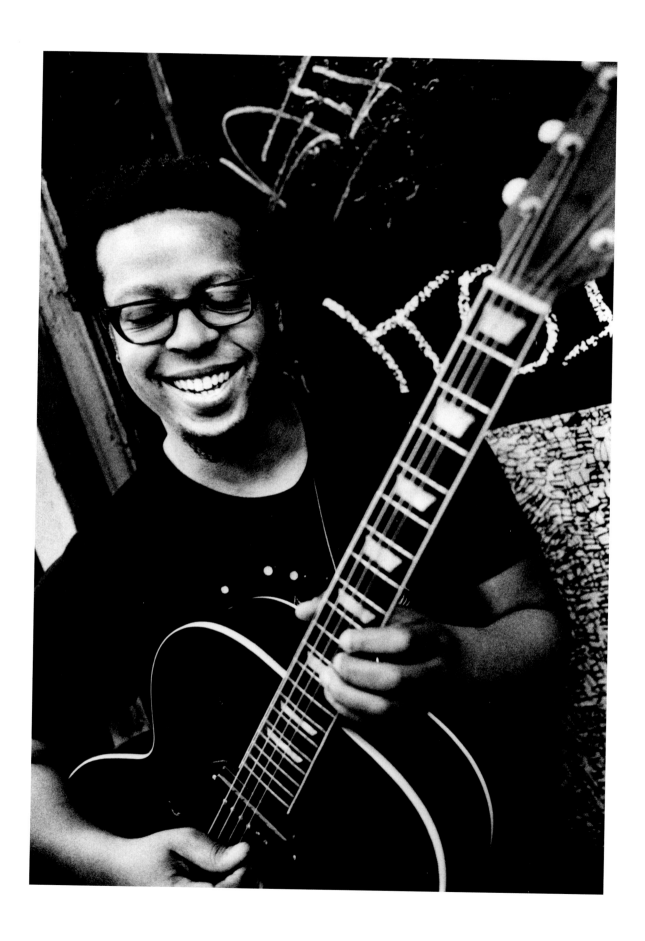

Allan Holdsworth

There's something I want the guitar to do that I haven't been able to make it do yet. I have struggled to put out more of a rock sound into a traditional jazz trio setting, where a lot of the music is kind of soft, while at the same time making the electric guitar sound less gnarly. I'm trying to get the guitar to take orders from me, instead of the other way around, though usually I'm the one getting beaten up.

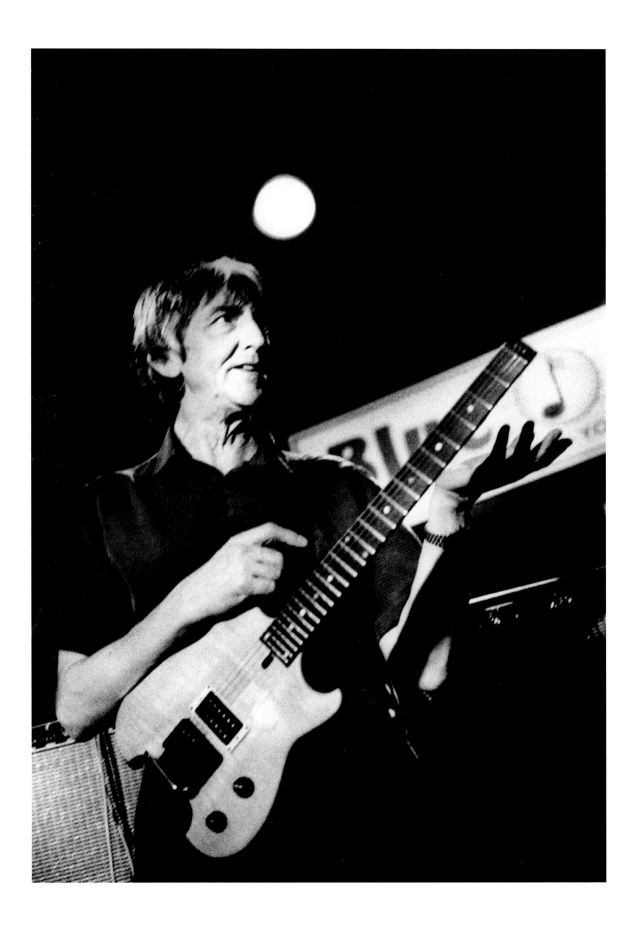

José Luis Beltrón Díaz

Education: National School of Art in Havana, Cuba

Influences: Heitor Villa-Lobos, who made me travel through his preludes into the samba scene in *chorinho* ("little cry" in Portuguese, applied to a Brazilian performance style in music) and other native Brazilian rhythms. Carlos Rariñas, a Cuban composer who left one important piece for Cuban guitarists. In general, all of the richness of our musical roots. Guitarists like Kenny Burrell, Joe Pass, and Wes Montgomery captivate me chord for chord, scale by scale.

If someone asked me why I play the acoustic guitar and not the electric, I would respond: "It is like asking a runner if it is the same to run on fresh grass or a synthetic ground."

The acoustic guitar permits me to transmit with more trust in regard to all of the sensuality, the folklore, the strength of our music transmitted in the rhythm cell of the sound of the Cuban drum.

I give thanks to God for being born on the island where the sensuality of the hips of a *mulatta* inspires the form of how you move your hands when improvising . . .

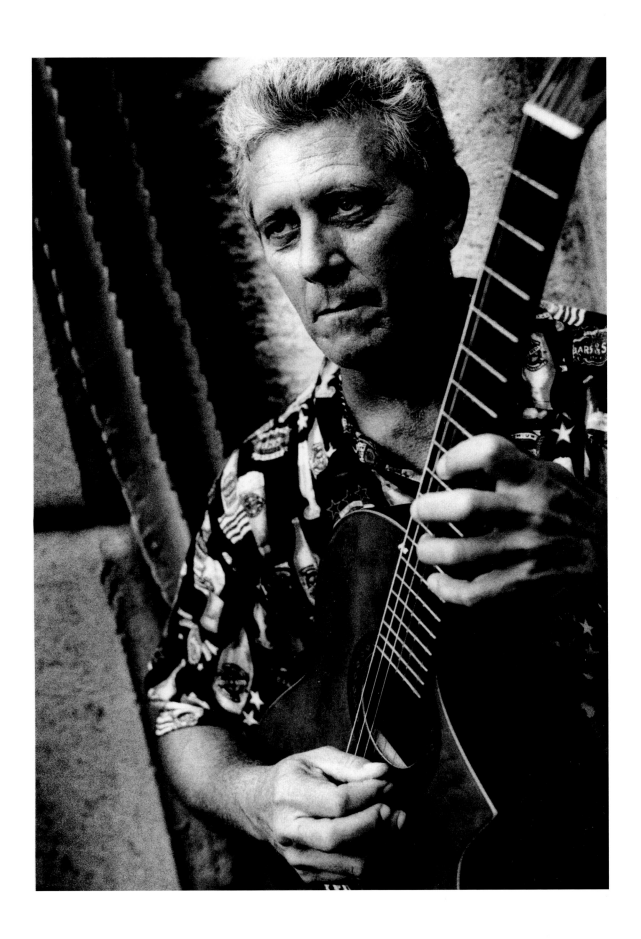

Ralph Gibson

Ralph Gibson was born in 1939 in Los Angeles, California, and in the 1960s he served as an assistant to renowned photographers Robert Frank and Dorothea Lange. He has been awarded Guggenheim and National Endowment for the Arts fellowships, and was decorated Commandeur de l'Ordre des Arts et des Lettres, France, among many other accolades. His work has been featured in hundreds of international one-man exhibitions and has been published in more than forty monographs. He currently maintains a studio in New York. For a complete list of his awards, publications, and projects, visit www.ralphgibson.com.